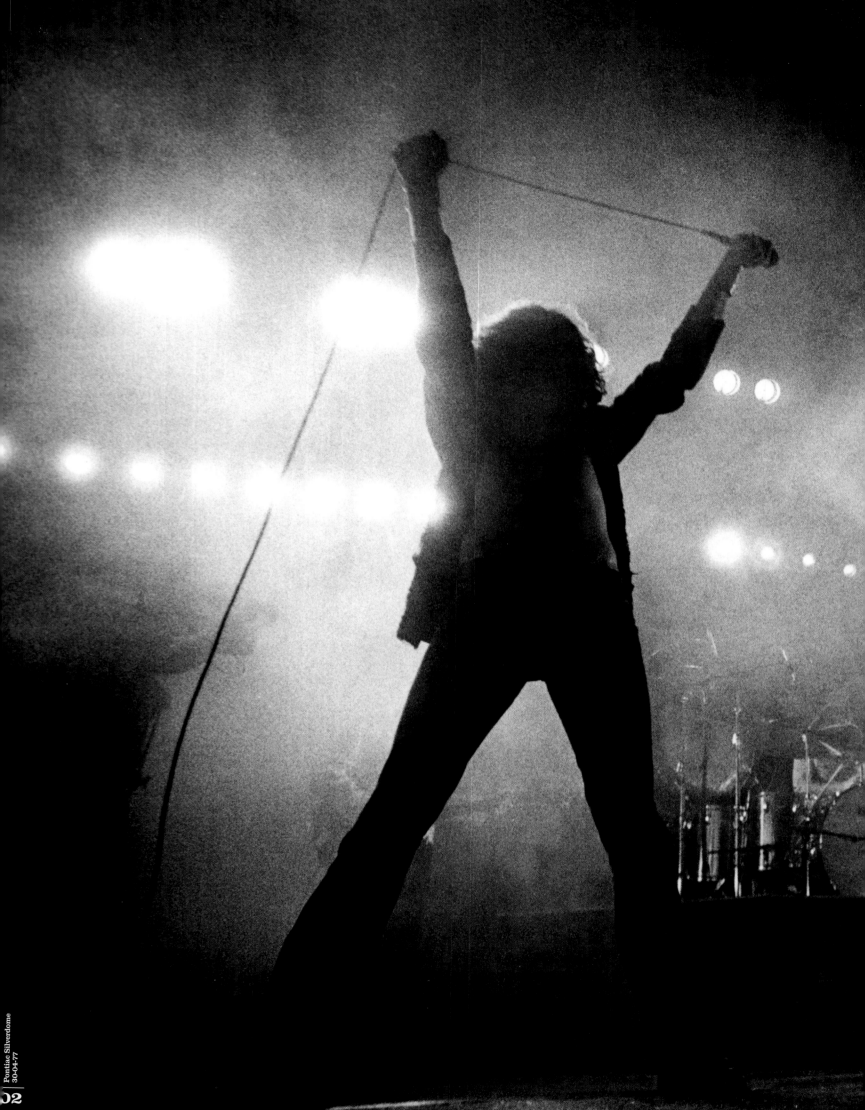

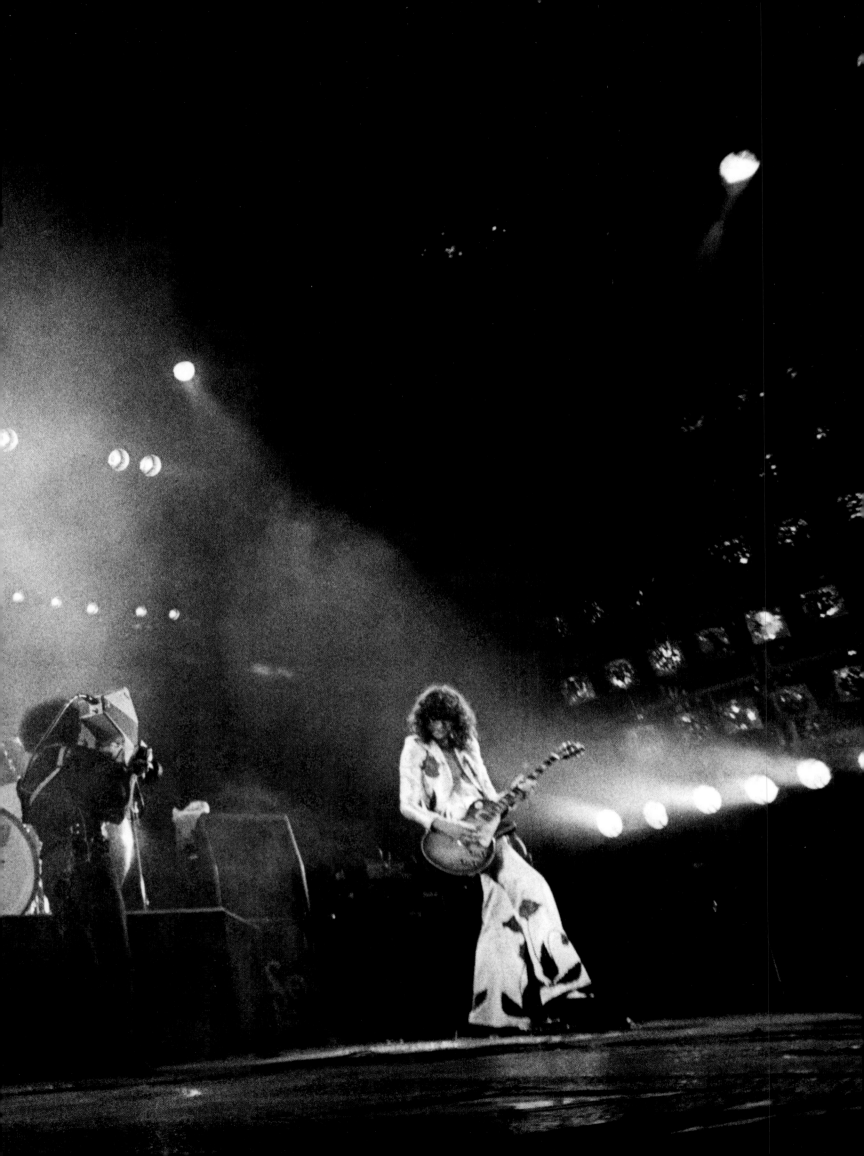

Led Zeppelin

Written by Dave Lewis
Design by Form®

A photographic collection by Neal Preston

VISION ON

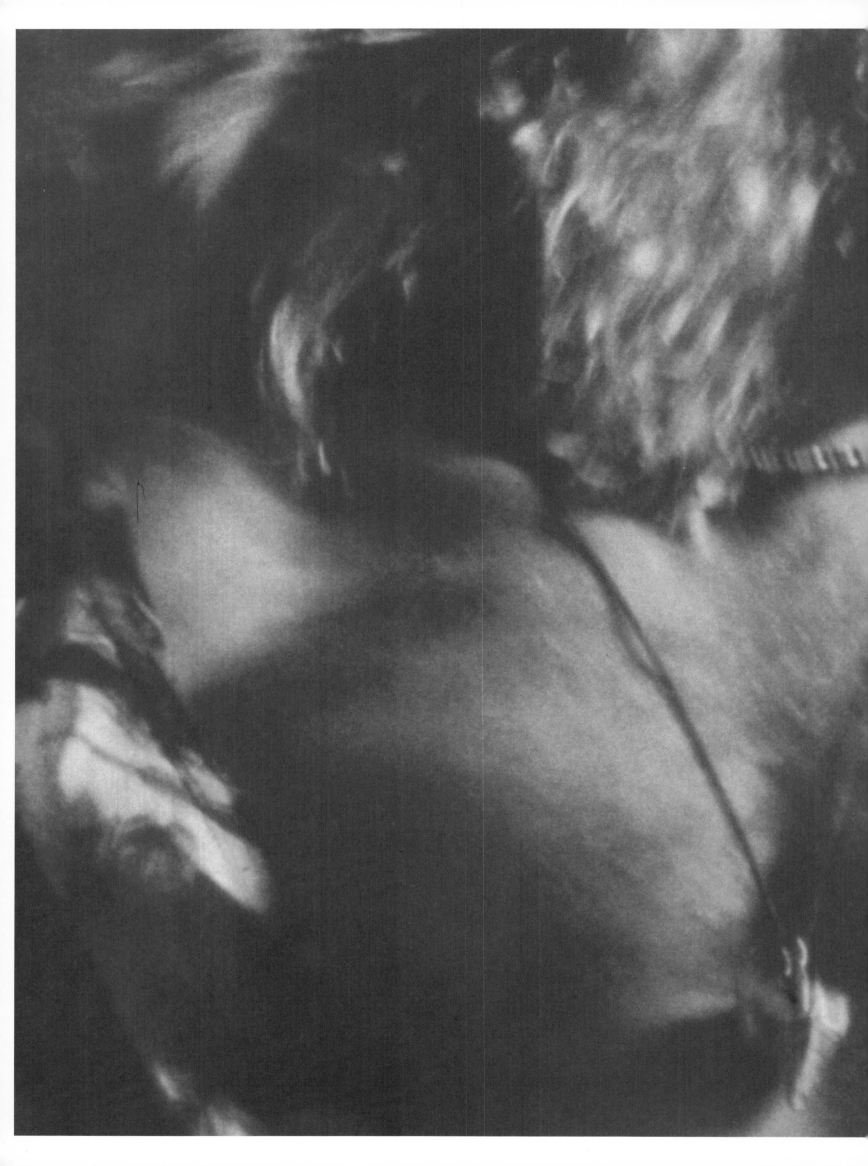

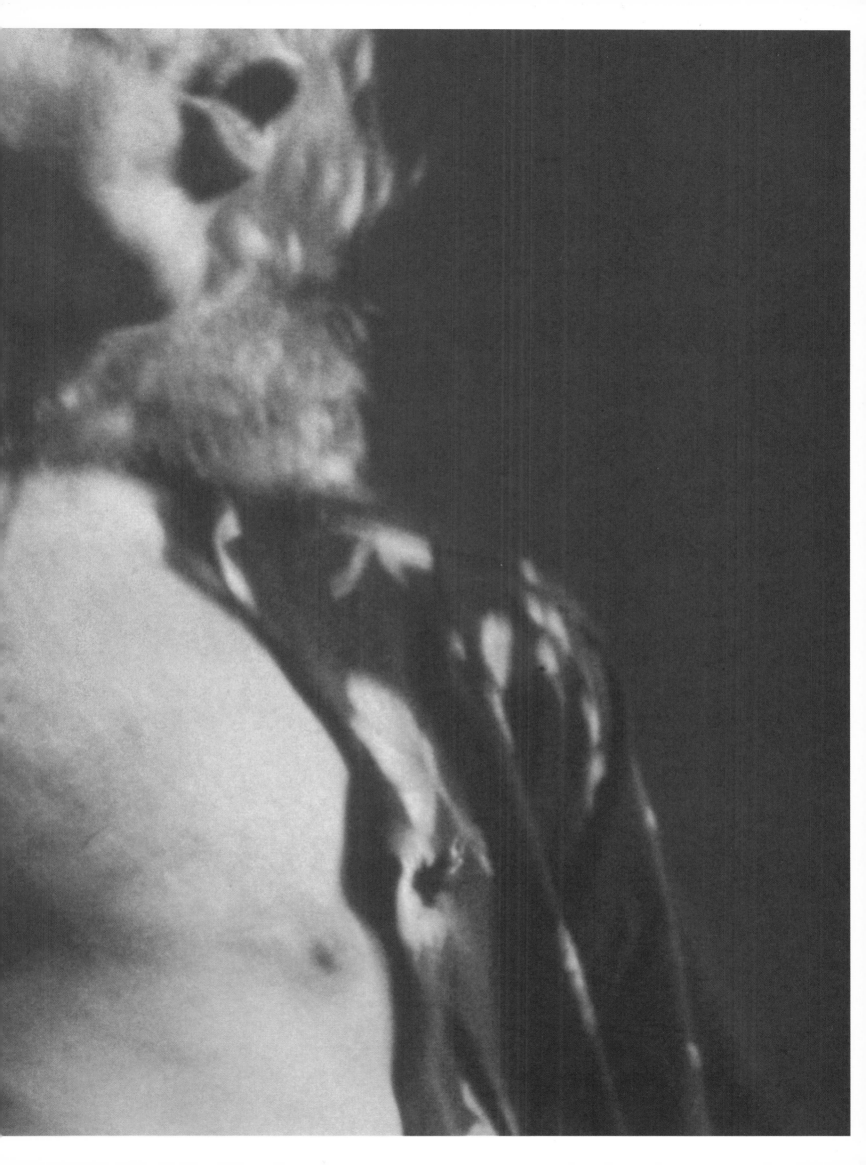

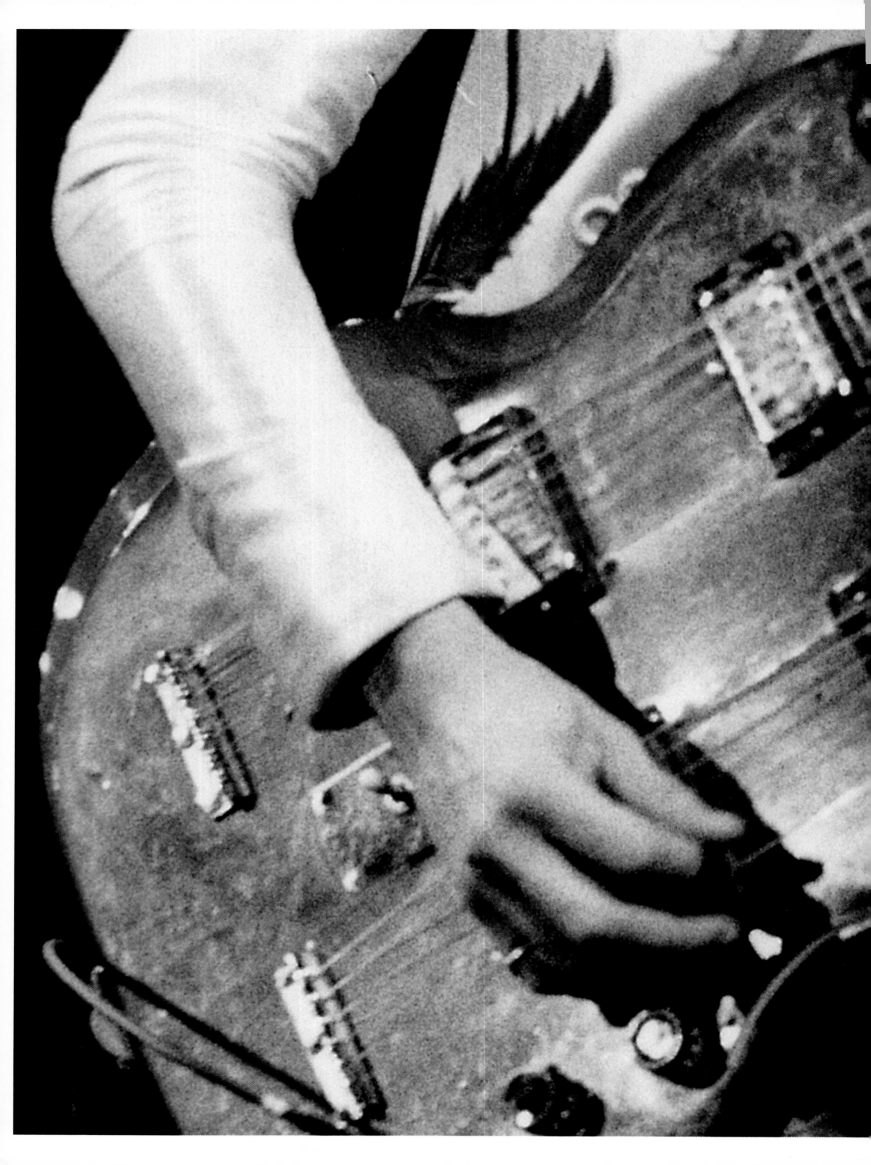

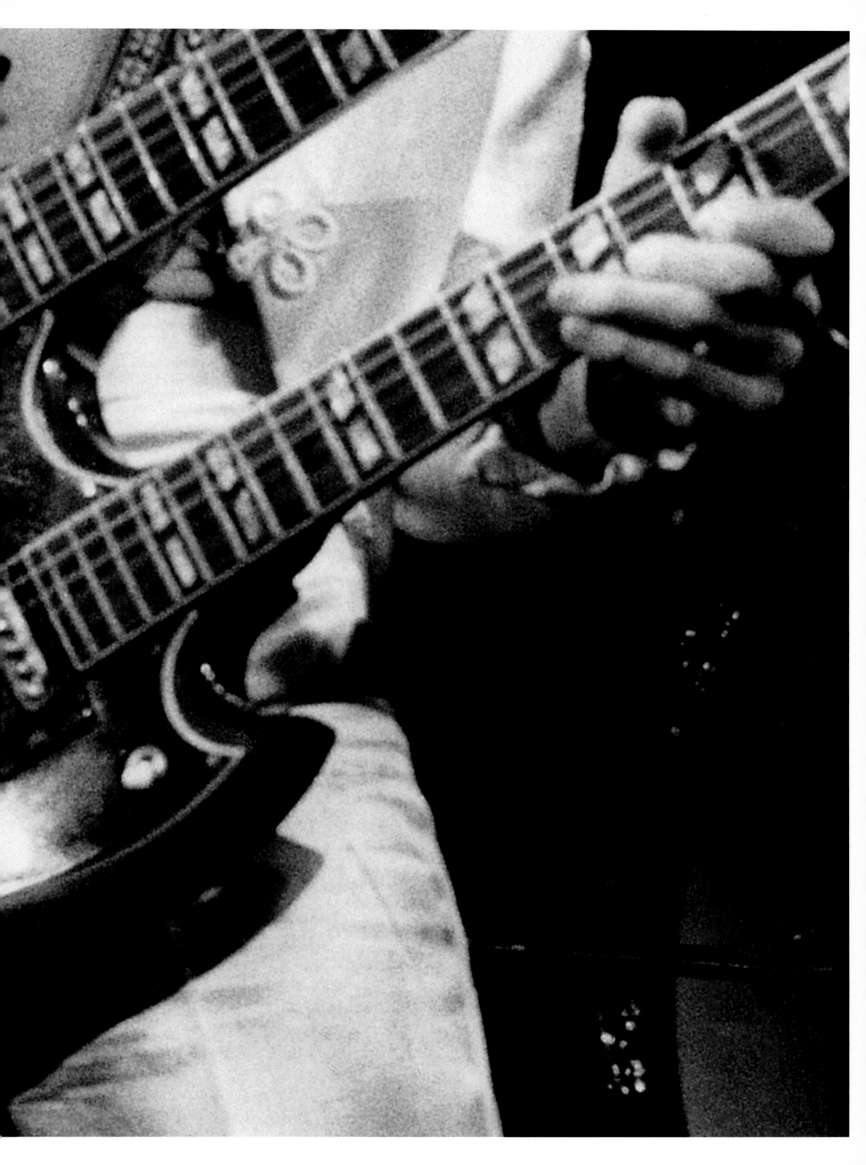

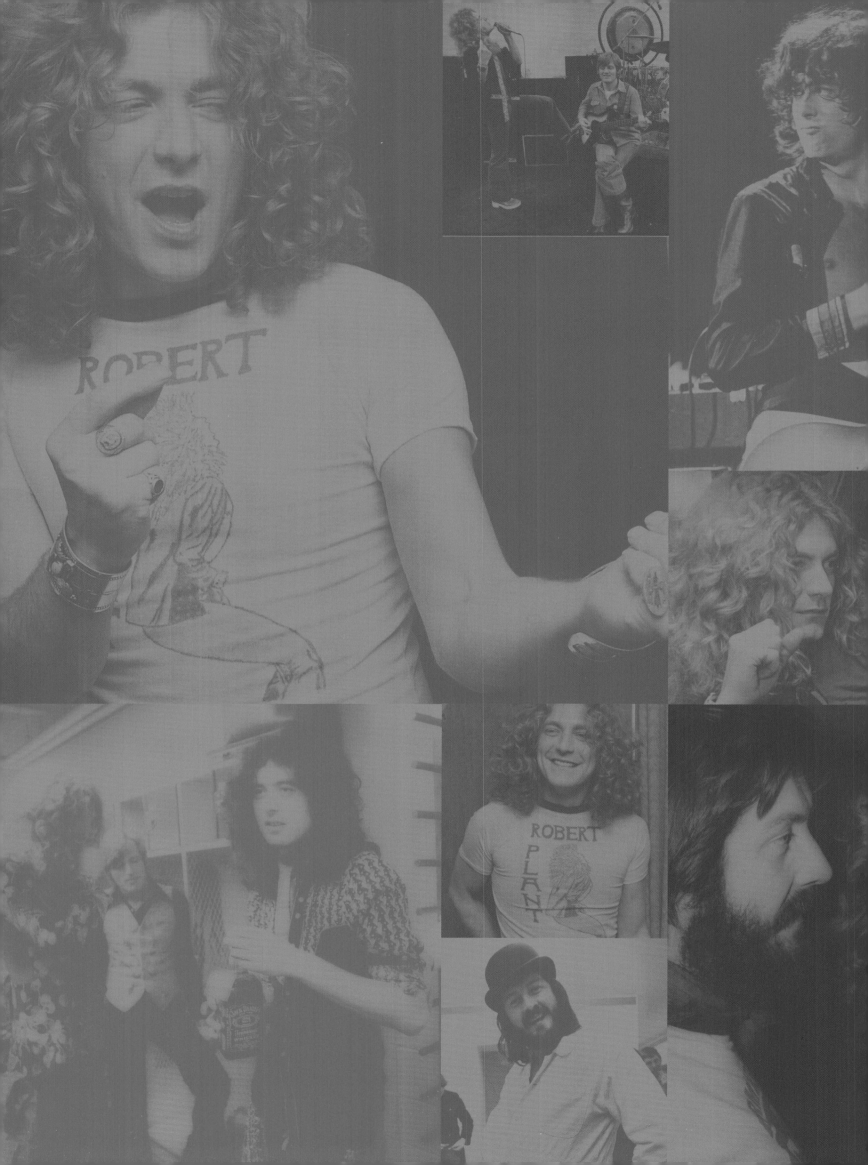

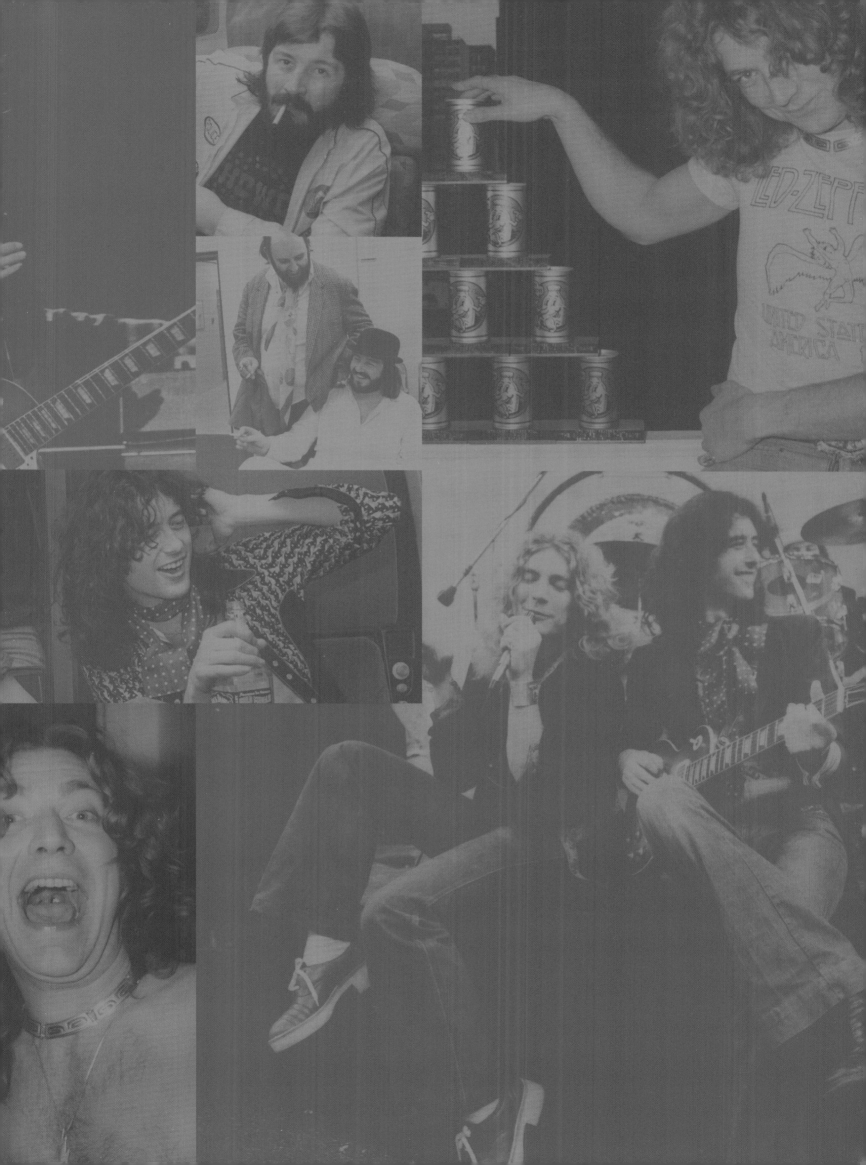

Introduction

The photographic images Neal Preston captured of Led Zeppelin back in the 1970s are still held in the highest esteem by their fans old and new throughout the world, and indeed by the band members themselves.

In early 1982, I had first-hand experience of this. Summoned to a meeting at their record company offices to discuss the cover design of what would emerge as their final album, a collection of previously unreleased outtakes appropriately titled *Coda*, I was asked to bring in a batch of cuttings and photos for Jimmy Page and Robert Plant to scan though. Picking up a shot of the band on stage at Kezar Stadium in 1973, Plant immediately exclaimed, "We need Neal in on this!" Right there and then, he promptly called him in America to enlist his help. The resulting centre spread sleeve deployed half a dozen of Neal's off-stage photos of the band. Neal's shots also adorn the booklets that accompany various official Zeppelin CD box set collections that have surfaced in recent years.

Neal Preston's association with the band was forged during their ascension to worldwide superstardom in 1973. Led Zeppelin had been enjoying massive success in America since their first visit in January 1969. They had come together in late 1968 from the remnants of the successful British R&B outfit The Yardbirds. Guitarist Jimmy Page had been at the forefront of the group's final years, and when they decided to split in the summer of '68, he found himself with the rights to the name and a handful of contracted shows in Scandinavia to fulfil. Page decided to put together a new Yardbirds. Initially he sounded out Terry Reid, an emerging singer on the UK scene. Reid turned down the job, instead recommending an unknown from the Midlands of England named Robert Plant. A trip to Birmingham to see him perform left Page in no doubt that Plant was ideal for the new venture. Plant in turn suggested his long-time friend John Bonham for the vacant drum seat. The line up was completed by highly respected session bass and keyboardist John Paul Jones.

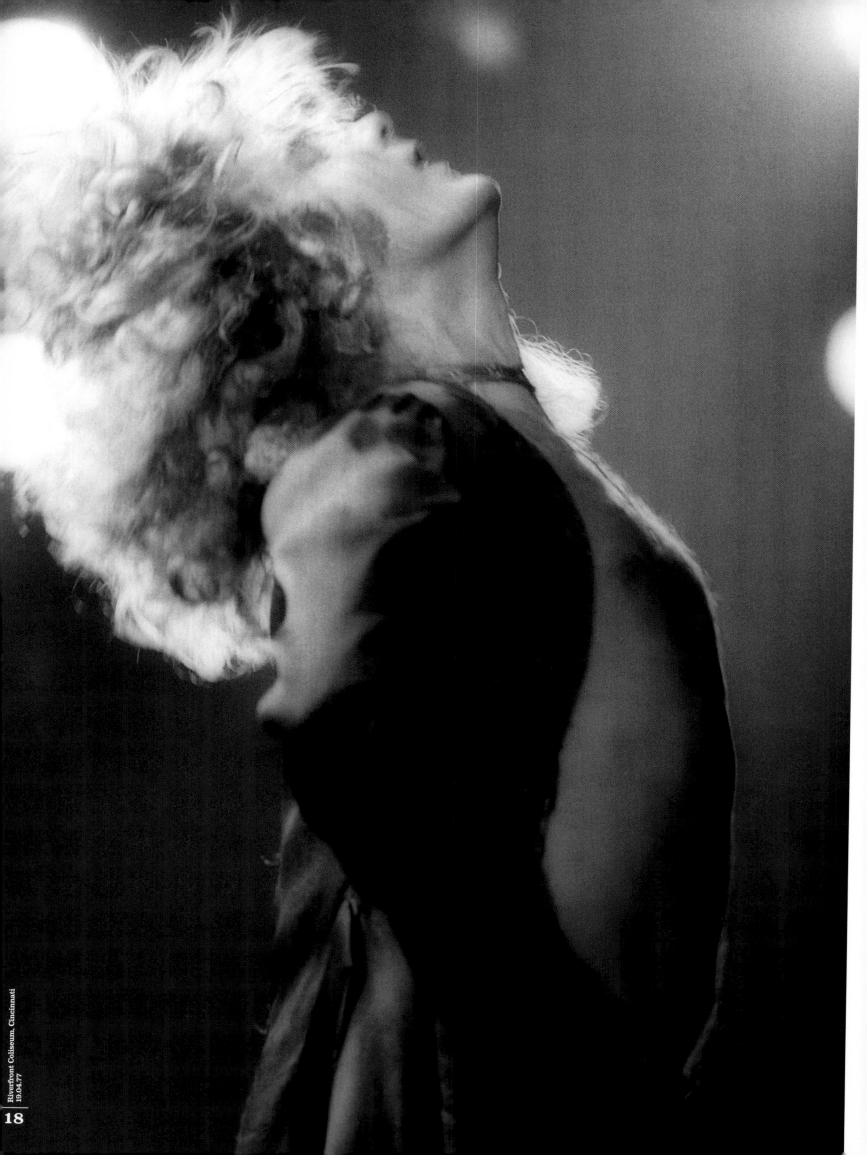

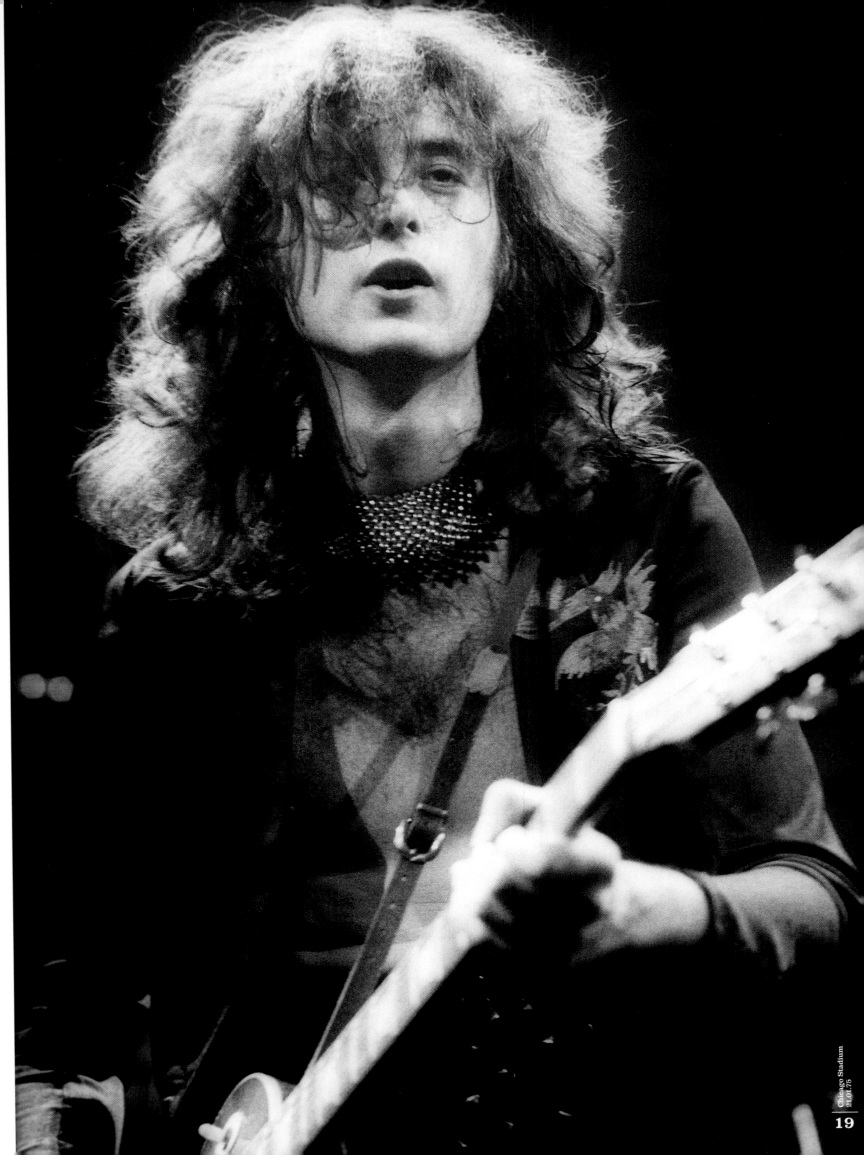

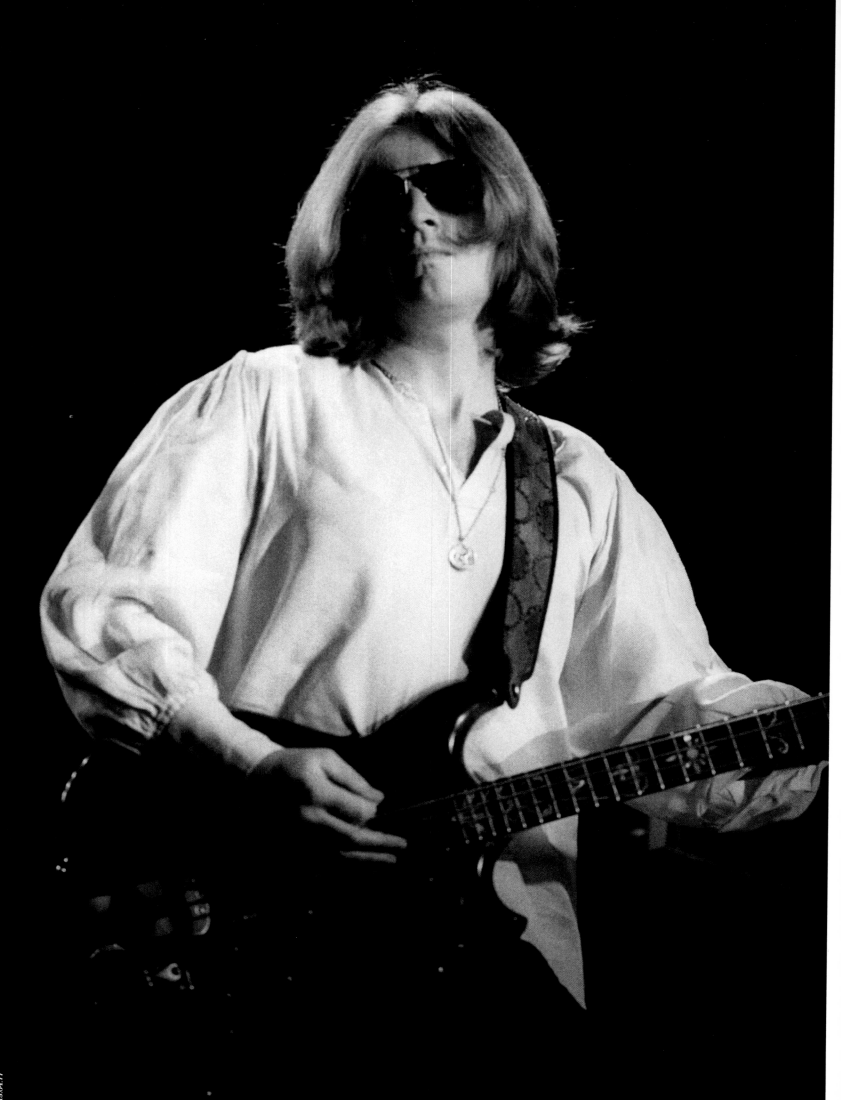

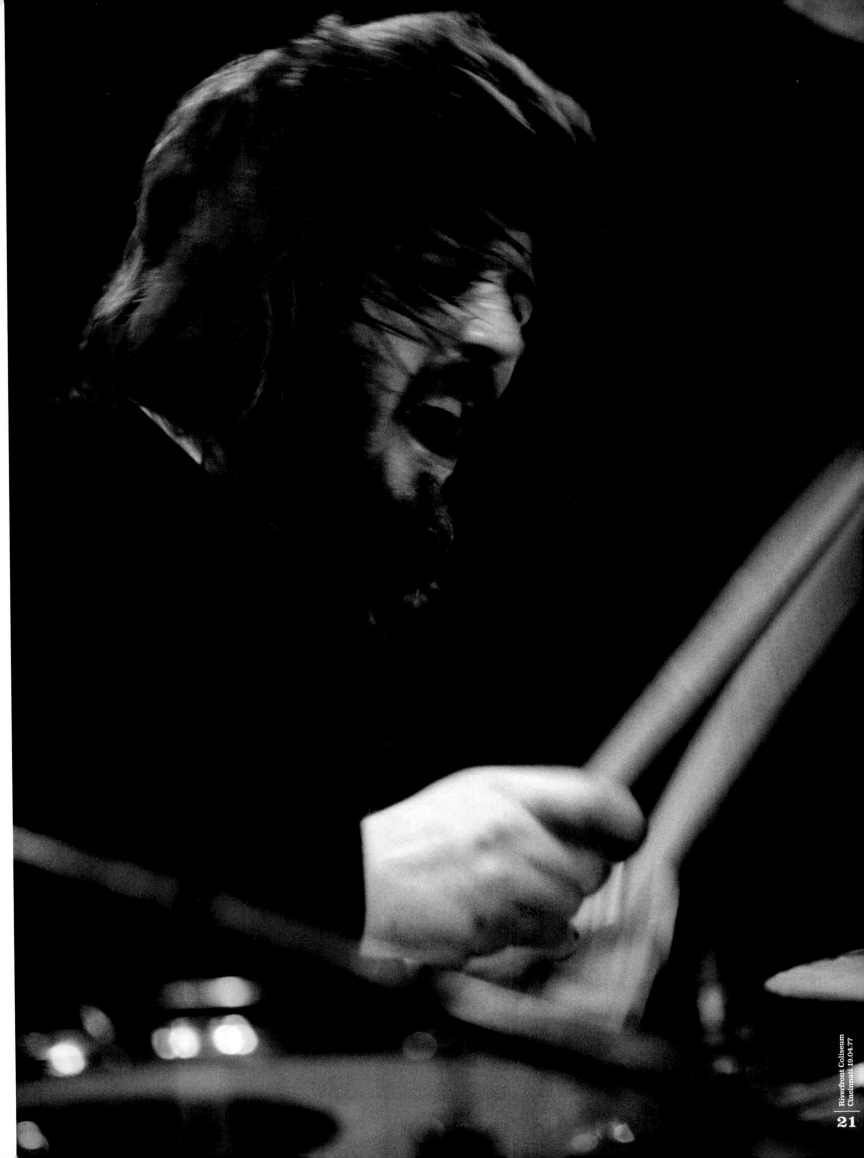

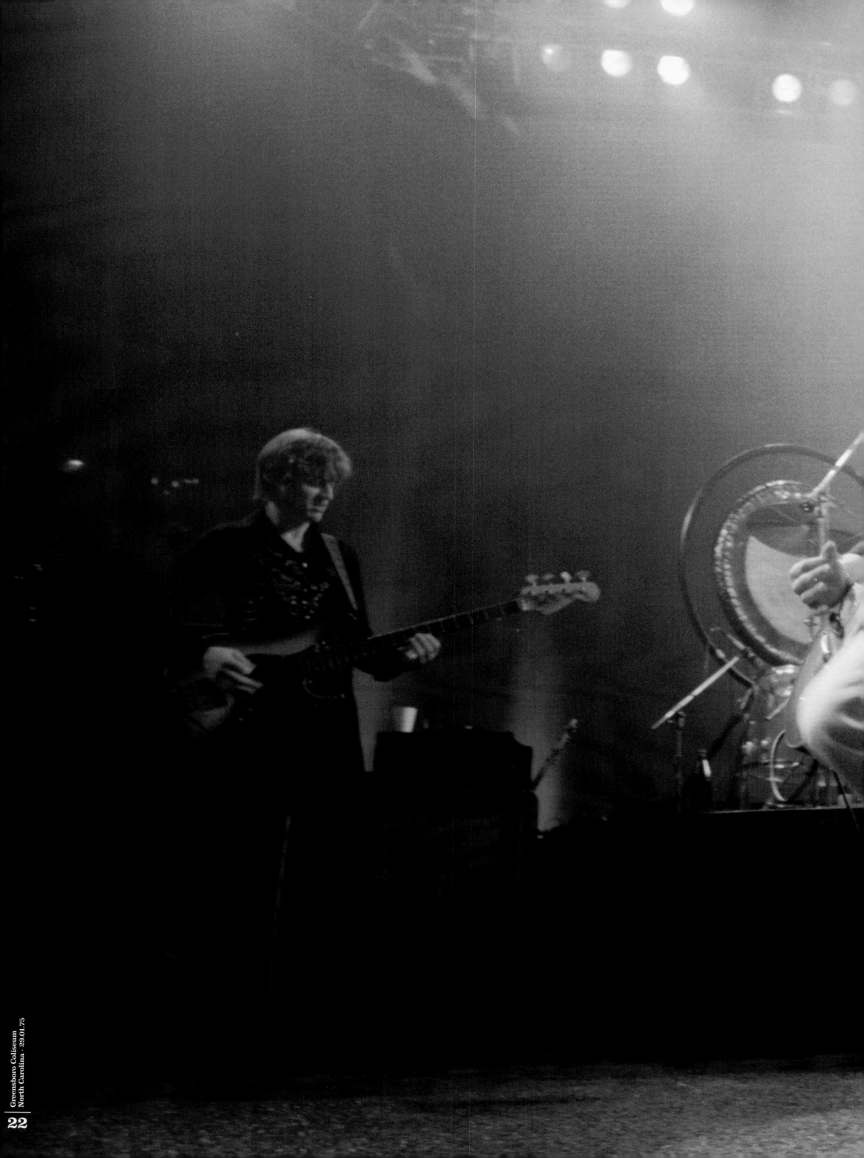

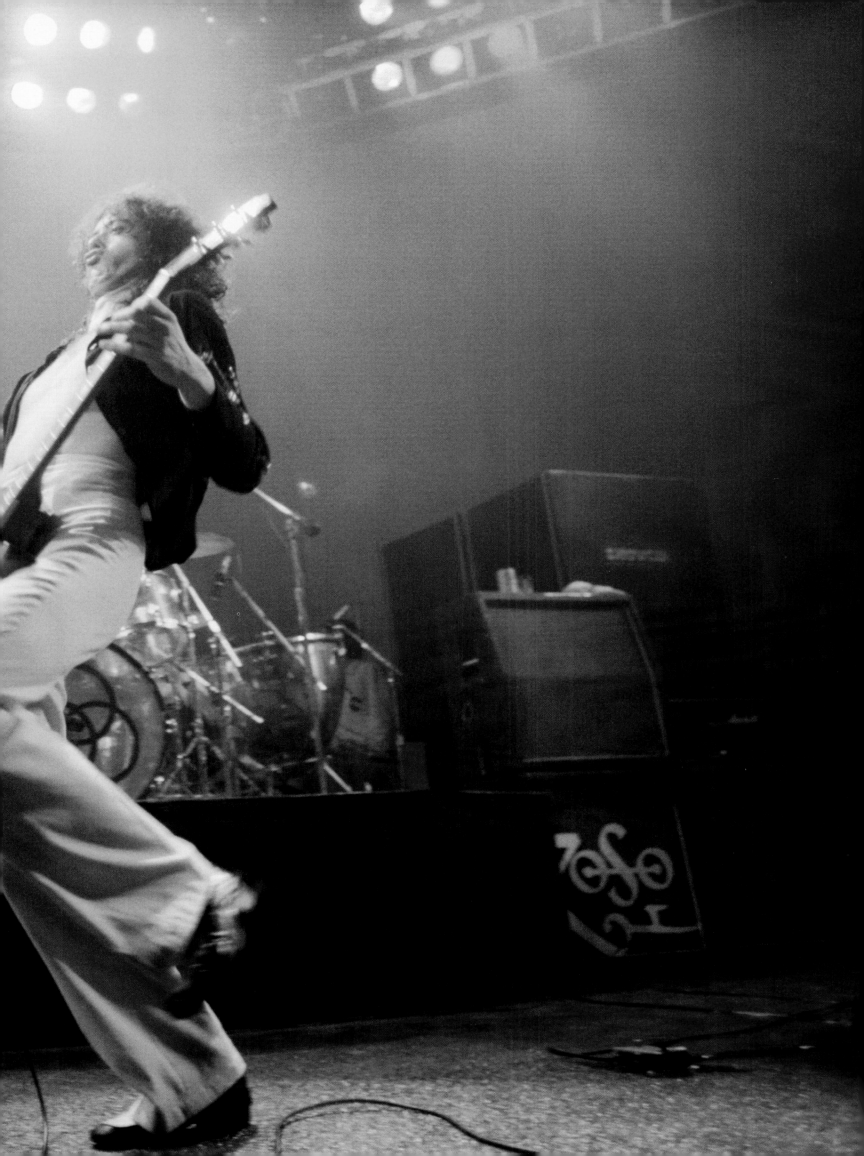

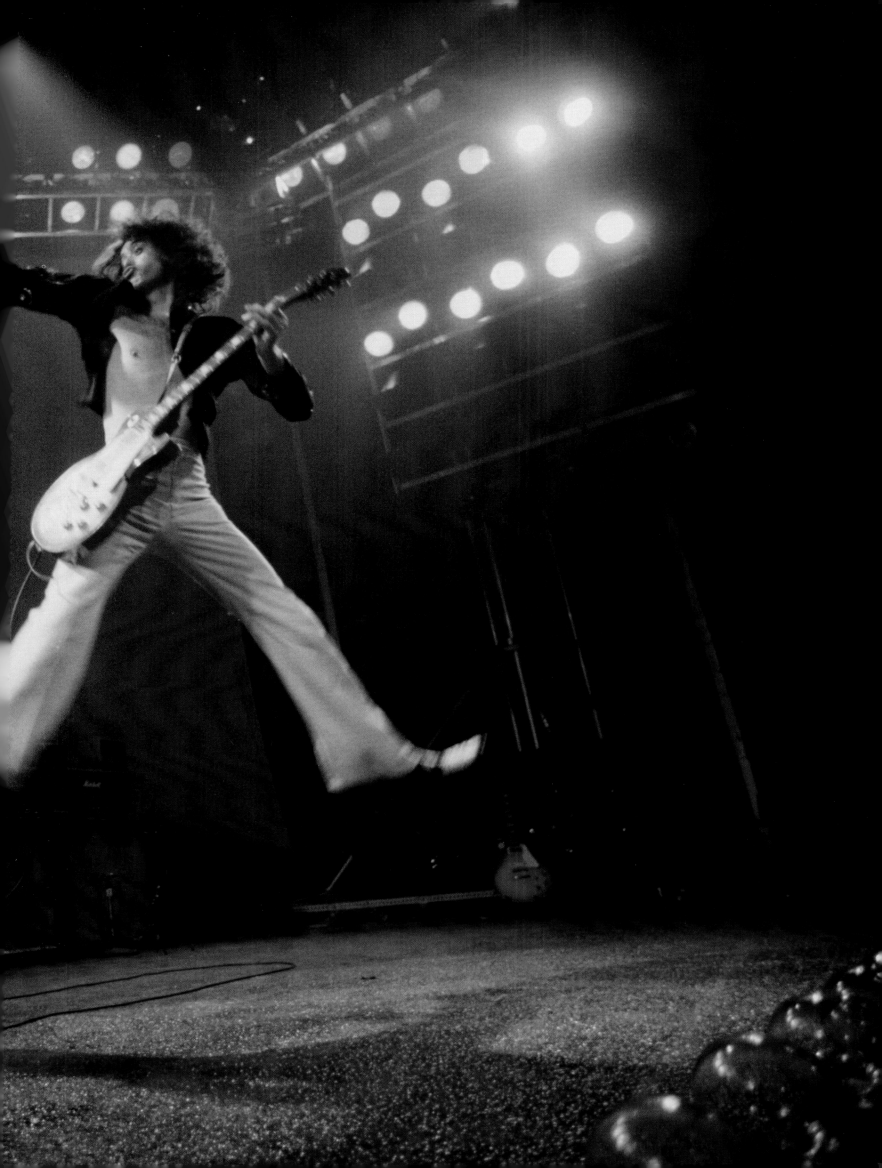

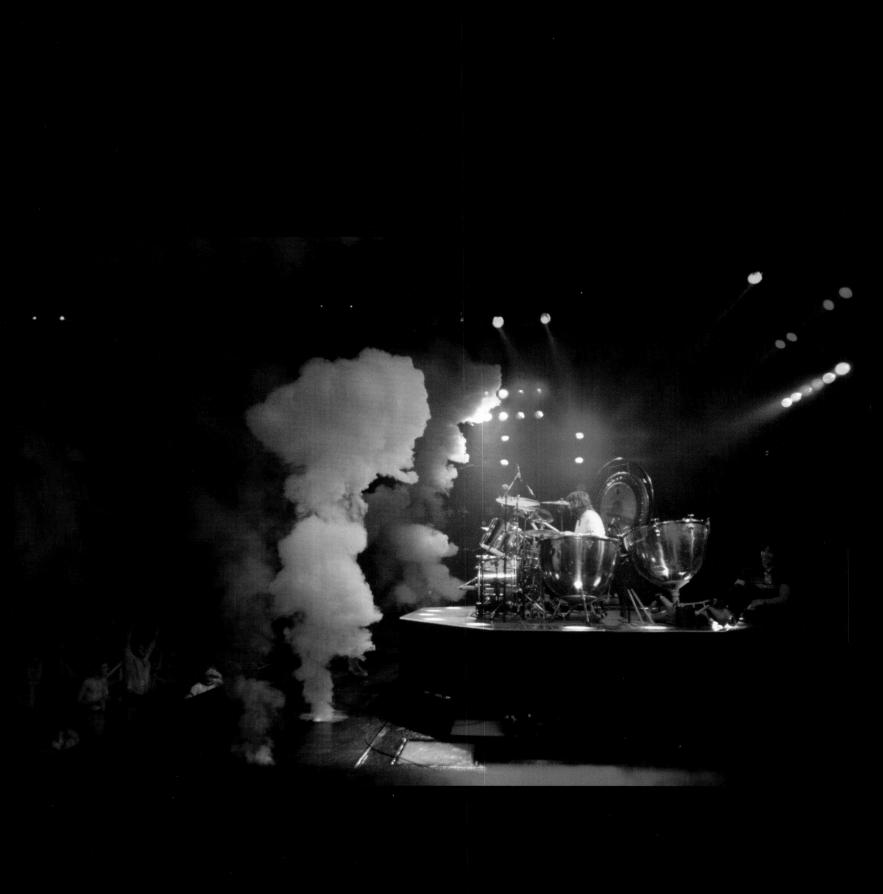

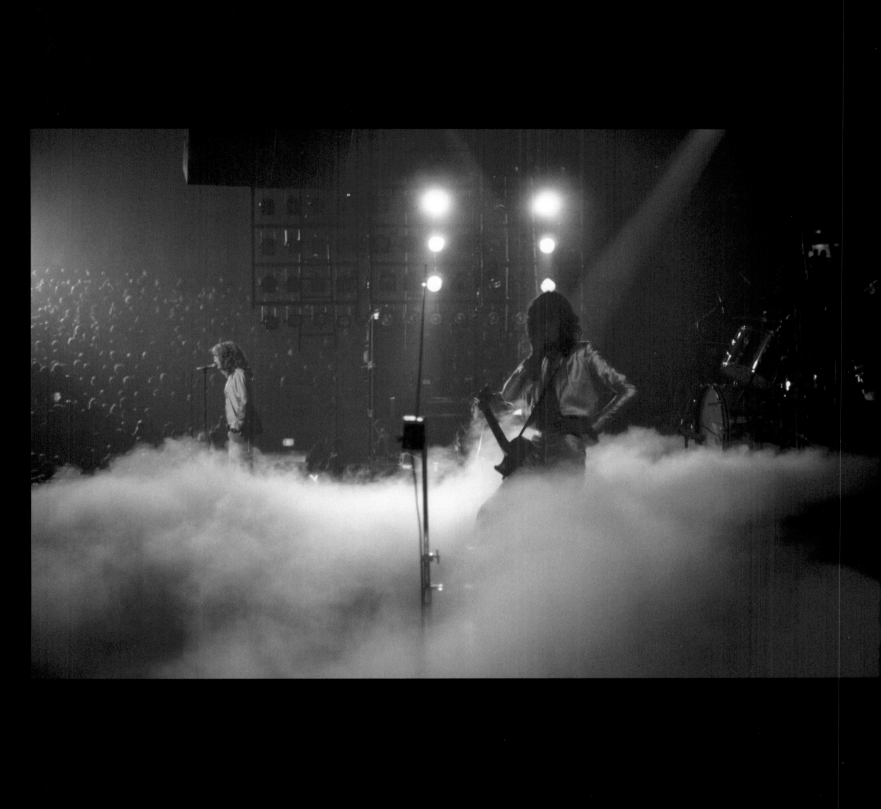

After fulfilling the Scandinavian dates, they returned to the UK and changed their name to Led Zeppelin - based on a remark by Keith Moon suggesting they would go down like a "lead balloon". They did anything but.

The chemistry of the four was instant. Within weeks, their hurriedly recorded debut album was riding high on the US Billboard chart. Their live reputation was forged initially on the college and ballroom circuits, where they became firm favourites at prestigious venues such as the Fillmore in New York and Los Angeles. Acclaim in the UK duly followed, and by 1970 they were selling millions of albums at home and abroad, and playing to packed arenas at every show. Under the astute guidance of manager Peter Grant, they developed an alluring mystique by refusing to pander to the media - there were no TV appearances and a no singles policy in the UK.

Musically, their crucial third album hinted at the breadth of ground they would subsequently cover. Zeppelin's foundations may have been rooted in blues-based rock, but they quickly broadened their approach to include folk, jazz, funk and Eastern influences.

Their fourth album, issued in 1971, cemented their reputation. The longest track from it, *Stairway To Heaven*, perfectly balanced the acoustic and electric elements of their work. Despite never being released as a single, it went on to became the all-time most requested track on radio stations across the world. Their 1972 visit to America had been slightly overshadowed as the Rolling Stones had been on tour at the same time. A year later the glory would be all theirs. Riding on the back of their just-released fifth album, *Houses Of The Holy*, it was during the 1973 US tour that Led Zeppelin graduated from being a mere top-selling rock band to becoming something of an institution in America. On the opening two dates alone, at Atlanta and Tampa, they drew over 100,000 fans - with no support act and no gimmicks - these were the days before MTV hype and fan websites. This was a purely musical phenomenon created by the strength of their album sales and relayed by word of mouth and their on-stage reputation.

By the end of the two-legged, three month trek, few kids in the United States would not have heard of these four Englishmen now breaking attendance records previously set by The Beatles - and Neal Preston was there, camera in hand, to see them do it.

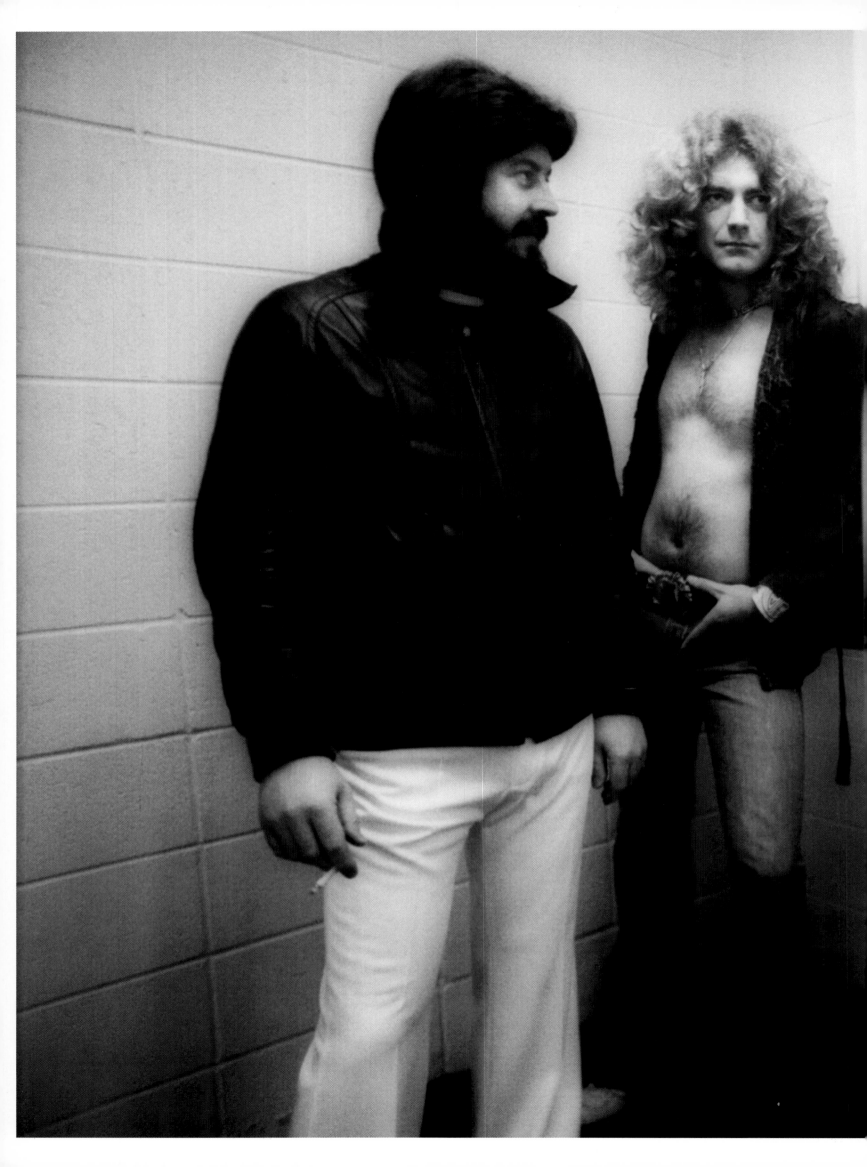

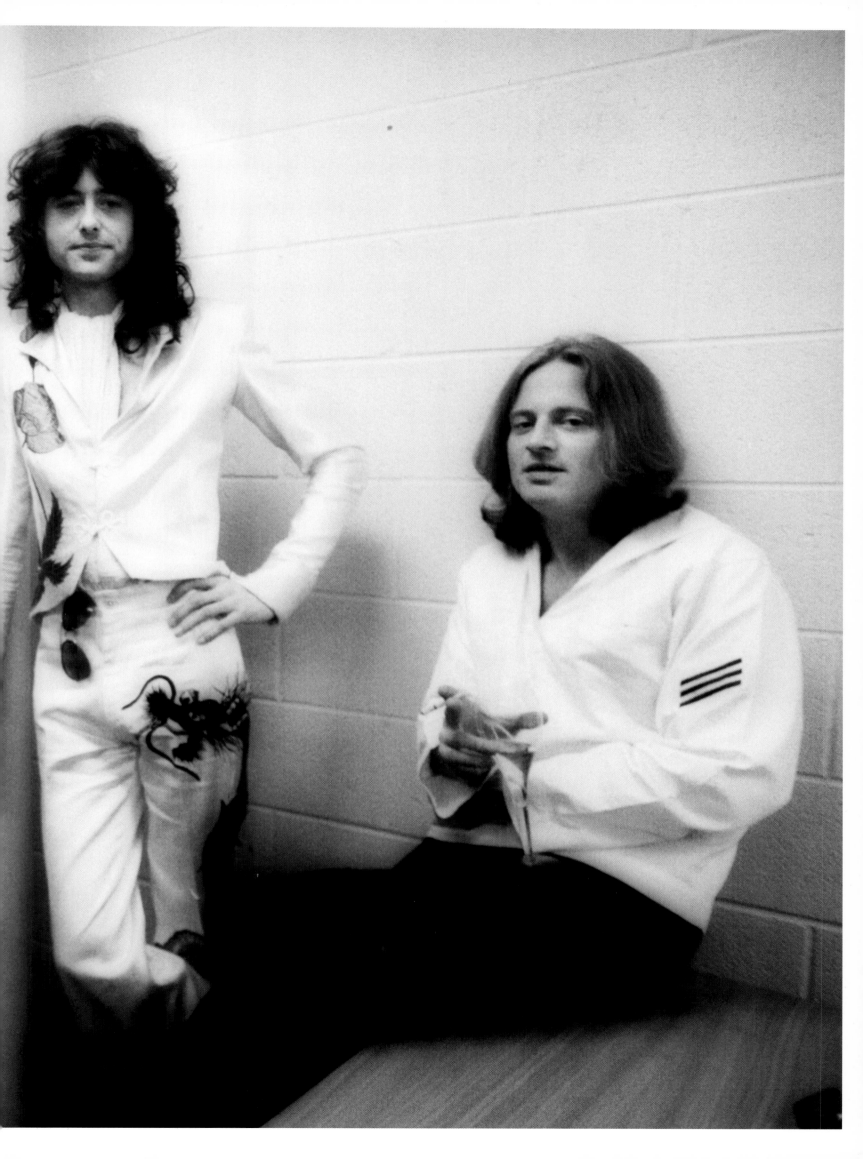

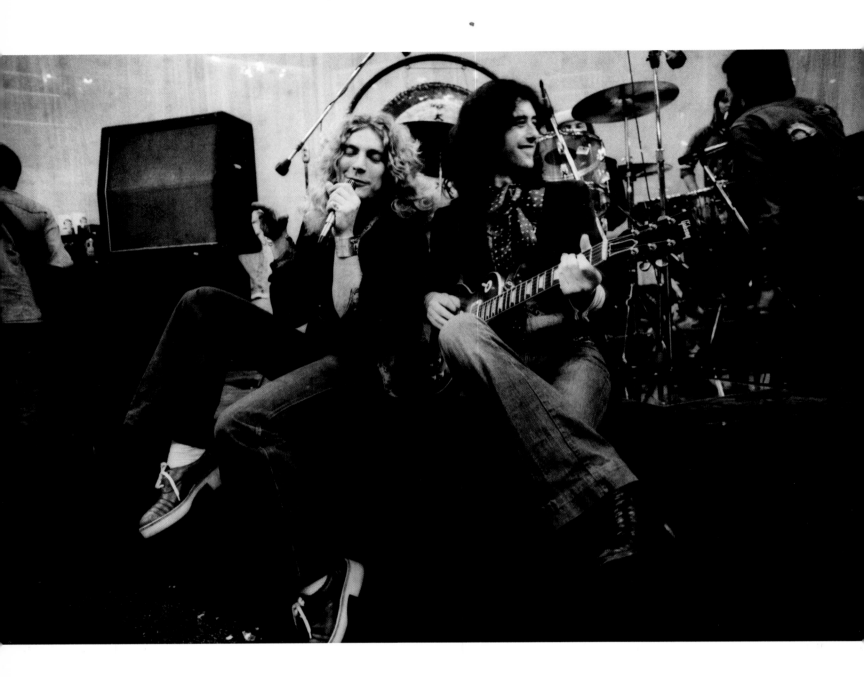

Final rehearsal for the 1975 US tour
Metropolitan Sports Center
Minneapolis · 17.01.75

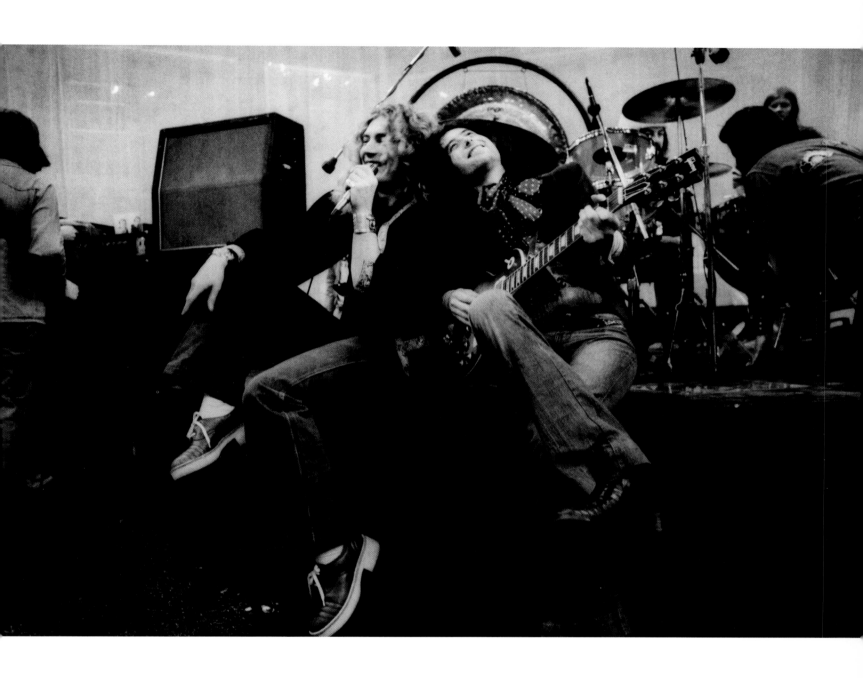

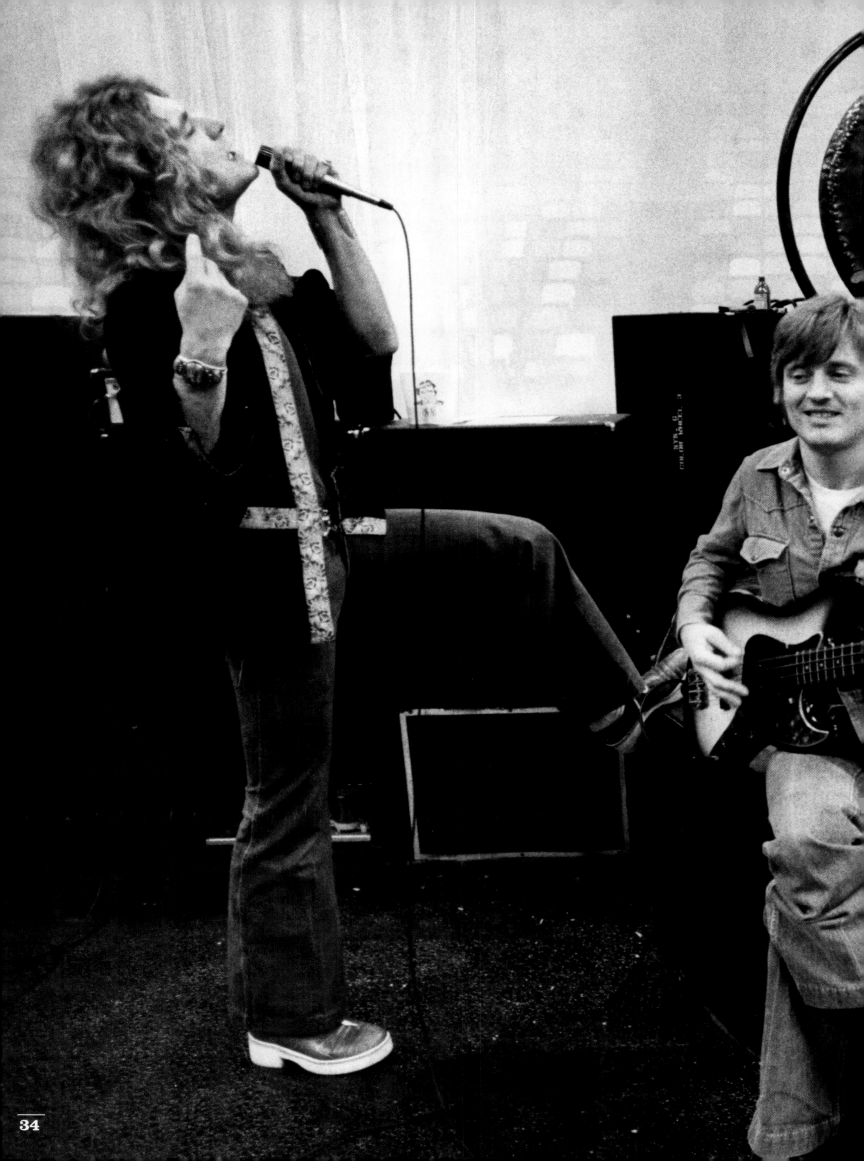

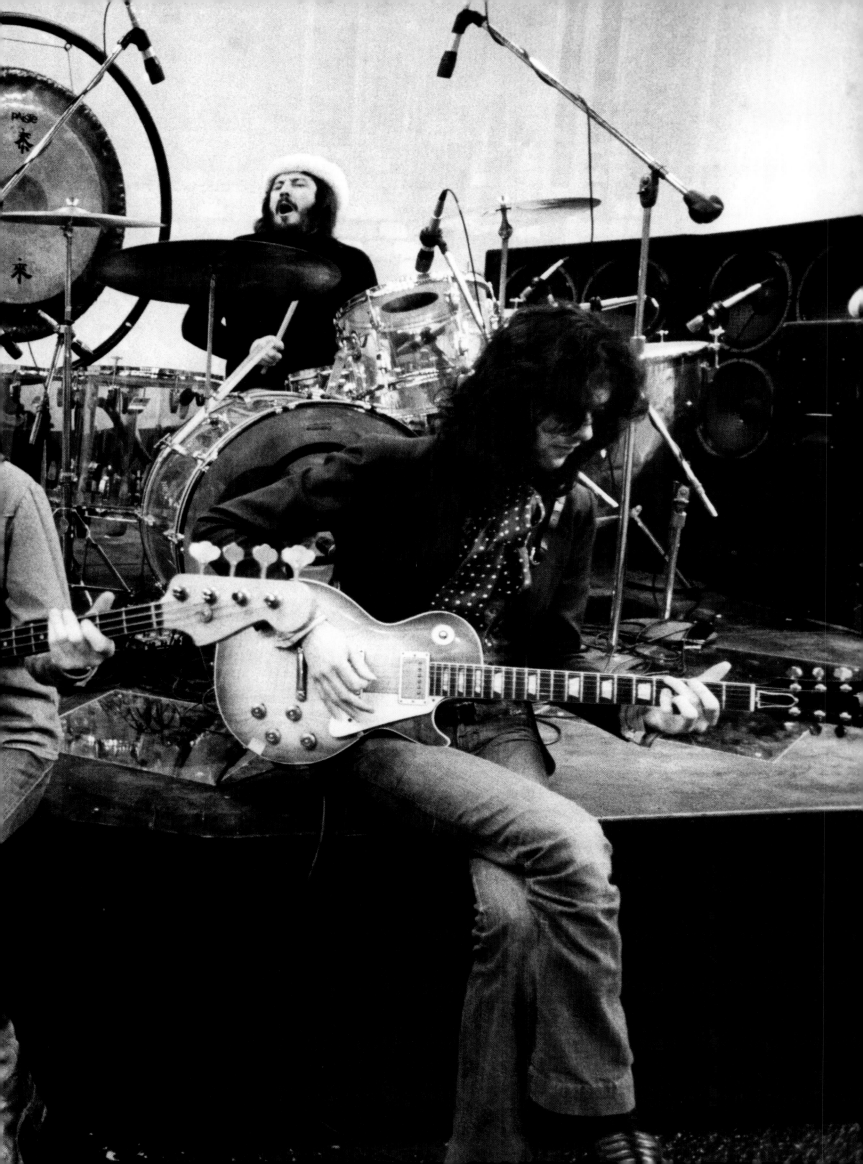

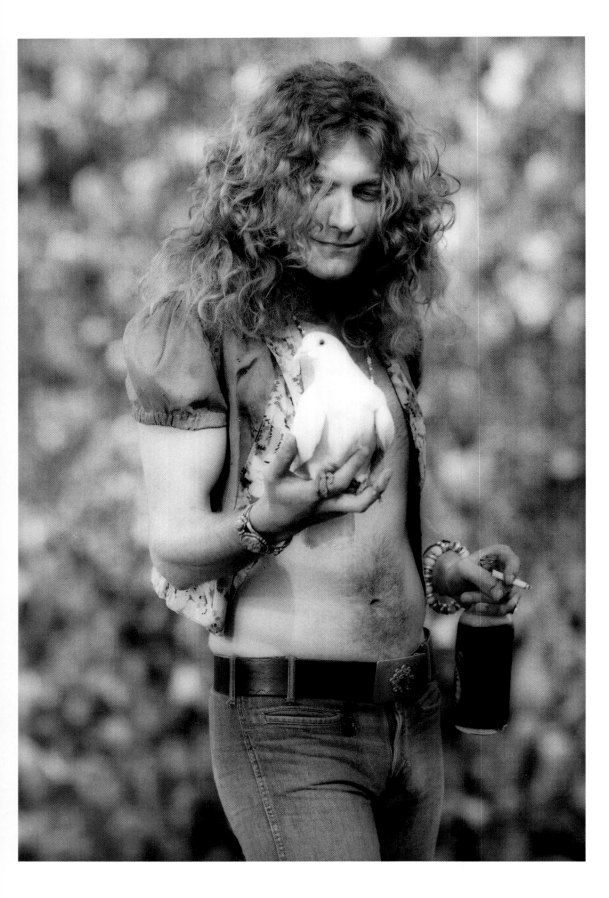

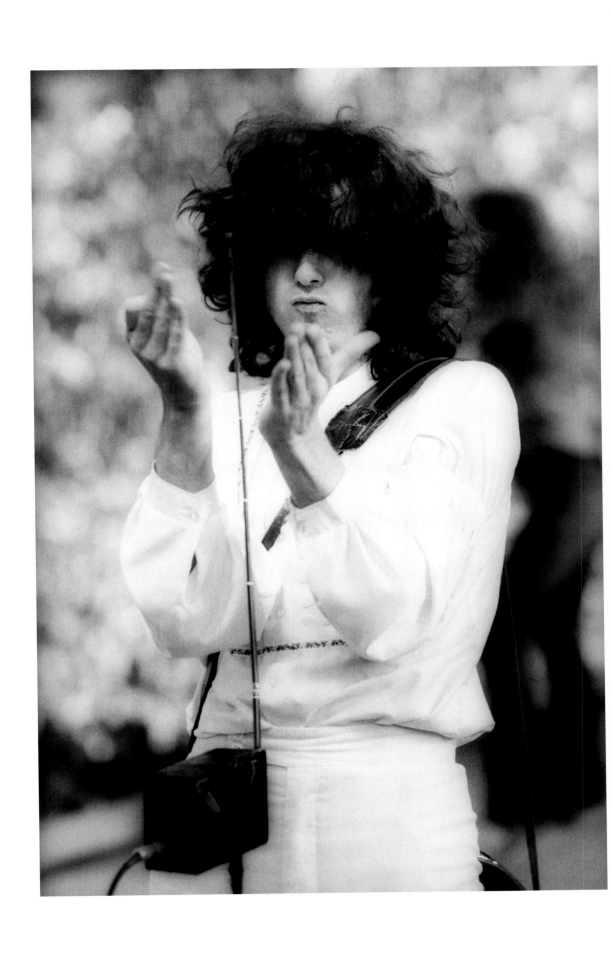

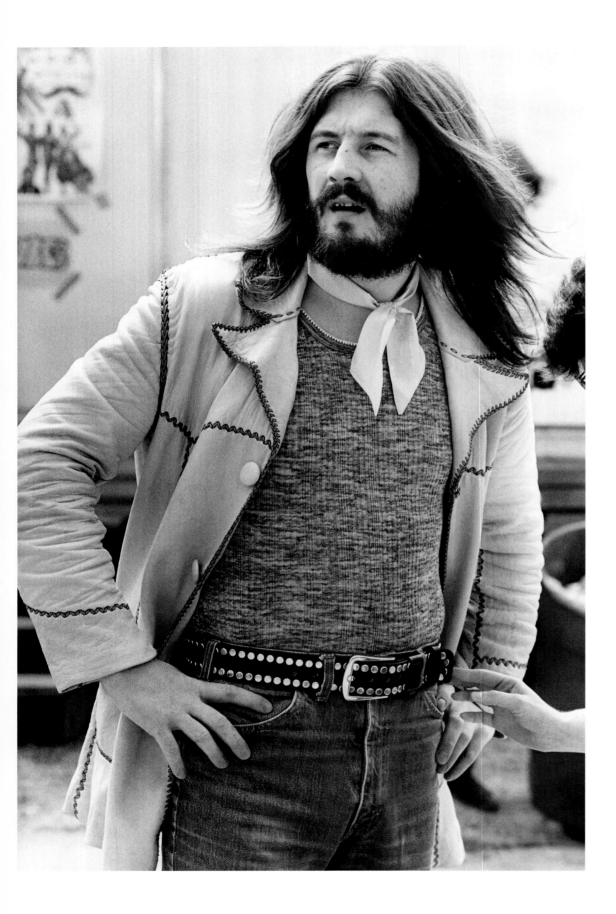

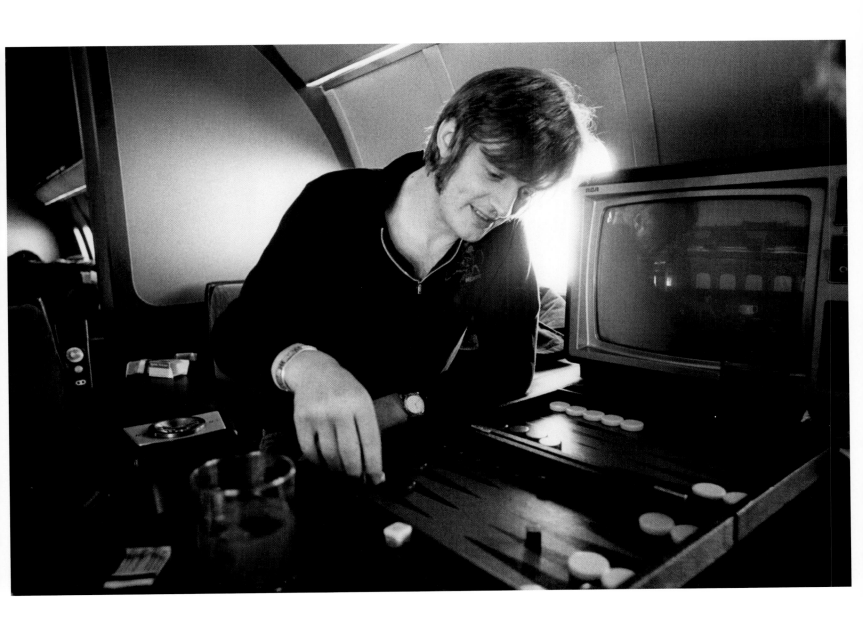

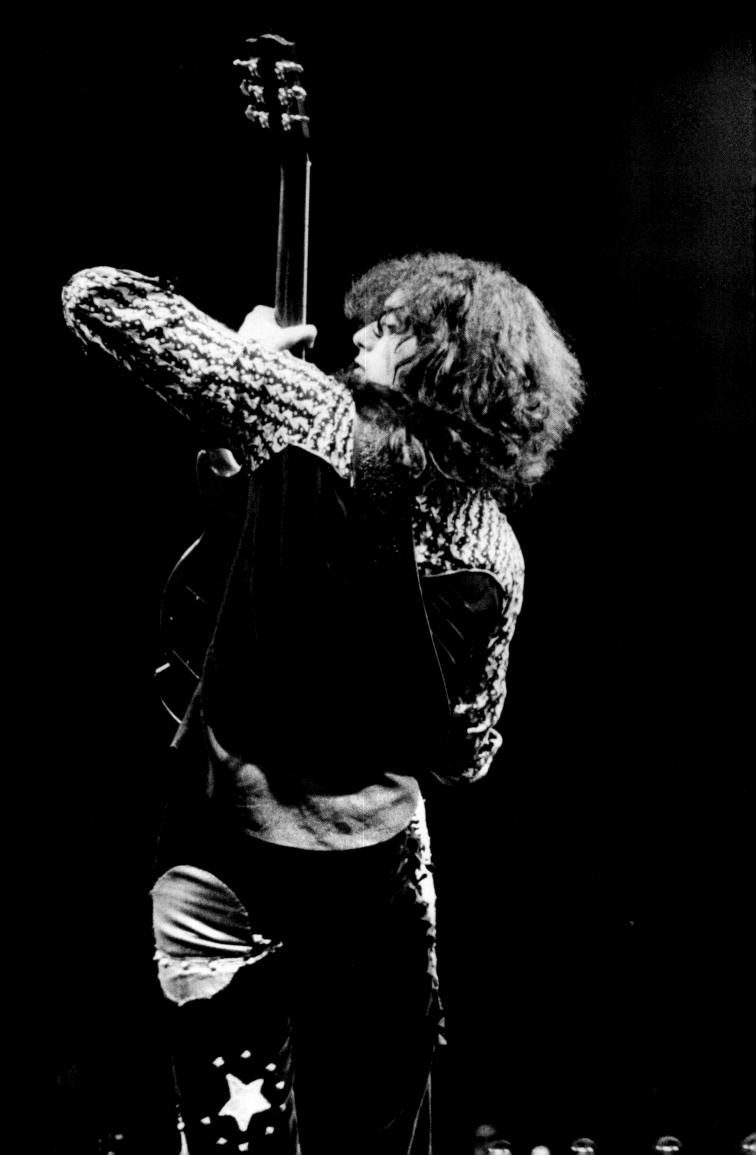

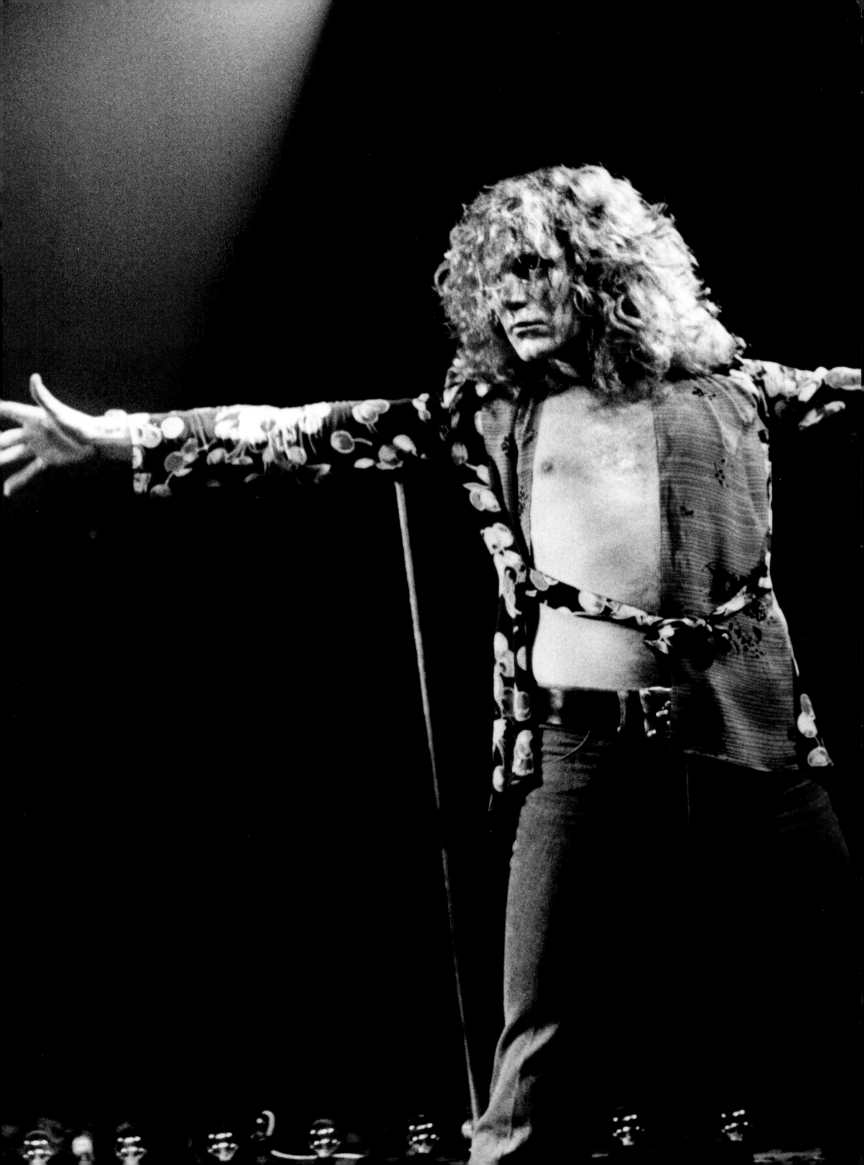

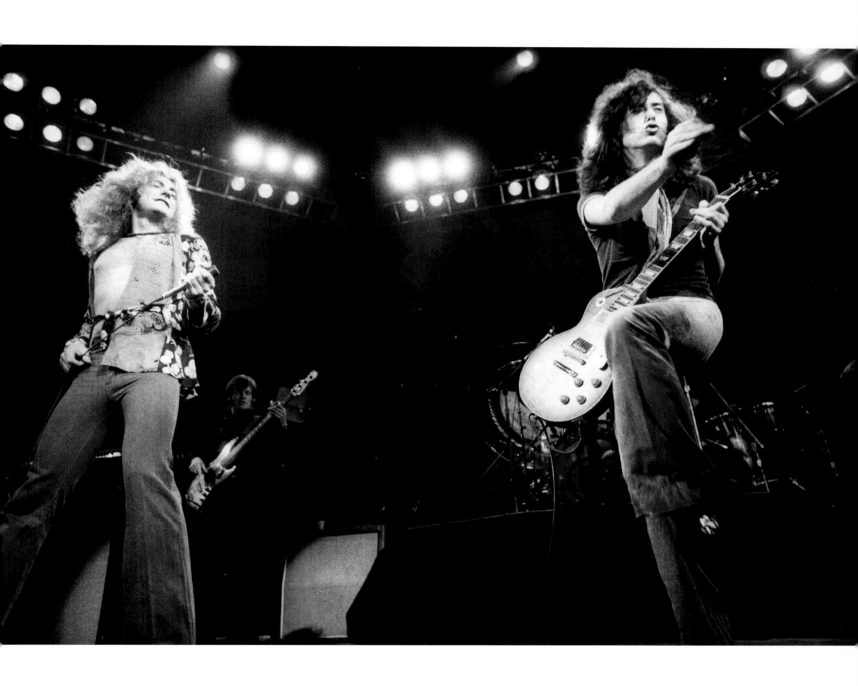

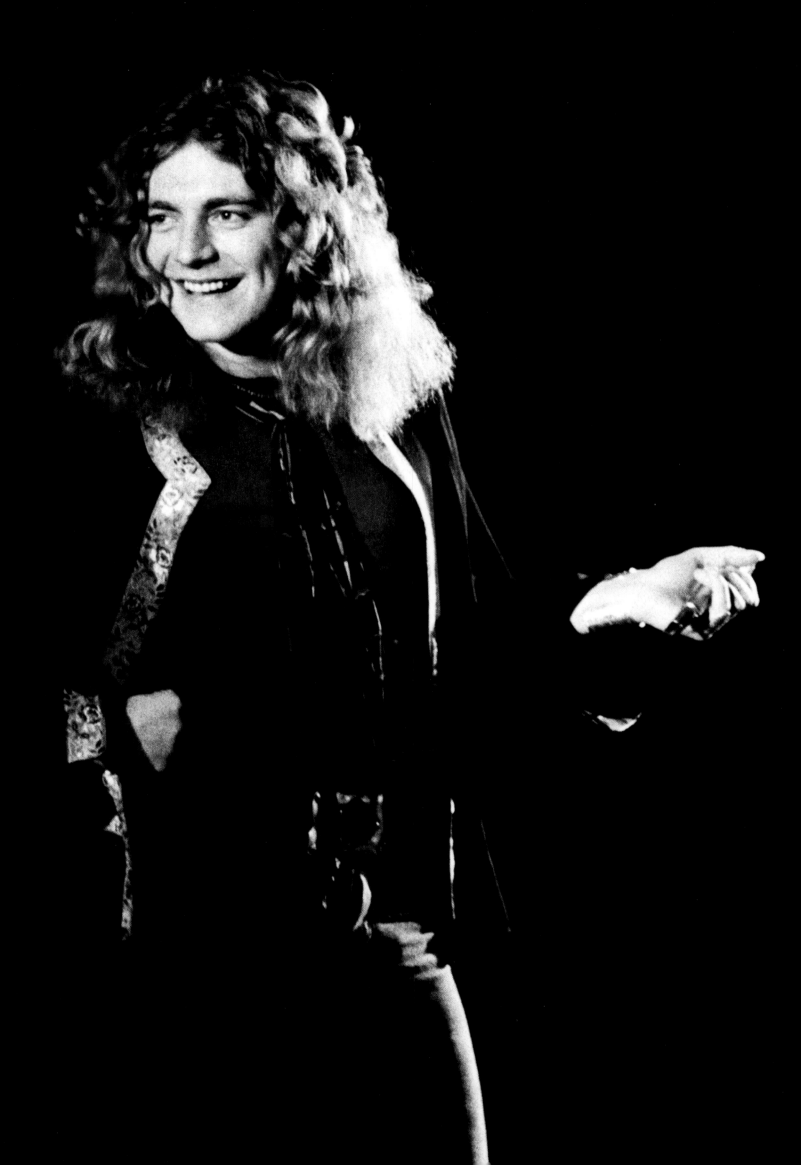

Rehearsal · Minneapolis
17.01.75

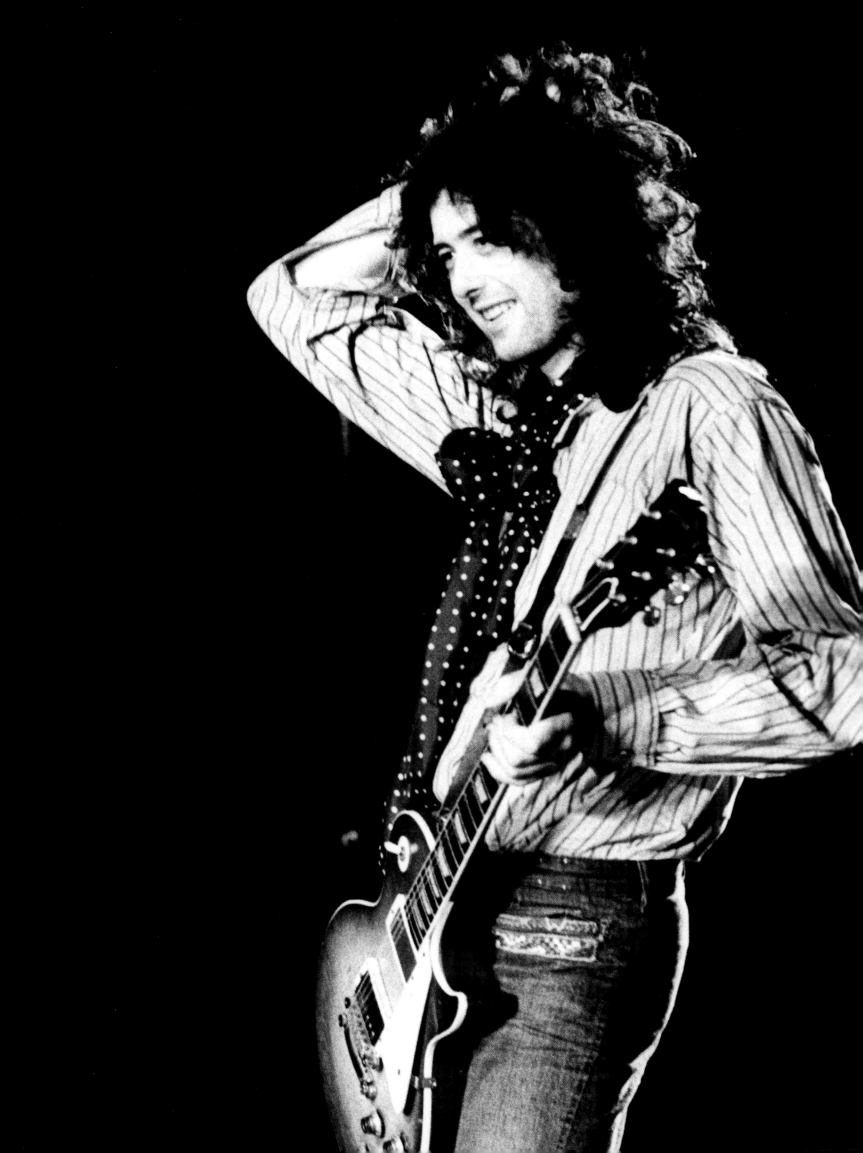

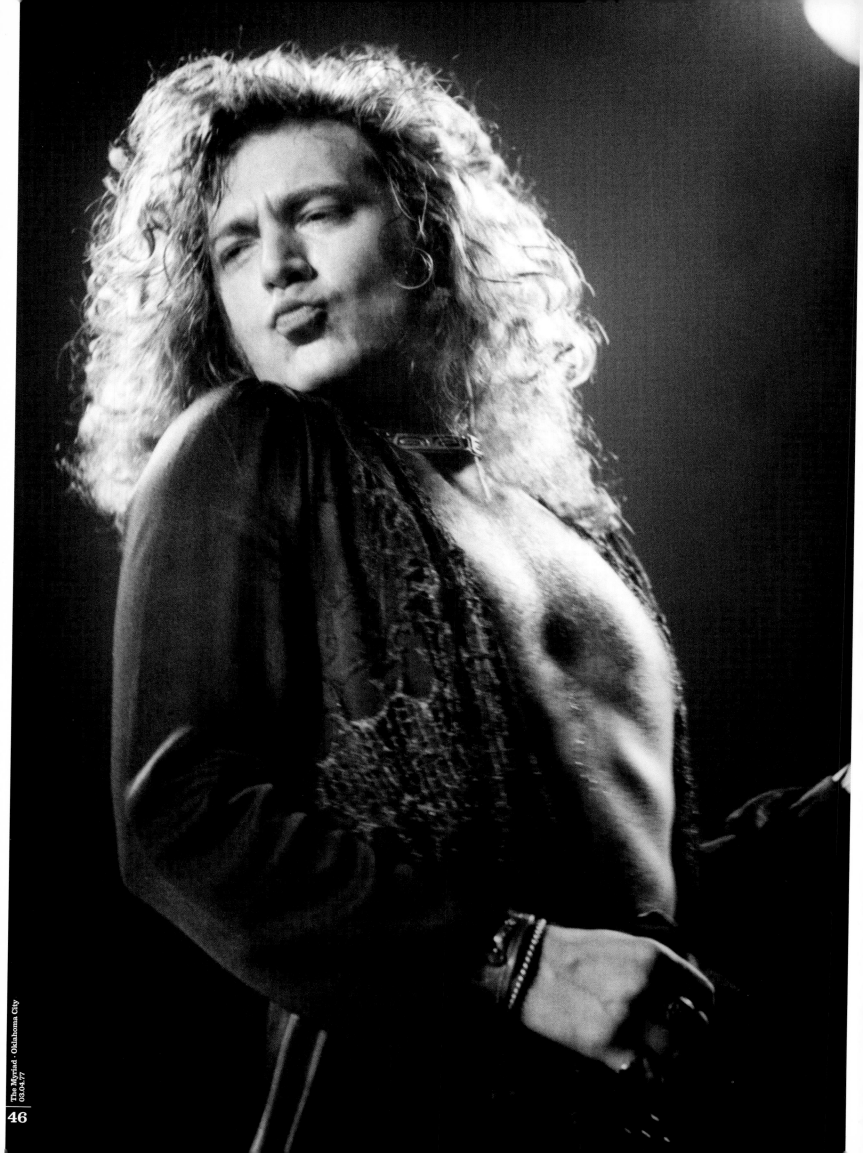

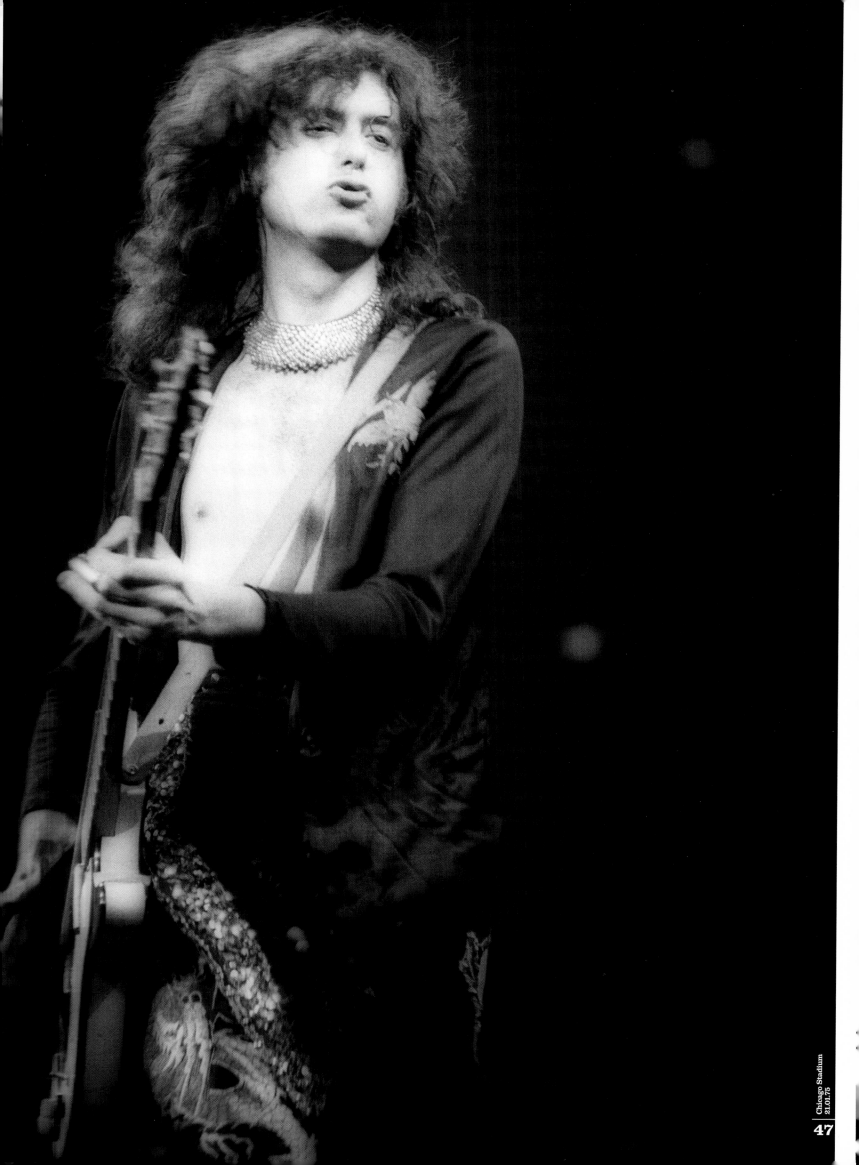

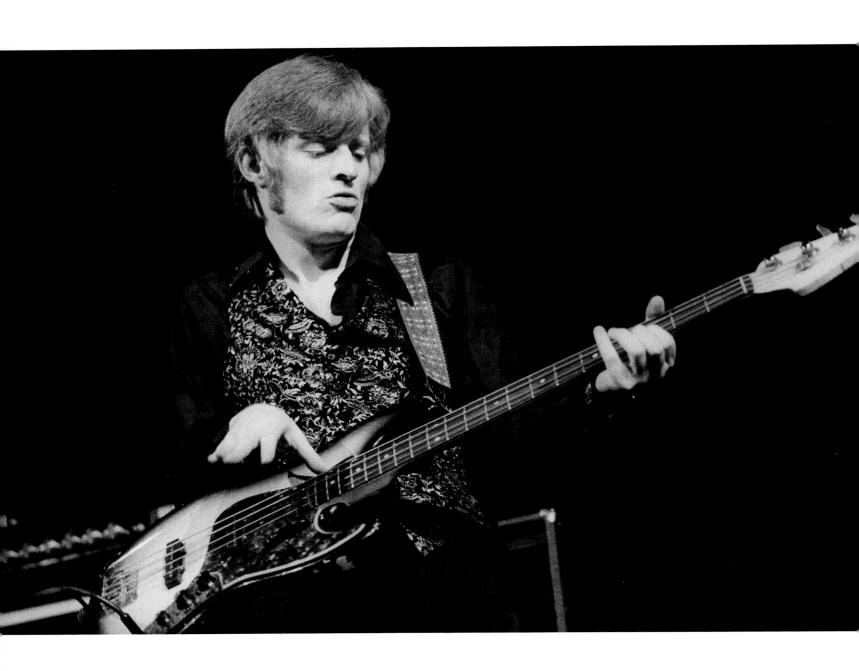

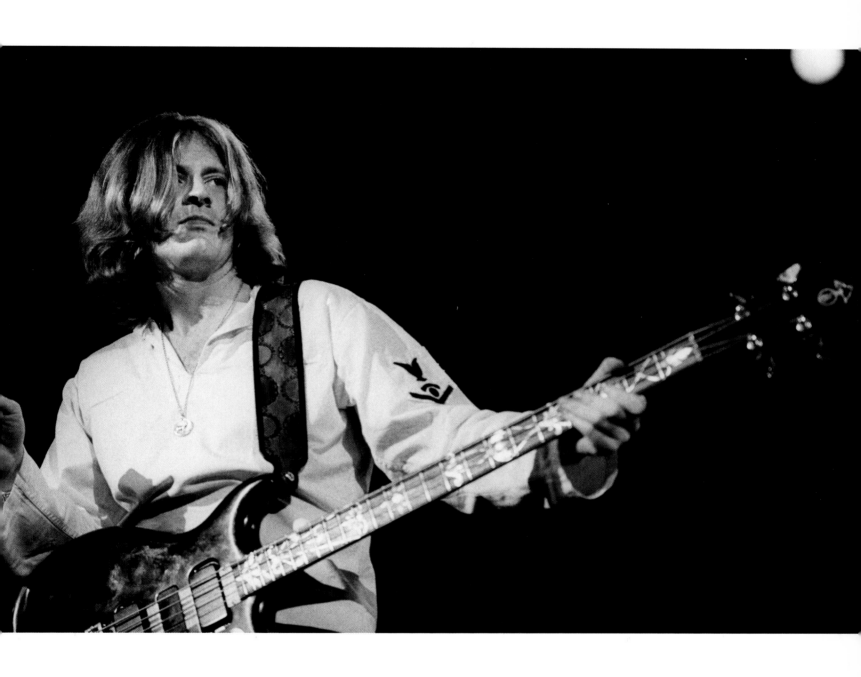

He had encountered the band as far back as September 1970 at a press conference at New York's Drake Hotel, and on stage at Madison Square Garden. For this tour he gained more intimate access to their shows, notably being present at the side of the stage, inches from the action, as they performed an open-air gig on an early June afternoon at the Kezar Stadium in San Francisco. Several images stand out from this day - an angelic white-shirted Page cups his hands, prayer-like, as he contorts all manner of noise from the theremin in *Whole Lotta Love*; Plant, bottle in hand, holds a white dove silhouetted by the vast crowd.

Another 50,000 fans packed the stadium that memorable day, earning the band some $1,000 a minute for two and a half hours' work. When the tour ended in July, Led Zeppelin were around $4 million richer (despite a bizarre $300,000 hotel robbery during their last New York show) and their new album, *Houses Of the Holy*, had secured double platinum status.

They were now without question the number one band on the planet. A little under two years later, Led Zep were back in America to reclaim their crown. Once again Neal Preston was there to chronicle it all from the start. On Friday 17 January, 1975, the band staged a rehearsal for their opening night at the Metro Sports Centre in Minneapolis, and Preston was allowed a rare opportunity to shoot the band at their soundcheck rehearsal in the most relaxed of circumstances. We see John Bonham, complete with a fur hat to keep out the winter cold; denim-suited, cowboy-booted John Paul Jones with a new short hair style; the cherubic Page with a polka-dot scarf and Plant, ever smiling and preening in readiness for yet another huge US tour. These images were in stark contrast to the more serious business of performing for real in the opening batch of dates in Chicago, Cleveland and Indianapolis.

Led Zeppelin were also expanding visually. For this tenth US visit, they incorporated stunning new lighting effects, including the pioneering use of krypton lasers and a massive neon-lit backdrop. Bonzo now mounted his drums on a high-rise rostrum.

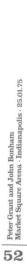

Peter Grant and John Bonham
Market Square Arena · Indianapolis · 25.01.75

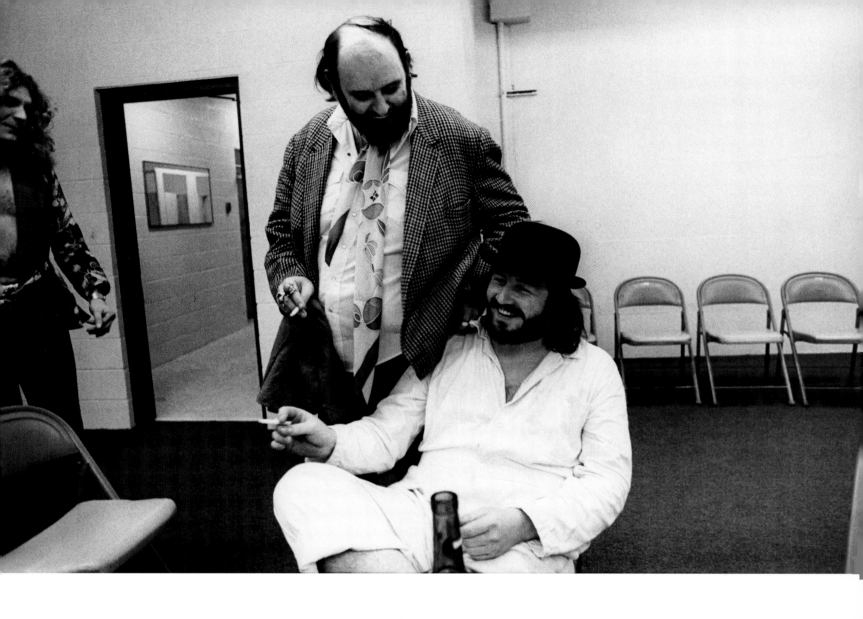

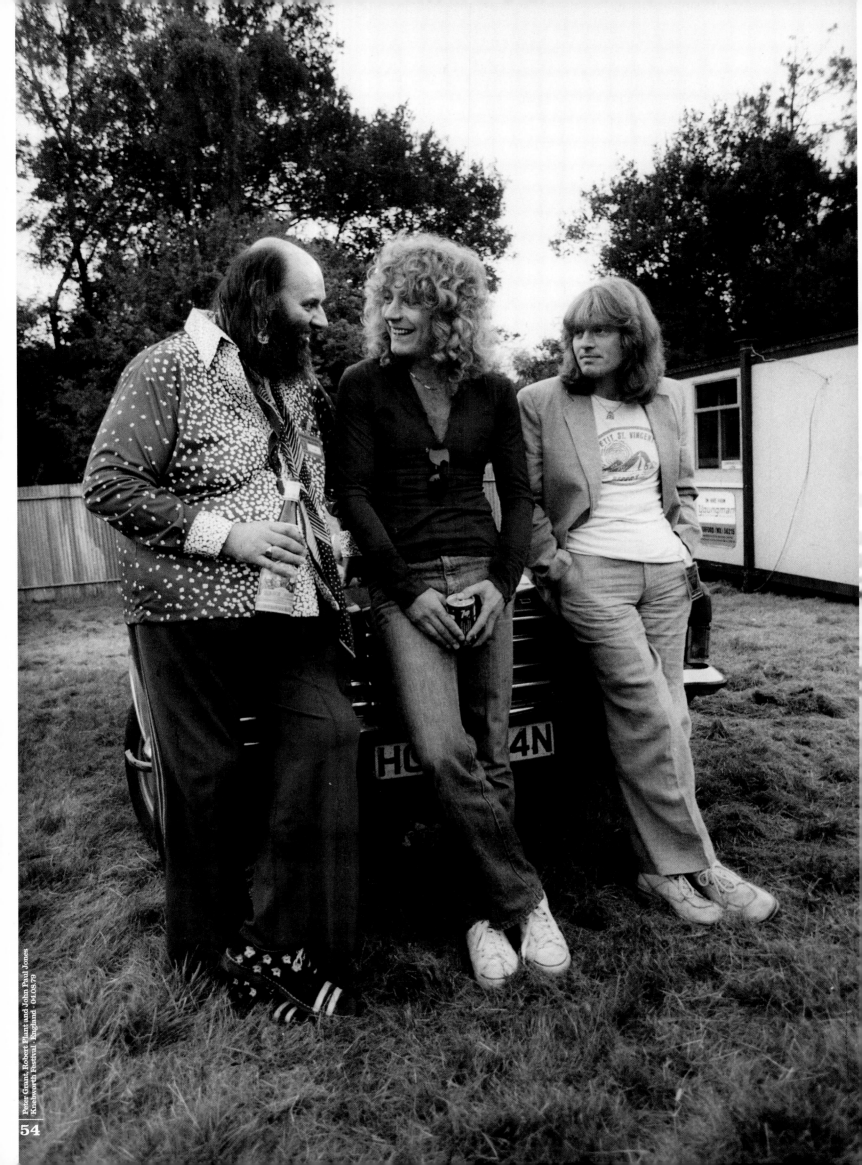

Peter Grant, Robert Plant and John Paul Jones
Knebworth Festival, England · 04.08.79

As their stature grew, so did their sense of presentation. Zeppelin's reputation was clearly forged on a musical level rather then any pop star imagery, but almost by default they built up an air of mystery by refusing to appear on TV and in the media. Prior to releasing the Led Zep film *The Song Remains The Same* in 1976, the only way for fans to view them was on stage and via any resulting photos published. Distinctive images of the band were now emerging courtesy of the likes of Neal Preston. On those '75 dates, Page emerged as a demonic figure in flamboyant embroidered jackets and trousers. Plant too elevated his status as the king of cock rock with open-chested wrap-around blouses. Even Bonham got to make a fashion statement, regularly aping the look of Kubrick's droogs in *A Clockwork Orange* by wearing a white boiler suit and bowler hat. On anyone else these garments would have looked faintly ridiculous. On Led Zeppelin it just looked so right.

Coinciding with the release of their critically acclaimed, multi-million-selling double album *Physical Graffiti*, the 1975 tour was another blockbuster affair. Early on they were somewhat restricted, with Plant laid low with flu and Page coping with an injured finger.

But by the time they reached Madison Square Garden in February, they were back to full strength, and Preston's images from their 12 February show capture Page in a defiant mood and ready to unleash marathon versions of *Dazed and Confused*. Travelling on the tour was *Rolling Stone* journalist Cameron Crowe, and Preston duly supplied the picture of their only *Rolling Stone* cover story - a stunning shot of Page on stage in Chicago with a gold necklace around his neck, with Robert Plant in the background.

The 1975 US tour also marked Preston's elevation into Zeppelin's inner sanctum. This unrivalled backstage access resulted in many intimate images of the well-chronicled "road fever" that surrounded them: the band watches films on their private jet Starship 1; notorious manager Peter Grant jokes around with Page and Rolling Stone Ronnie Wood at the Nassau Coliseum; Page slugs from a bottle of Jack Daniels before taking the stage in Indianapolis; a now poignant image of Bonham stretched out asleep on the plane; and John Paul Jones, debunking their debauched reputation, is calmly ensconced in a game of backgammon. Preston's shots display the often underplayed humour and camaraderie of Zeppelin on the road.

Next page: Knebworth Festival England · 04.08.79

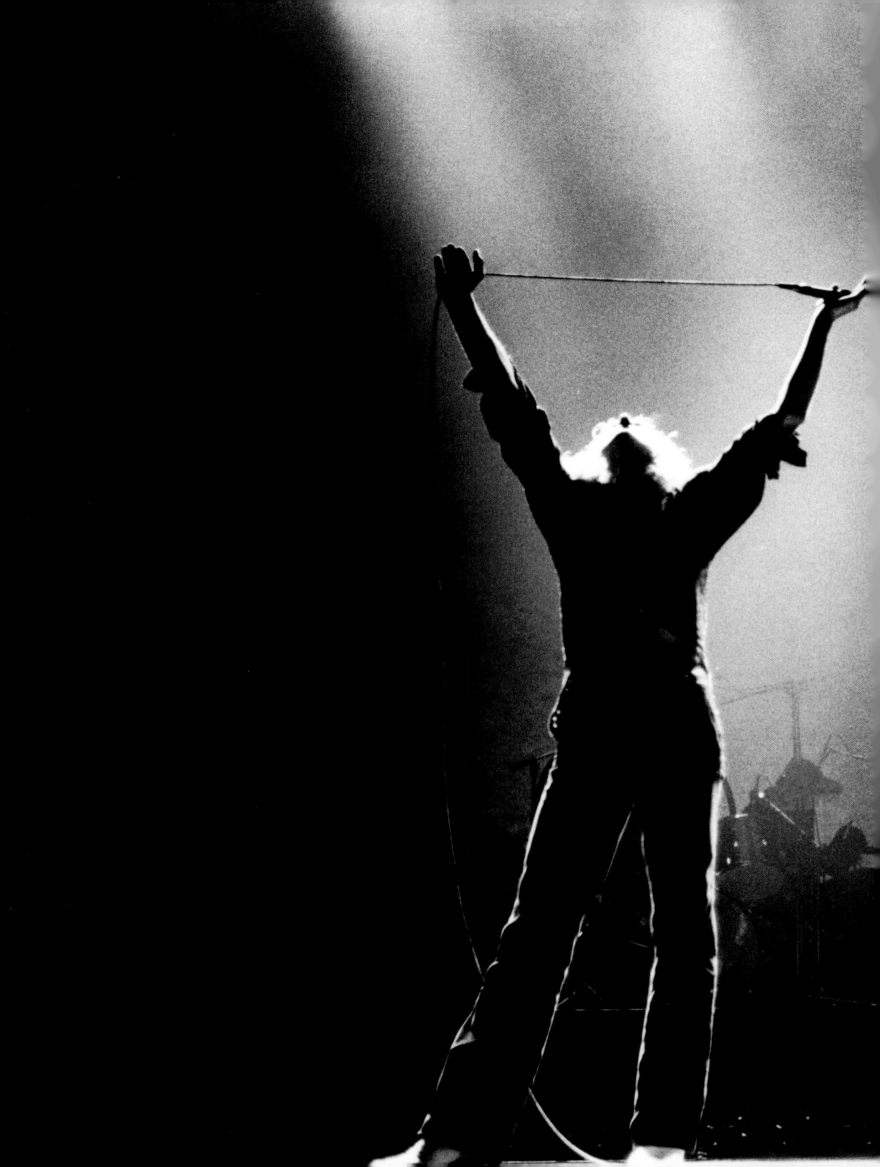

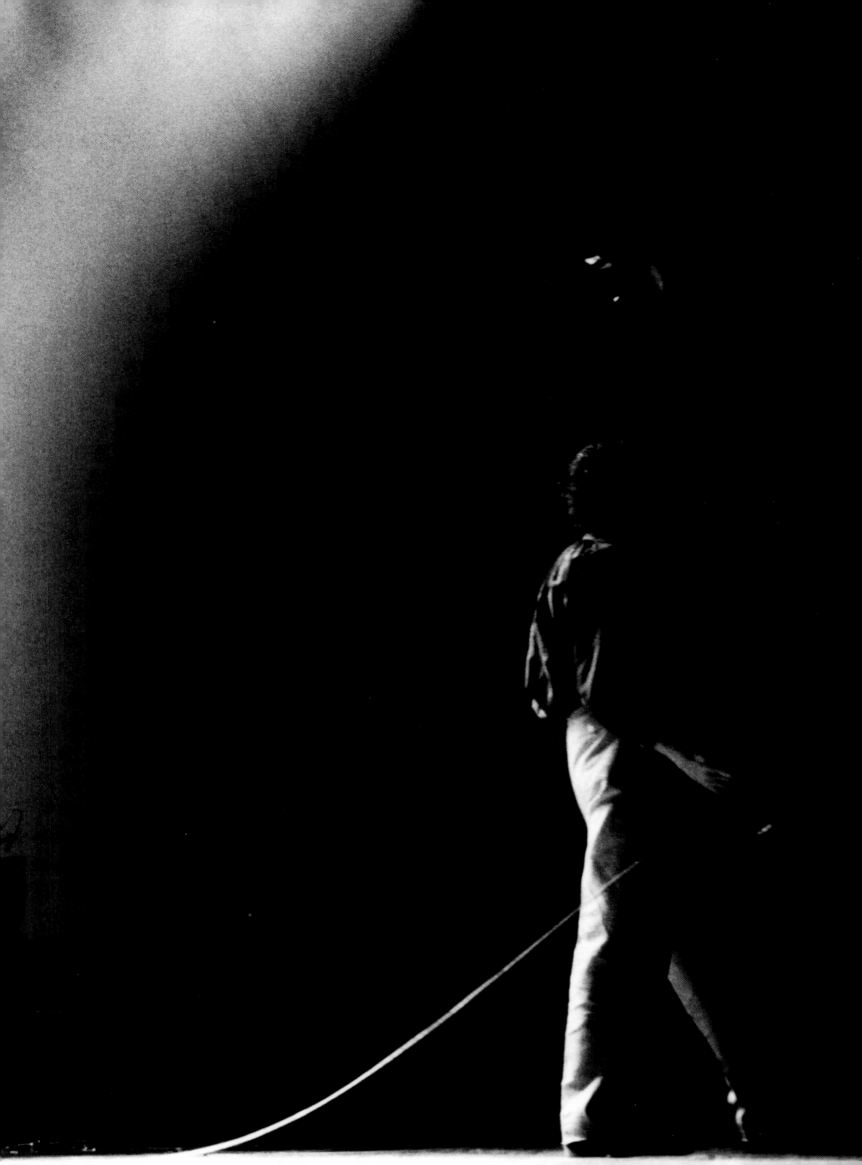

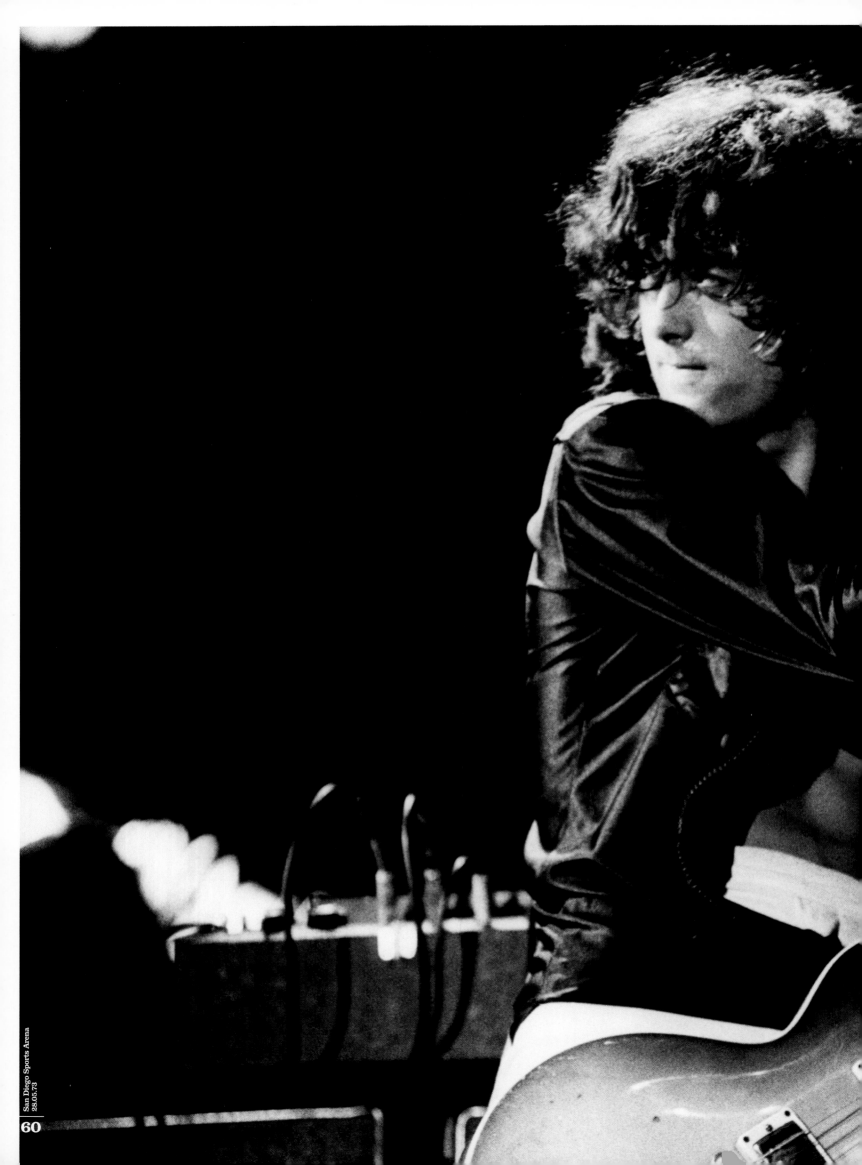

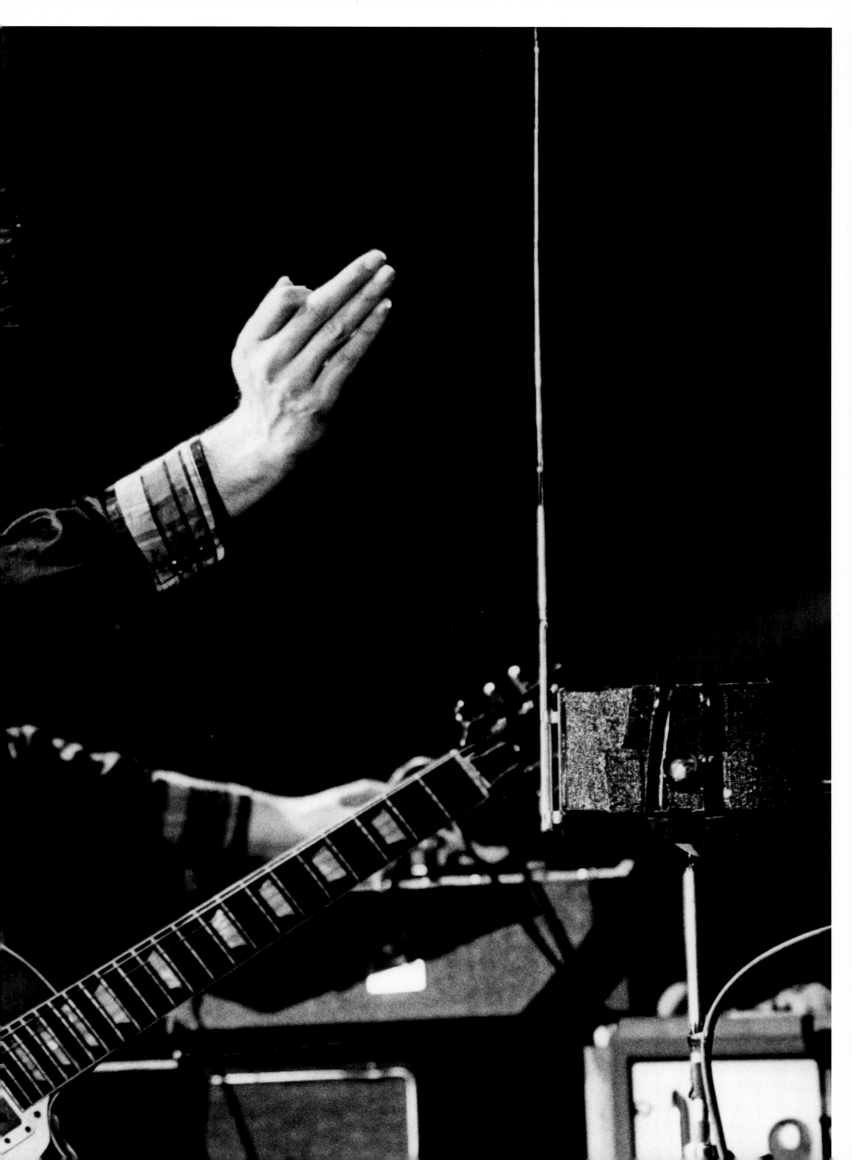

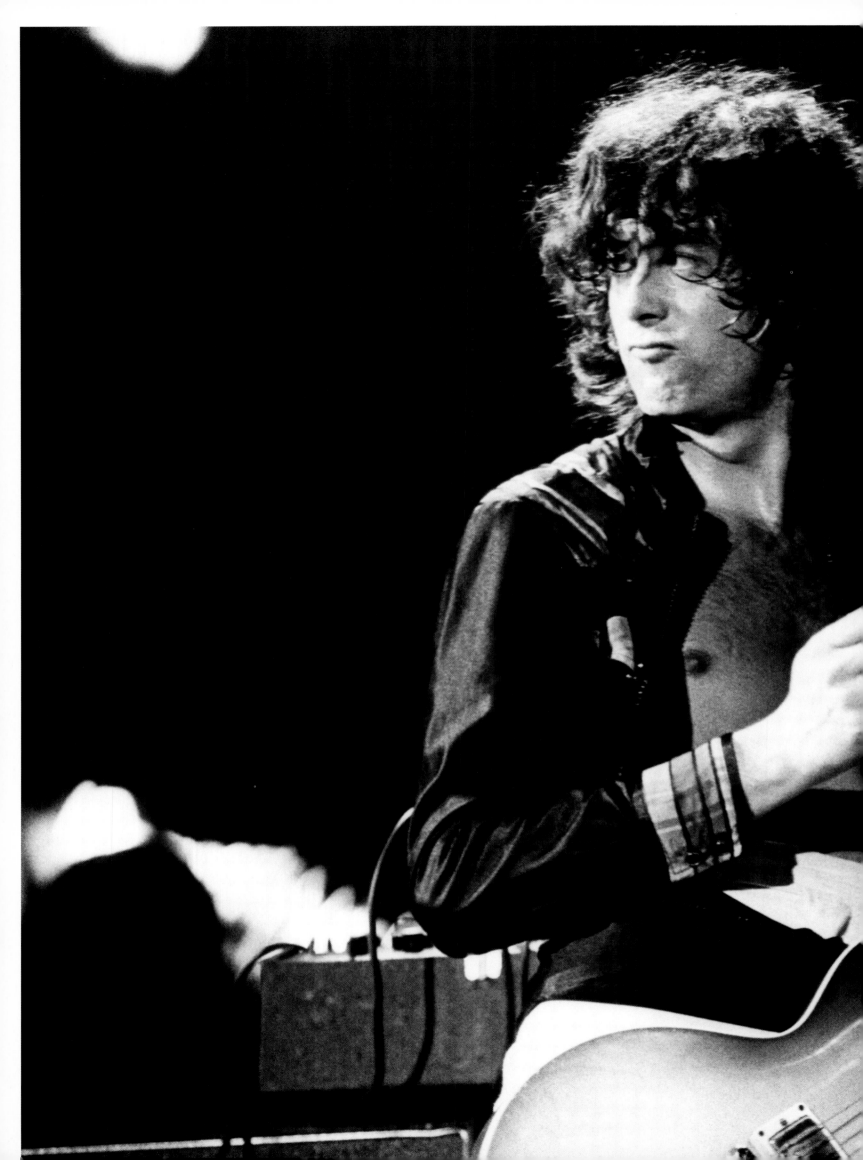

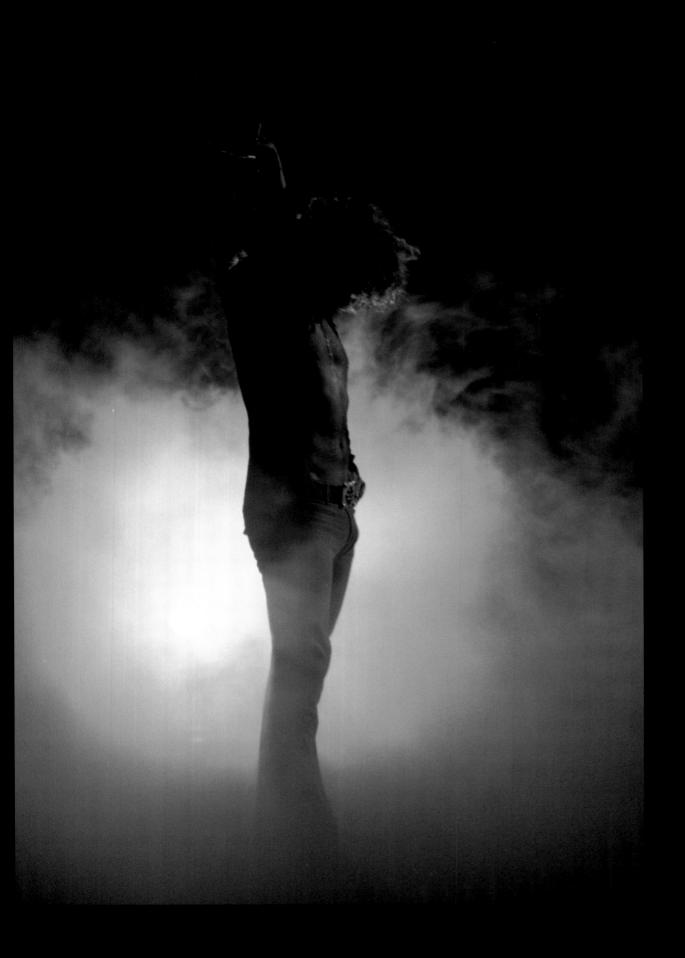

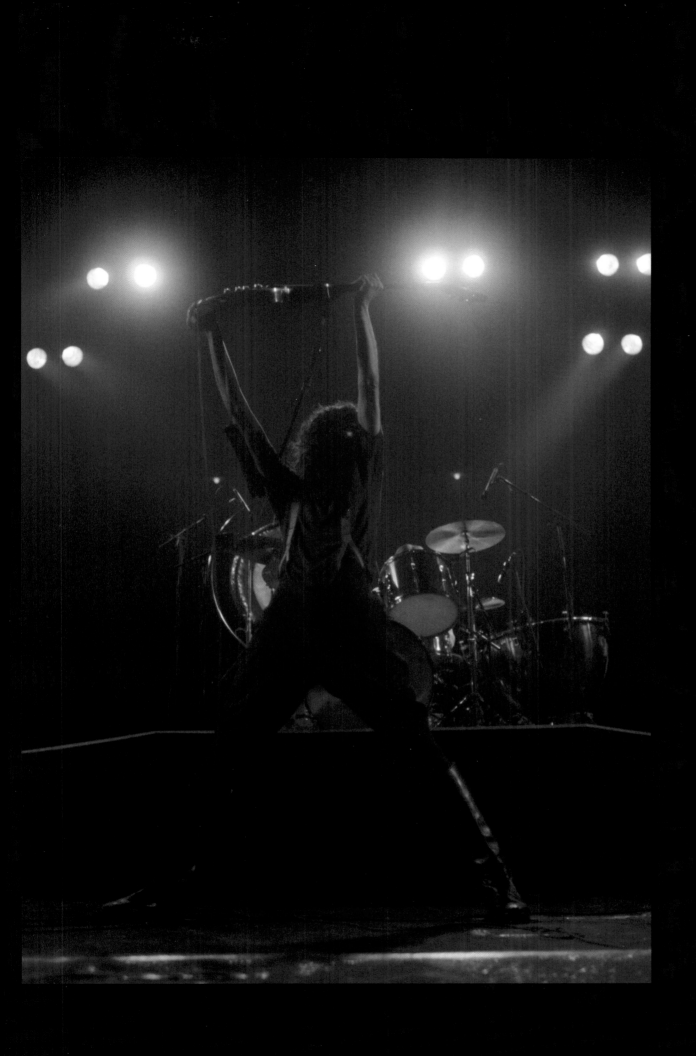

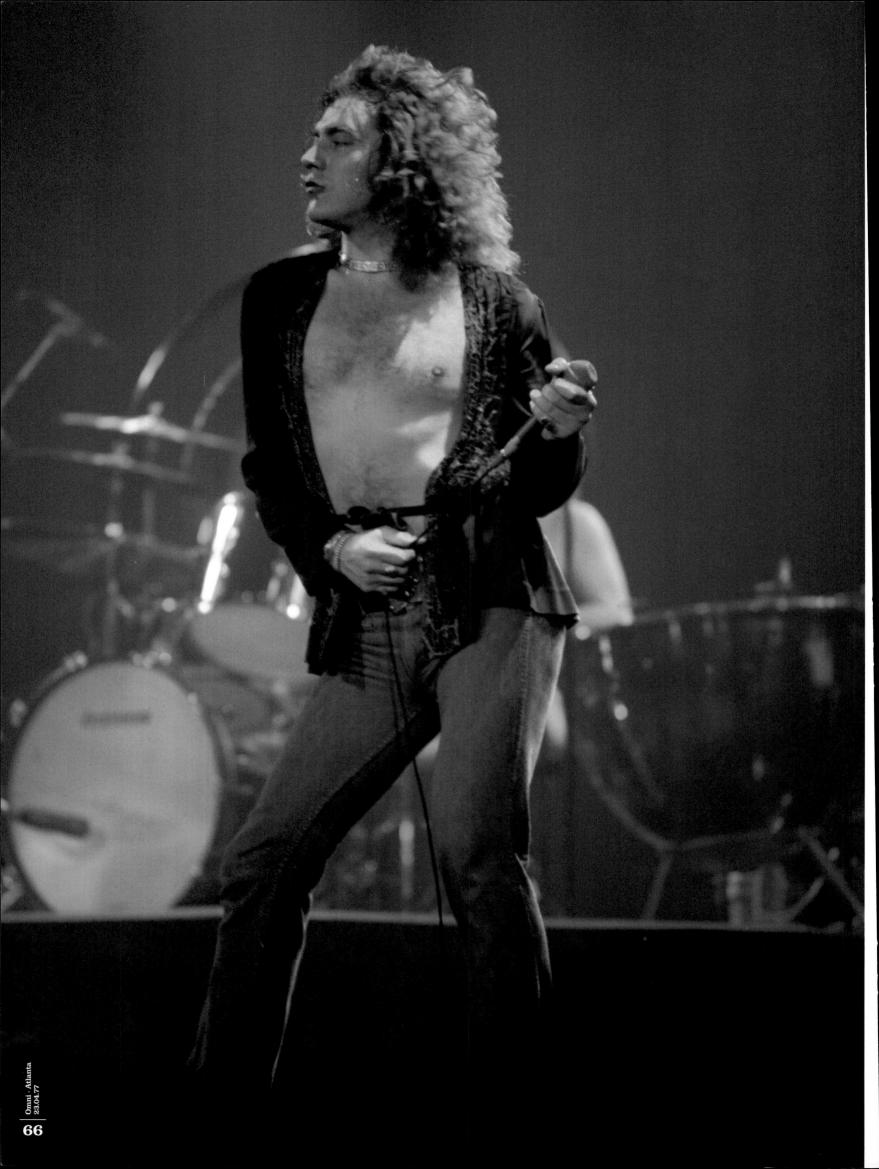

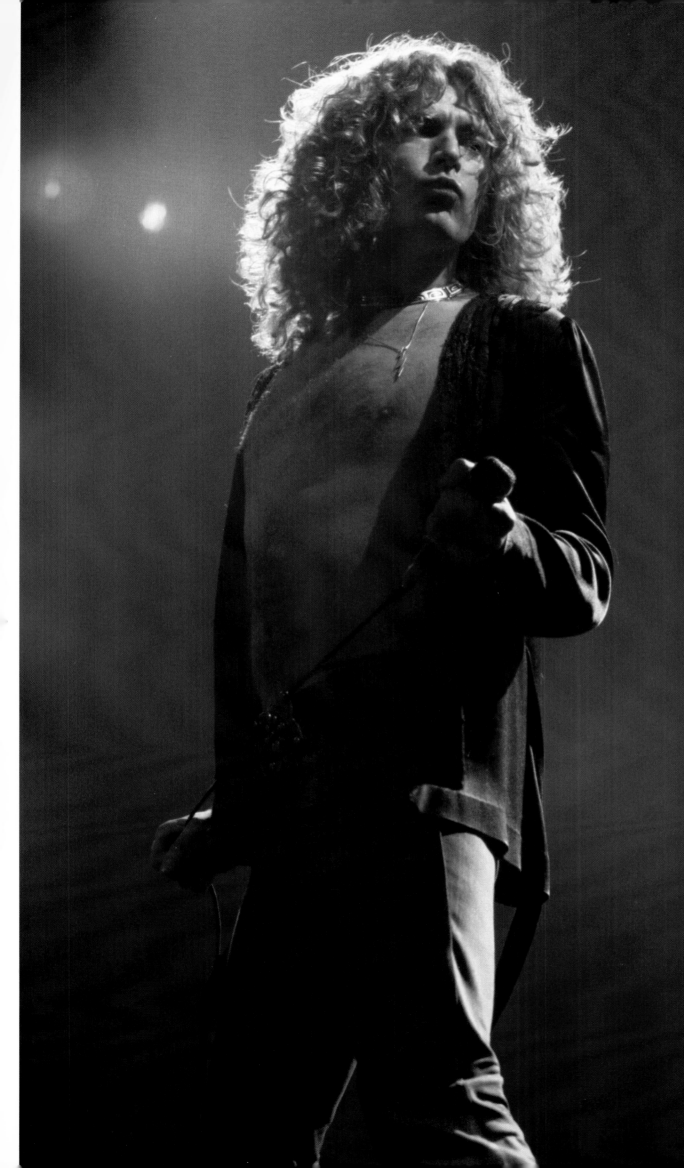

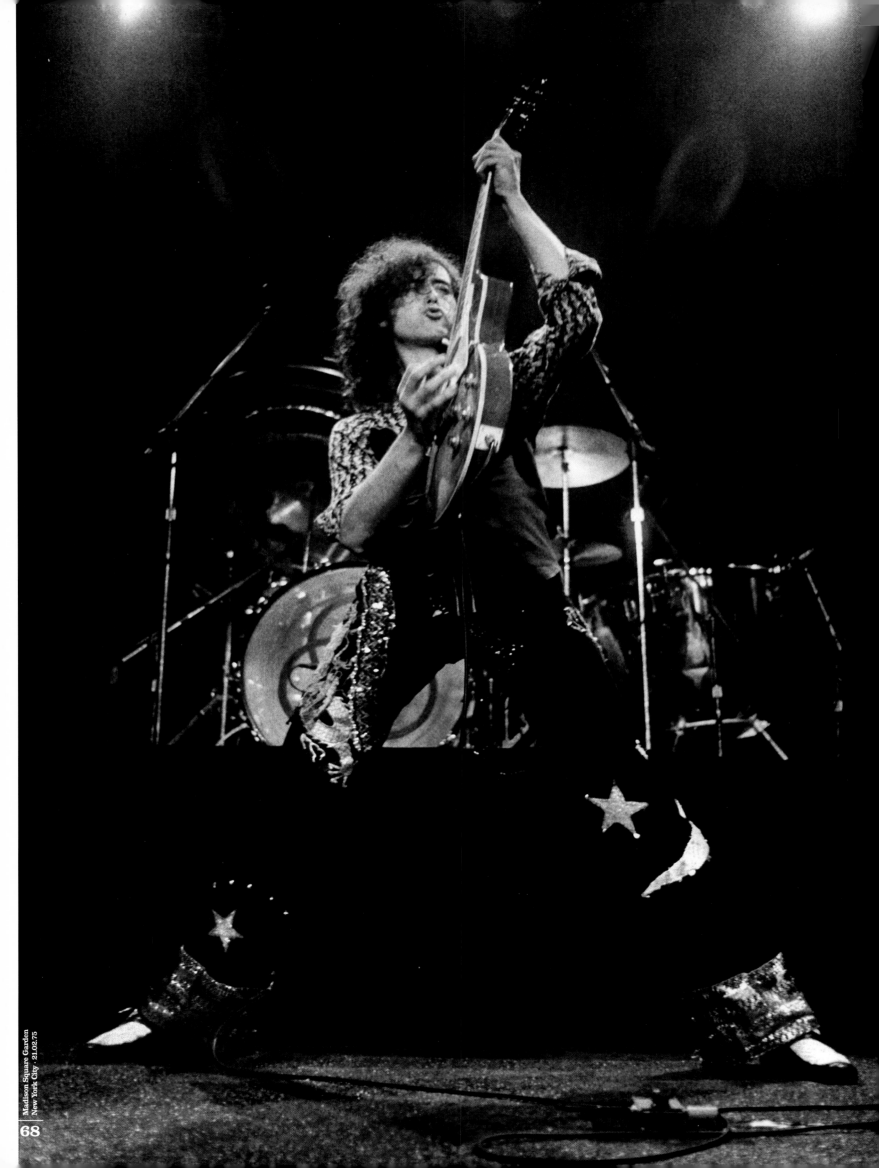

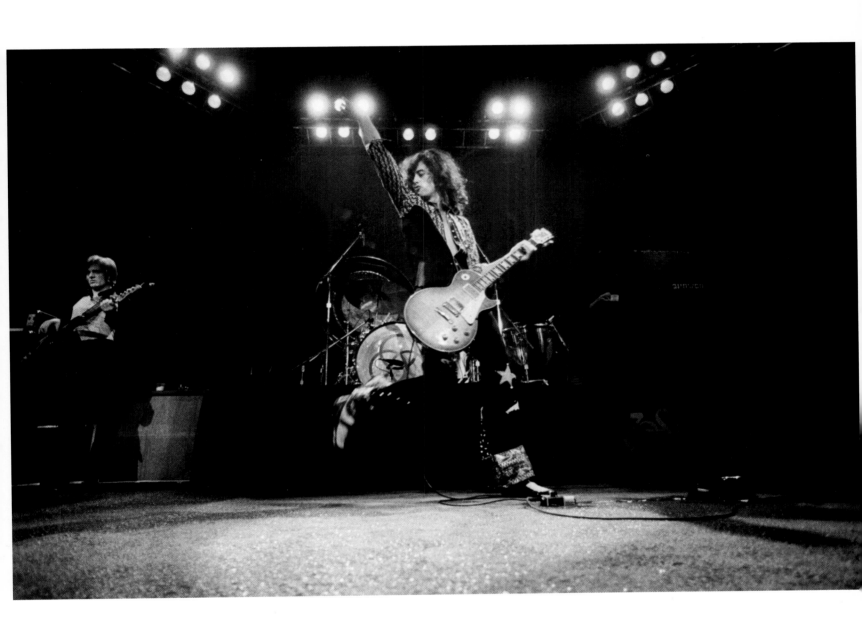

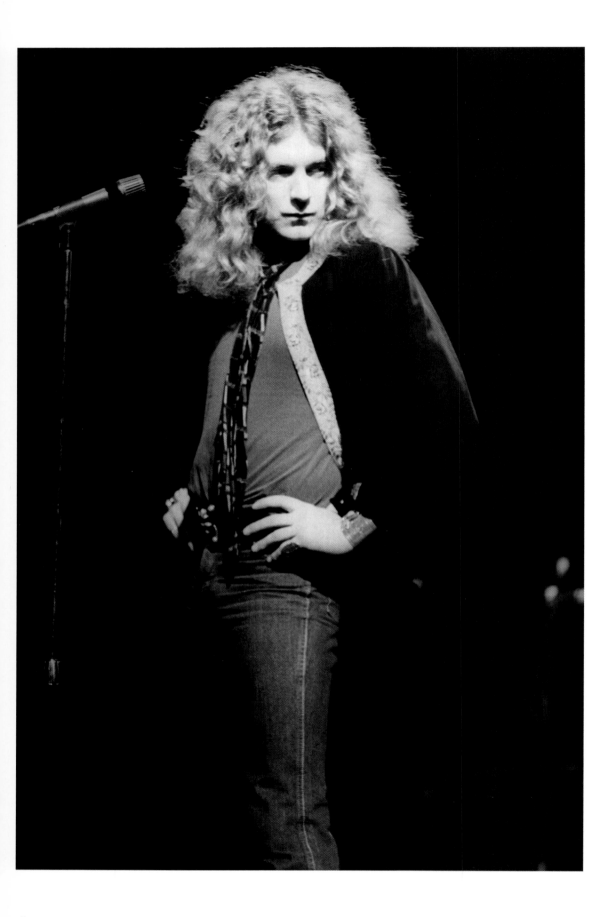

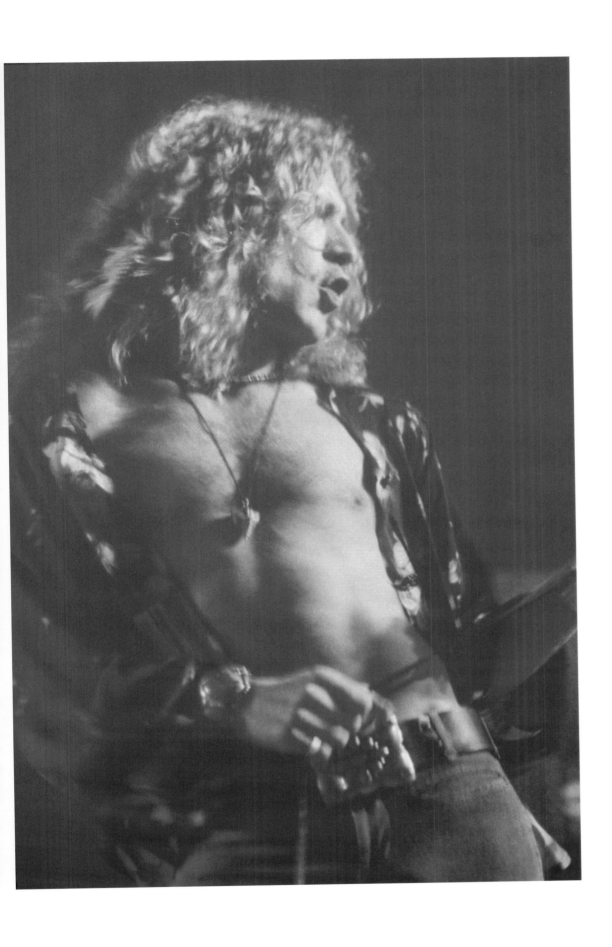

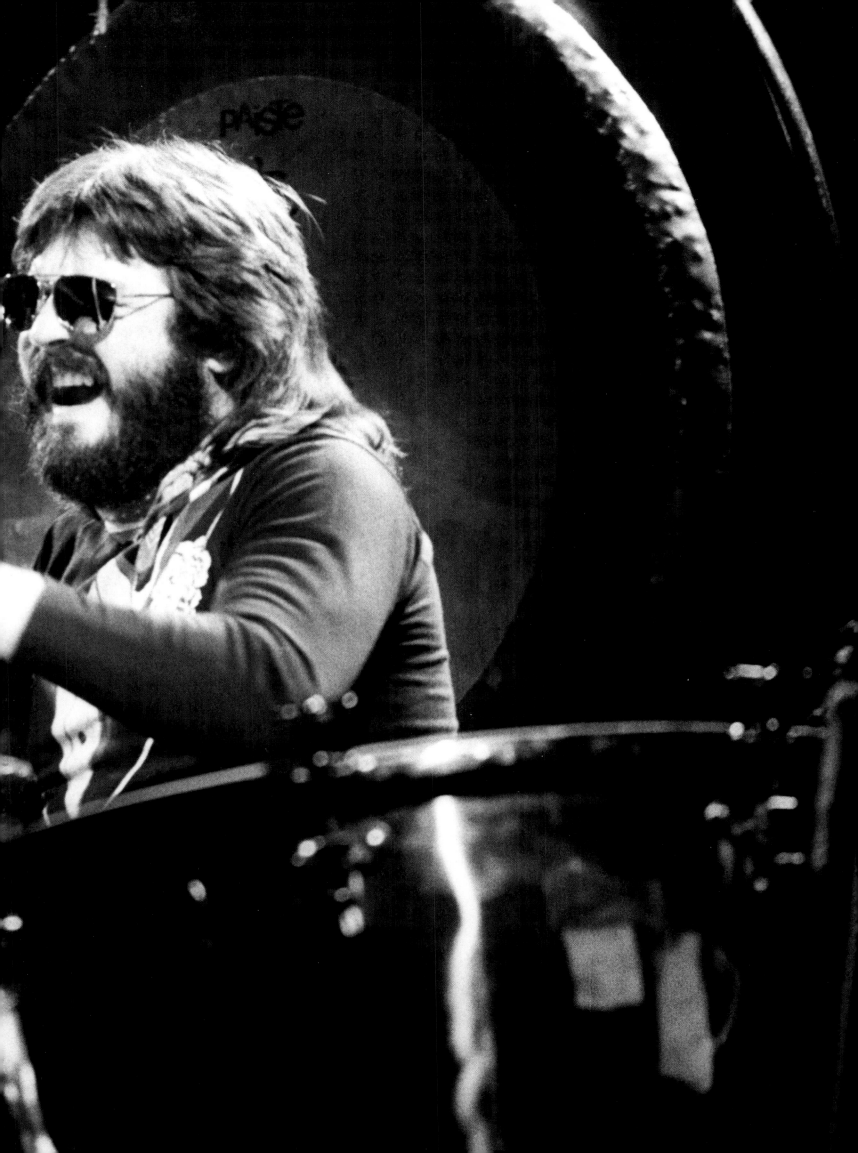

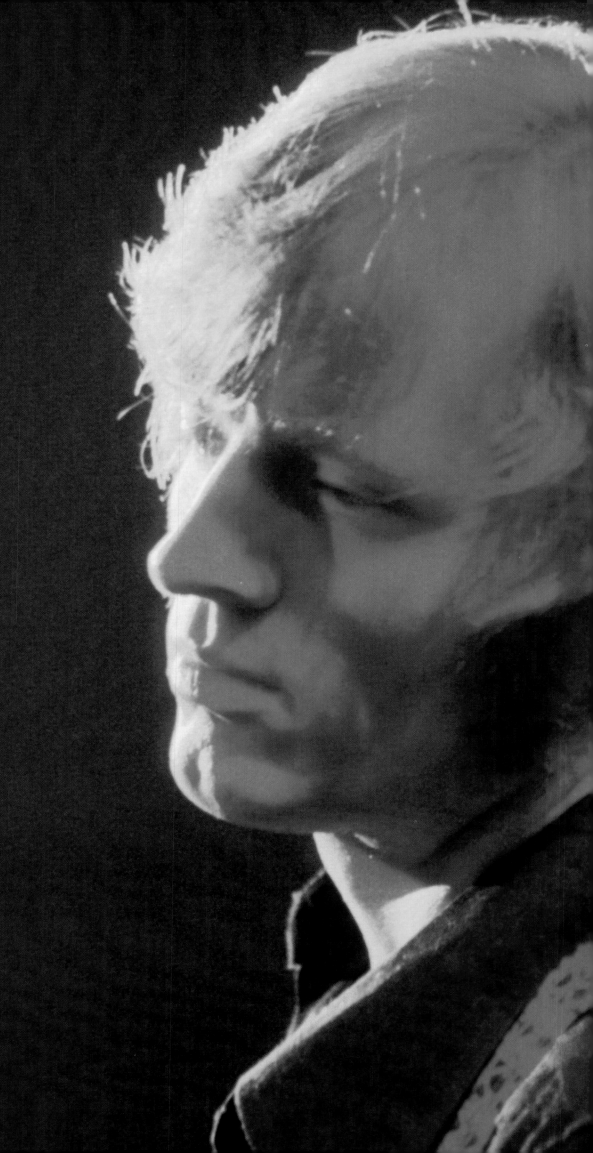

Zeppelin returned to the UK in the late spring of 1975 to play five sold-out dates at London's Earls Court. The plan was to return to the US in the late summer, but Plant's involvement in a serious car crash on the Greek island of Rhodes halted all that. While he recovered from his injuries, the band recorded their seventh album, *Presence*, and finally got around to completing their feature film *The Song Remains The Same*. In the autumn of 1976, the band launched the film at a star-studded premiere at the Fox Theatre in Los Angeles. Preston was there to relay their latest triumph, also attending the afterparty at the Bistro with Linda Ronstadt and Ronnie Wood.

After a two year interval, Led Zeppelin finally came back to America in 1977, bigger than ever. Even by their own standards the statistics were mind-boggling. Over one million fans would see them perform across the 49 scheduled shows. Looking back, this 1977 tour with its staggered itinerary and massive arena venues became the blueprint for which the likes of U2 and the Stones would base their mega-dollar-grossing touring campaigns of the '80s and '90s. It was an astonishing trawl, in turn triumphant, reckless and chaotic - an extraordinary flexing of sheer musical force supported by a backstage entourage that was spiralling out of control.

Employing a renowned violent London underworld figure and part-time actor John Bindon as part of their security would prove most unwise. Regrettably, the tour ultimately ended amidst backstage violence in Oakland, California, and then personal tragedy when Plant heard the shattering news that his five-year-old son Karac had died of a virus in England.

Before all that, Zeppelin had strutted their way through a series of defining performances, and Neal Preston's photos of this period capture the splendour and arrogance of a band so powerful that demand to see them resulted in riots as the tickets went on sale. The 1977 portraits of Jimmy Page in particular remain some of the most stunning rock'n'roll images ever captured. White dragon suit covering his gaunt frame, he is a musician truly on the edge but still capable of many moments of sheer guitar genius. Preston was also present on a bizarre night in Chicago when Page stomped on stage clad in a jackbooted stormtrooper outfit complete with peaked cap. Compare too the nervous shot of the four of them backstage at the Silverdome Pontiac before performing in front of 76,000 (then a record for a one-act indoor performance), and the subsequent superb spread of the band oozing confidence, swathed in white light, performing *Achilles Last Stand.*

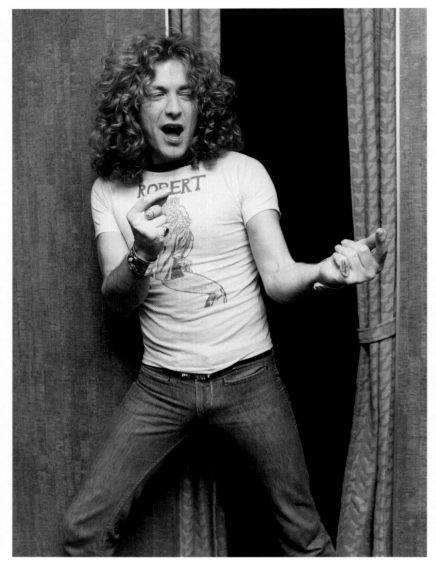
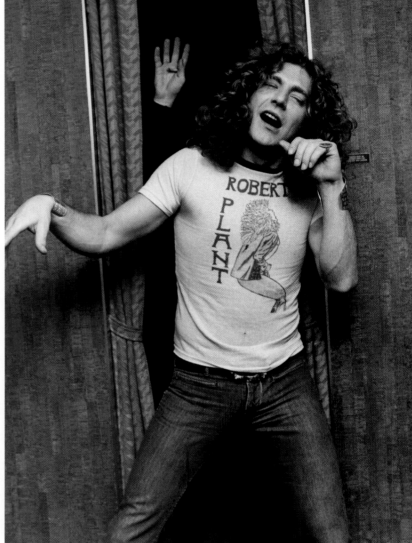

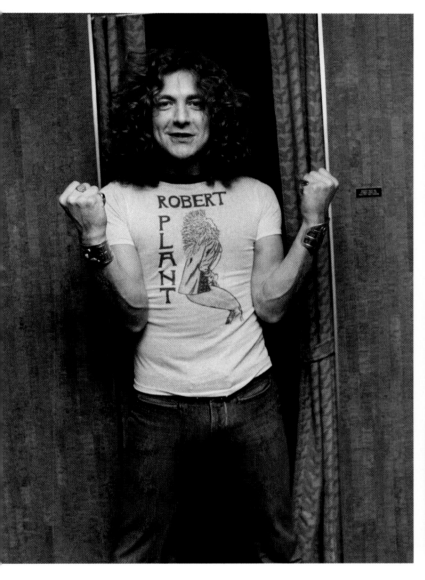 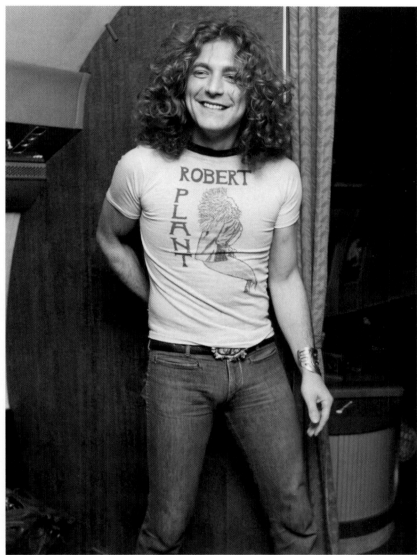

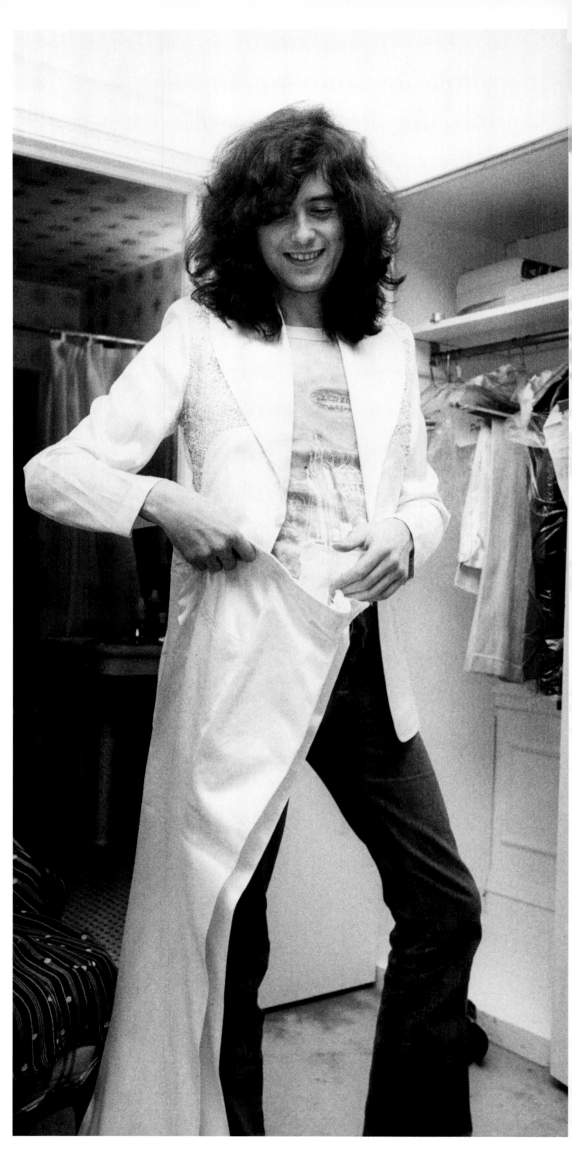

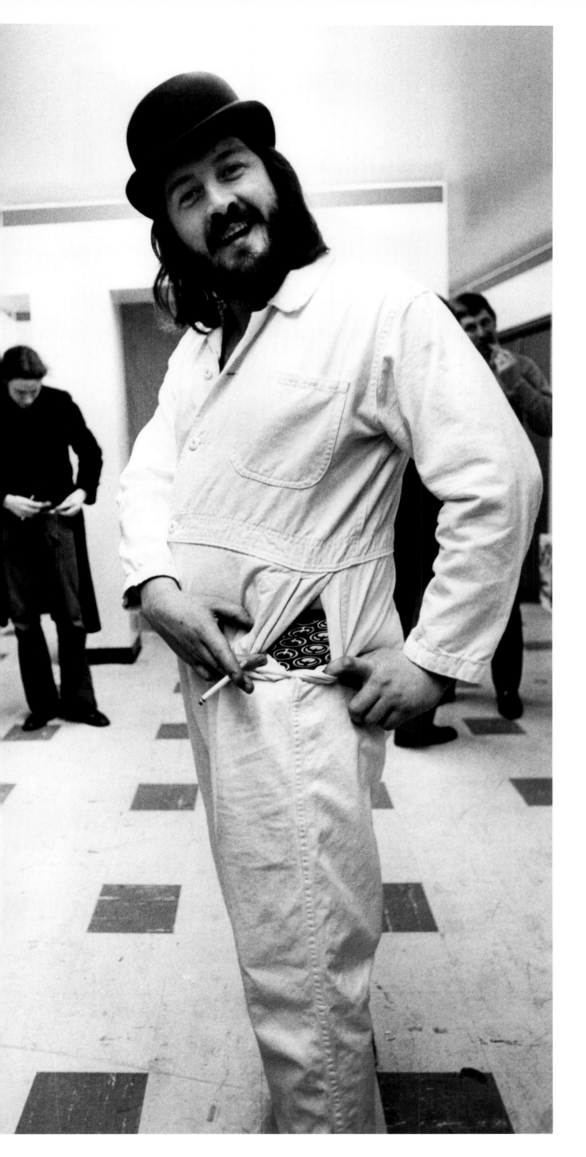

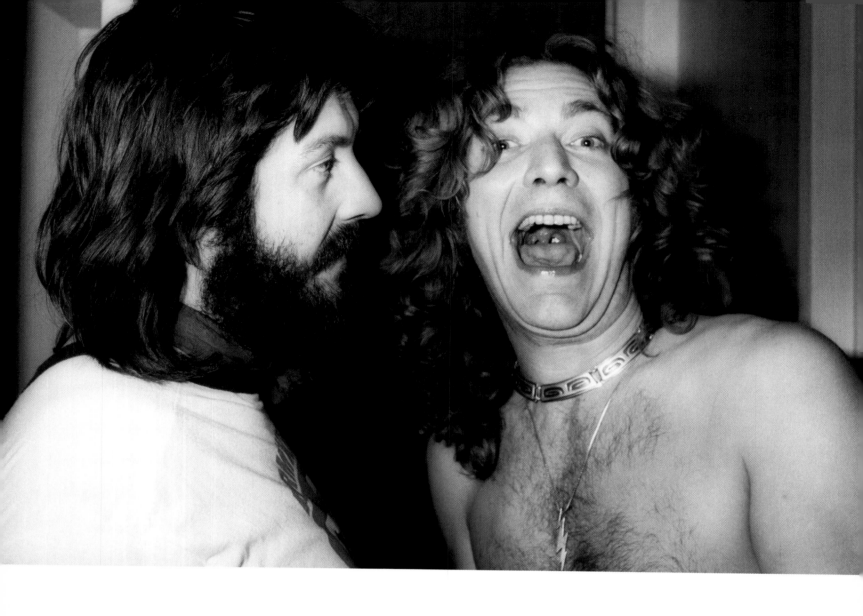

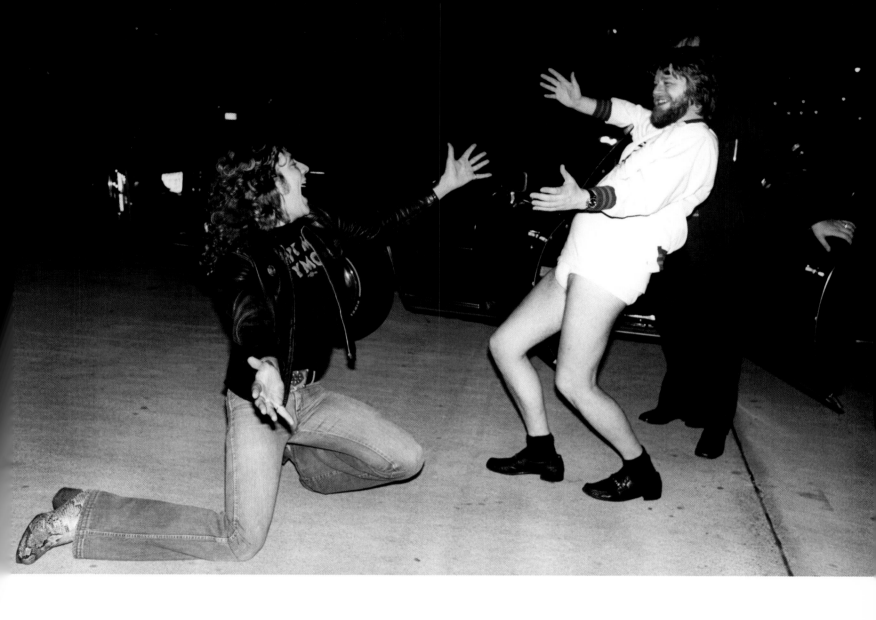

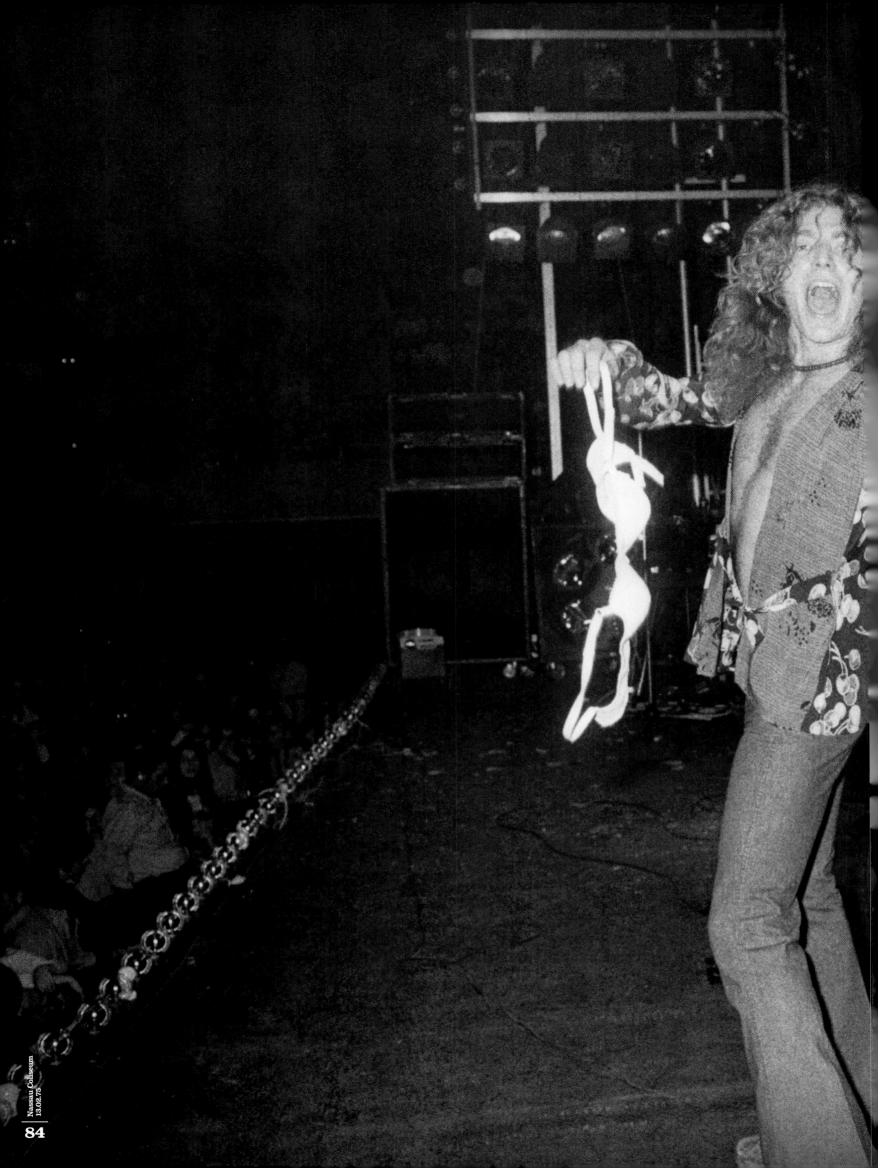

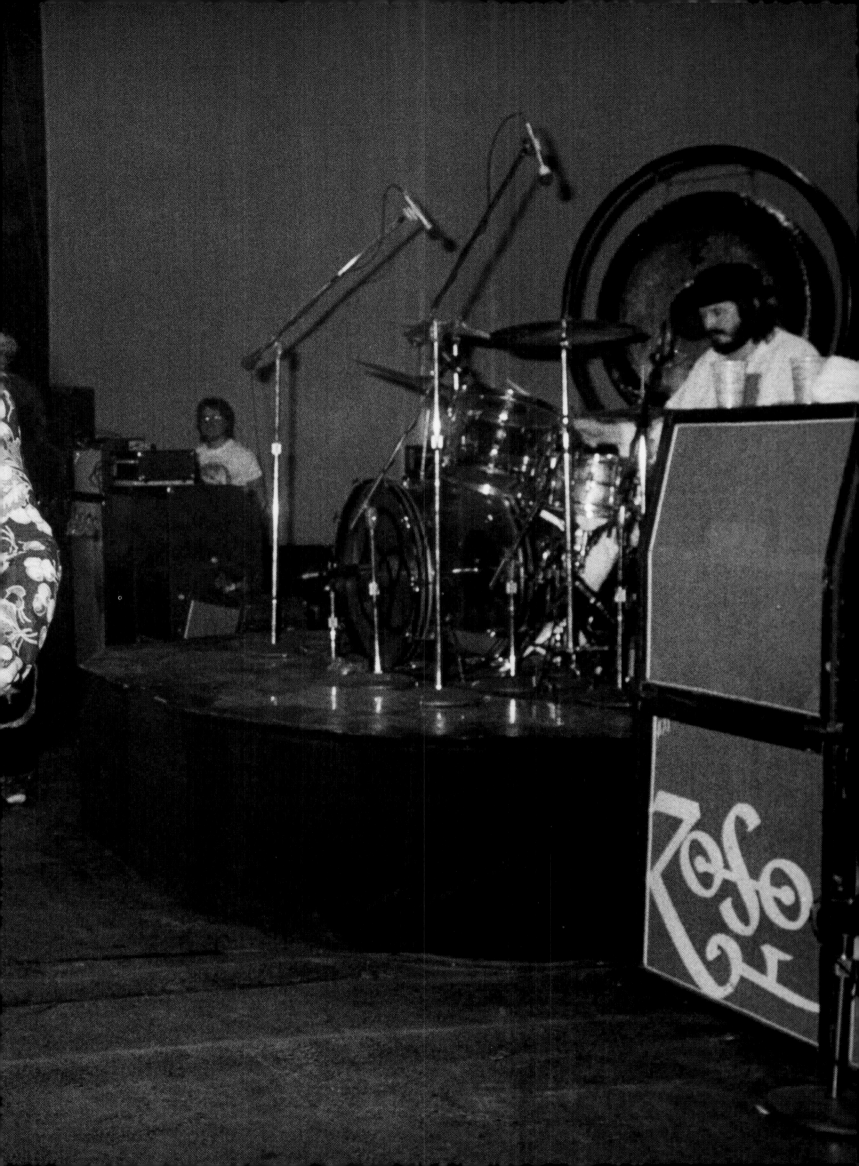

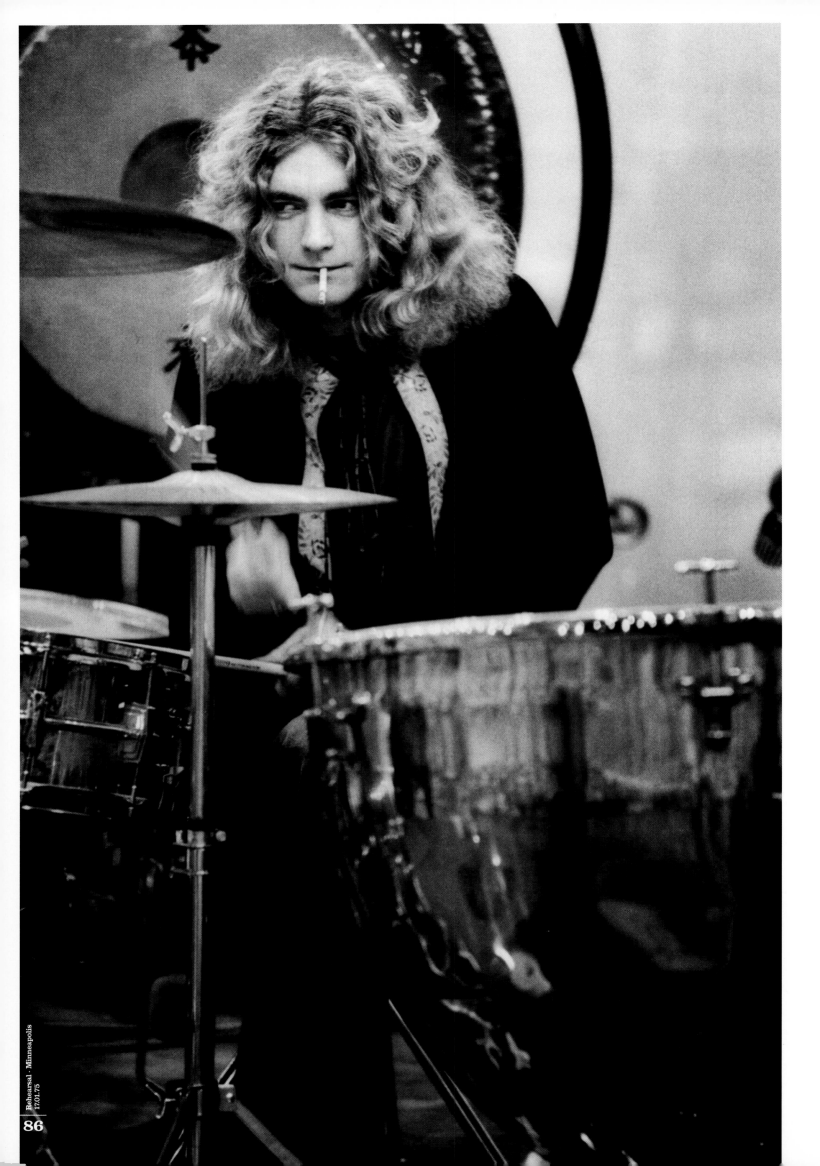

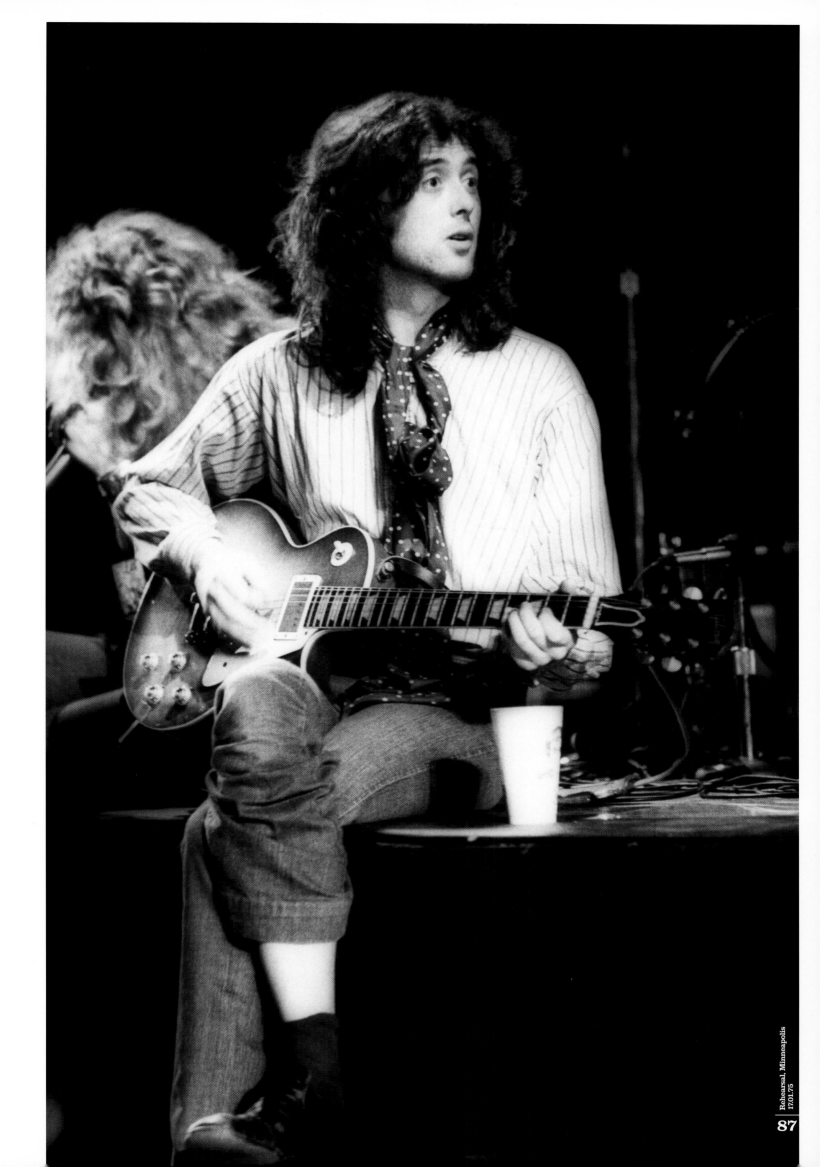

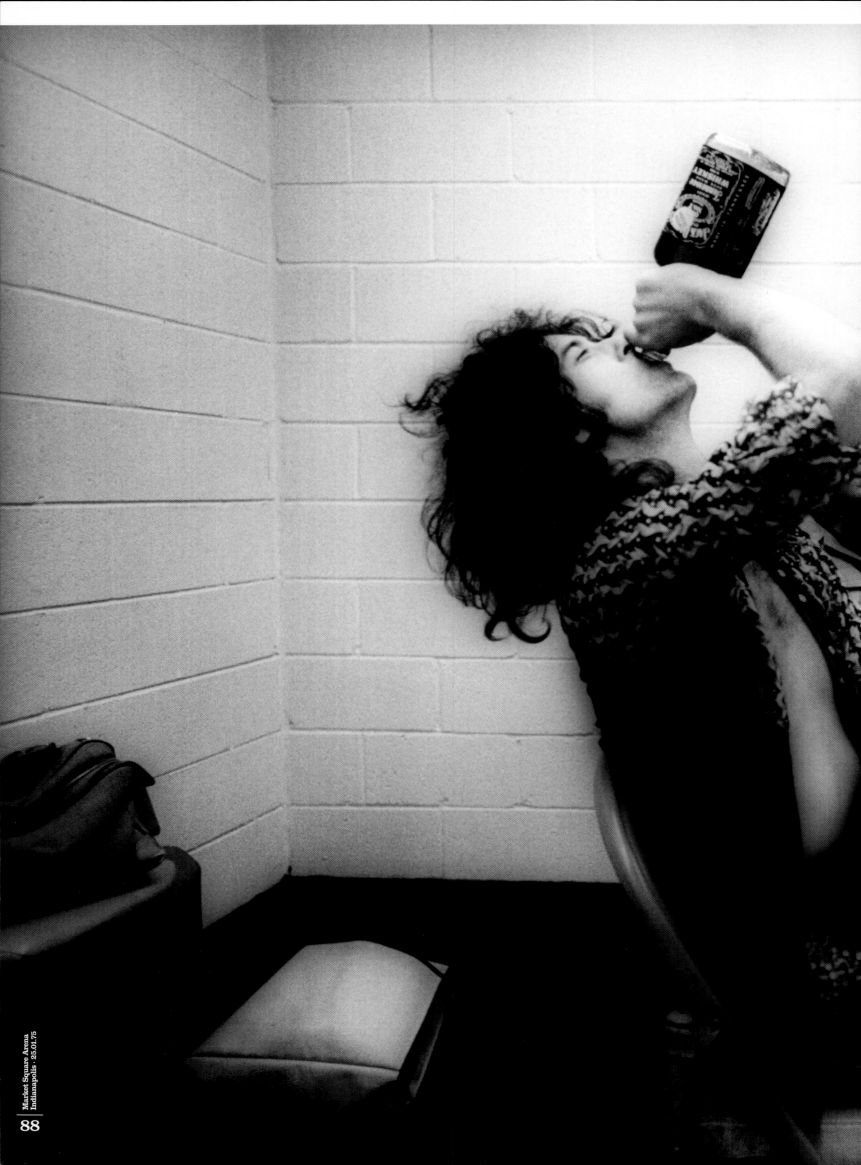

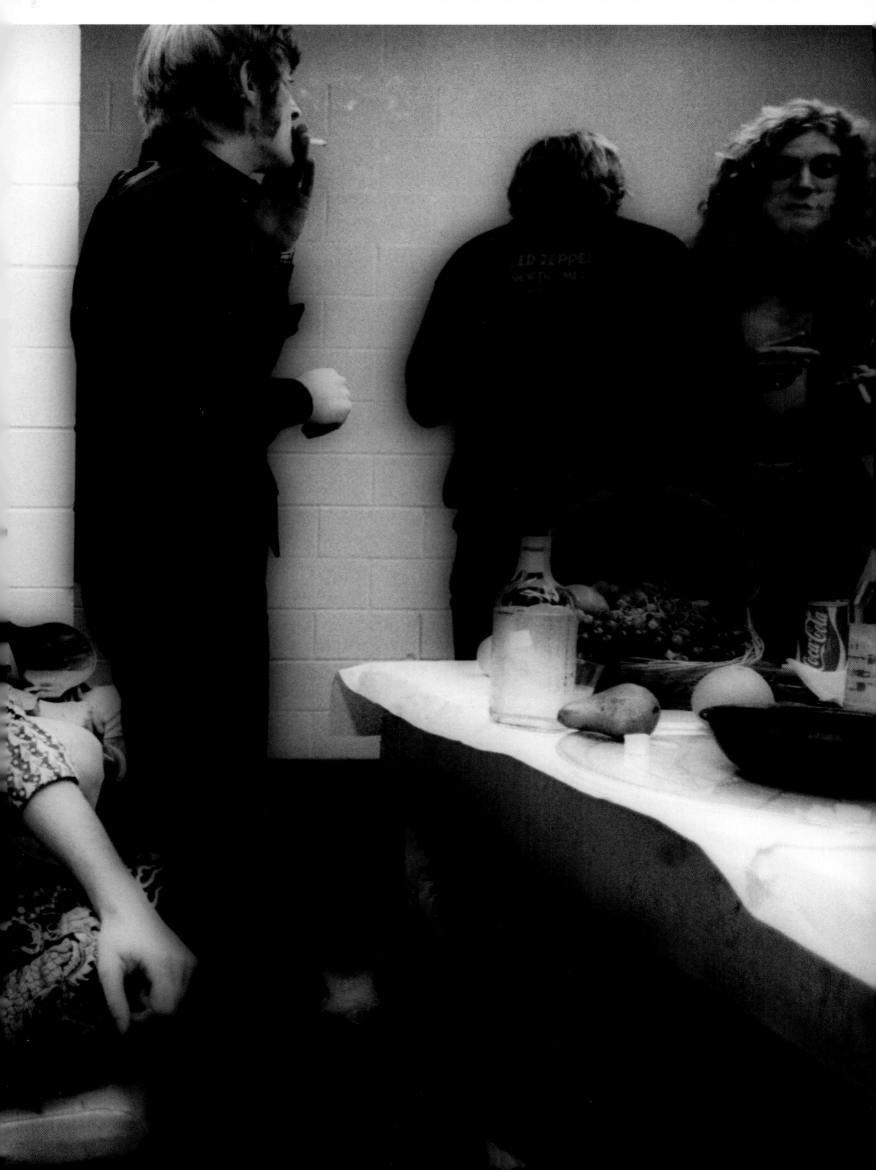

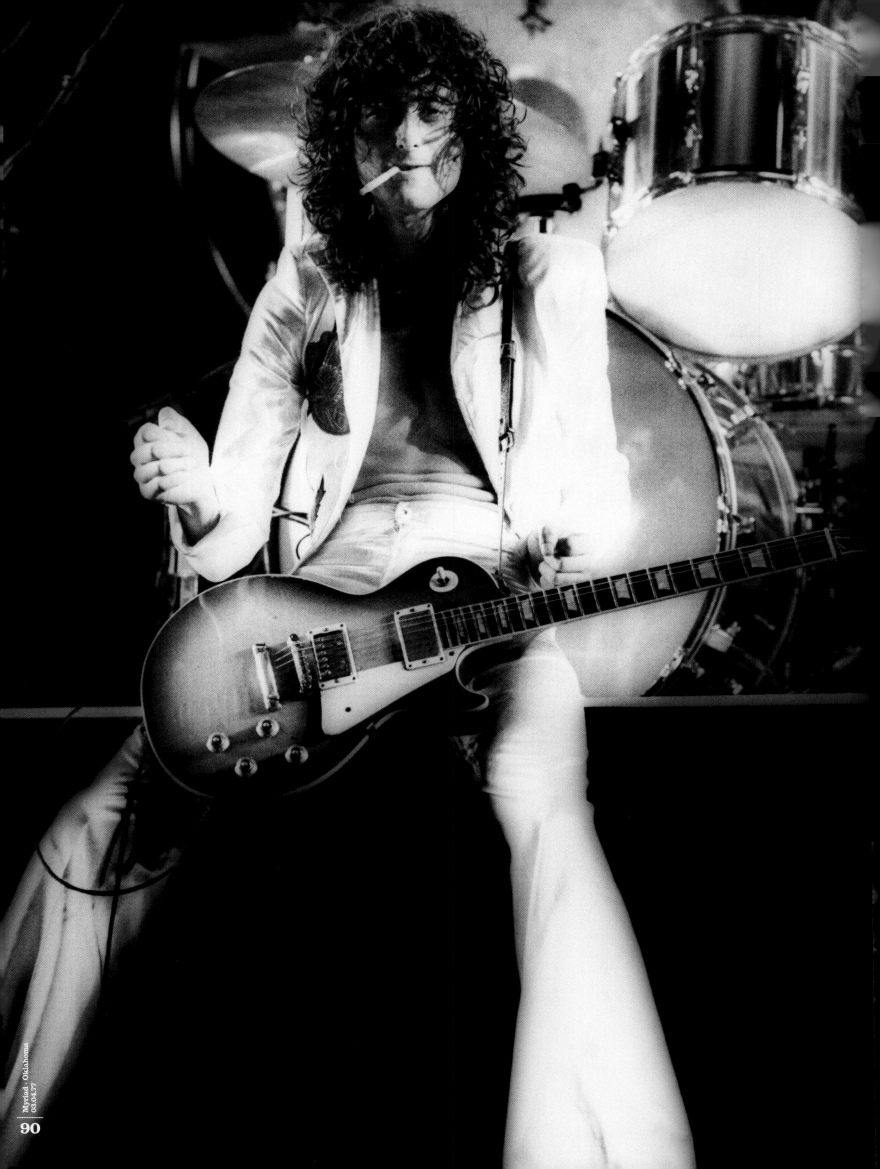

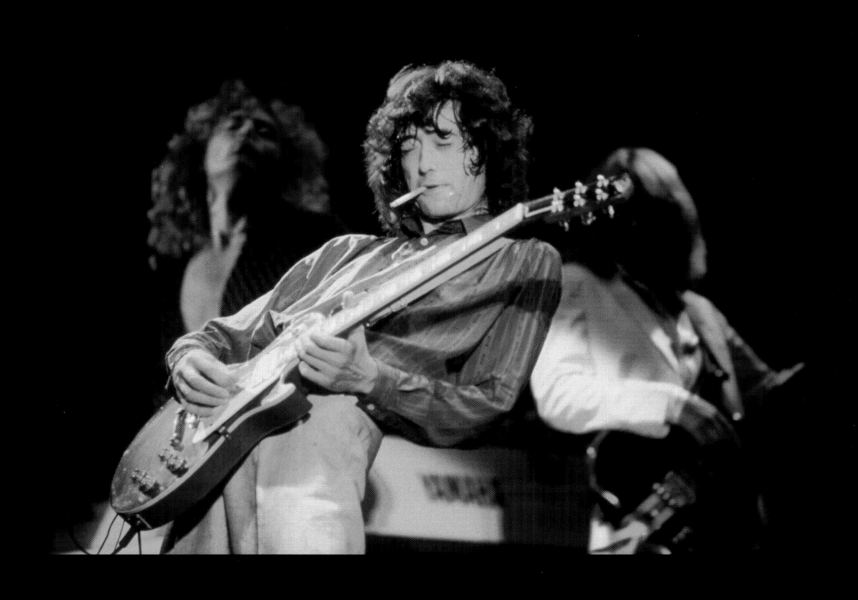

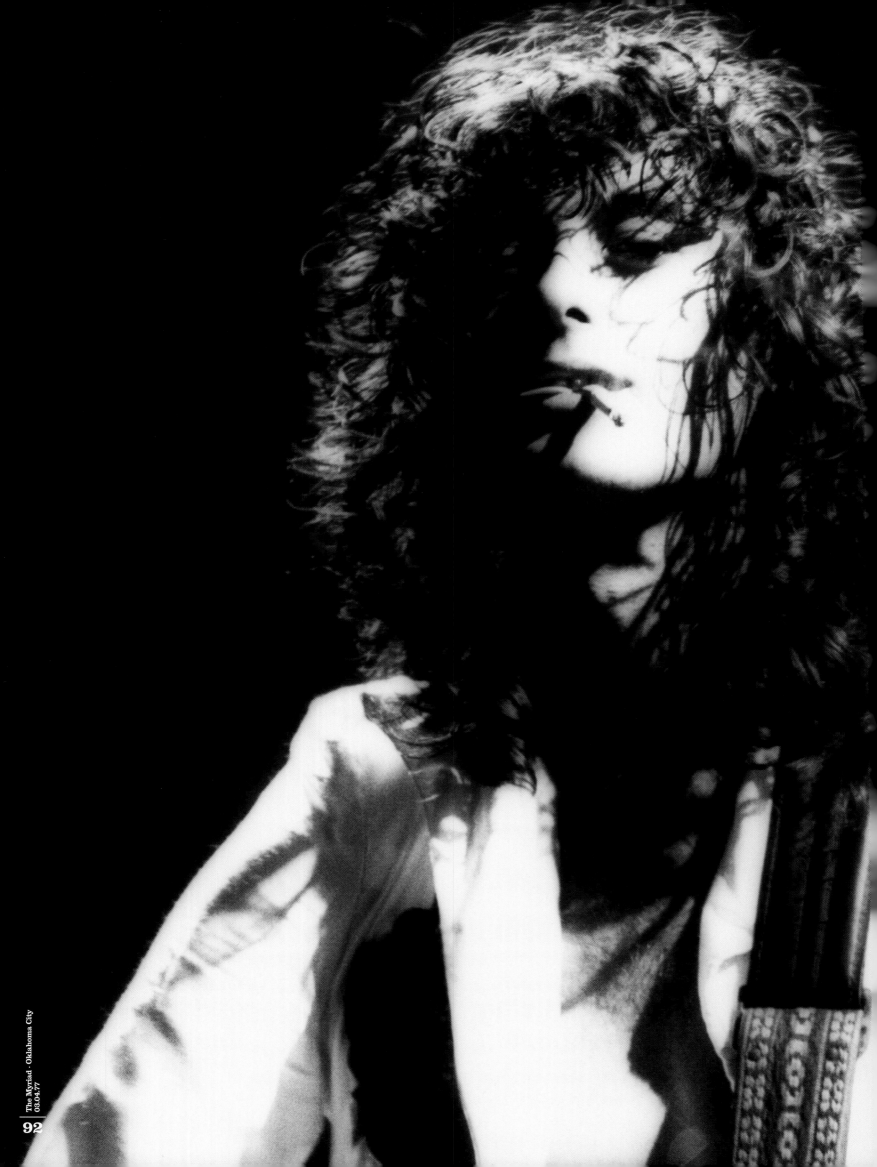

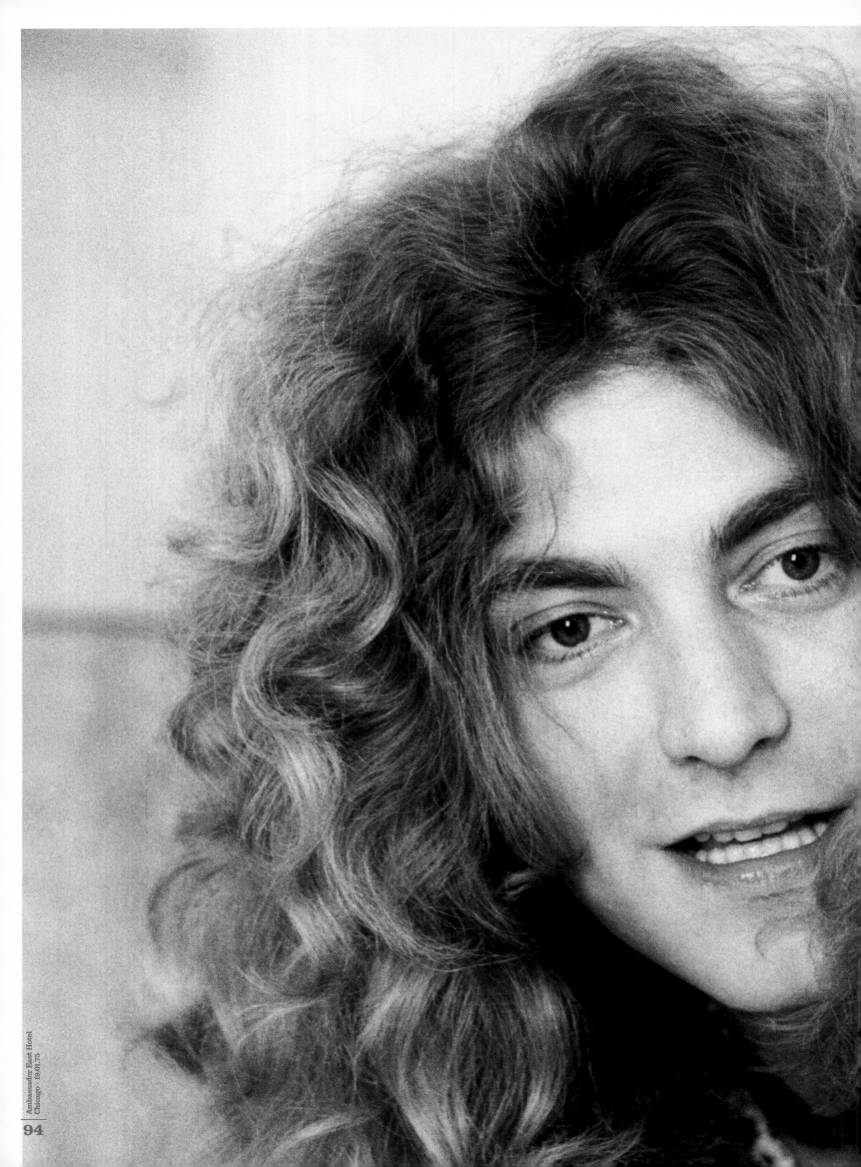

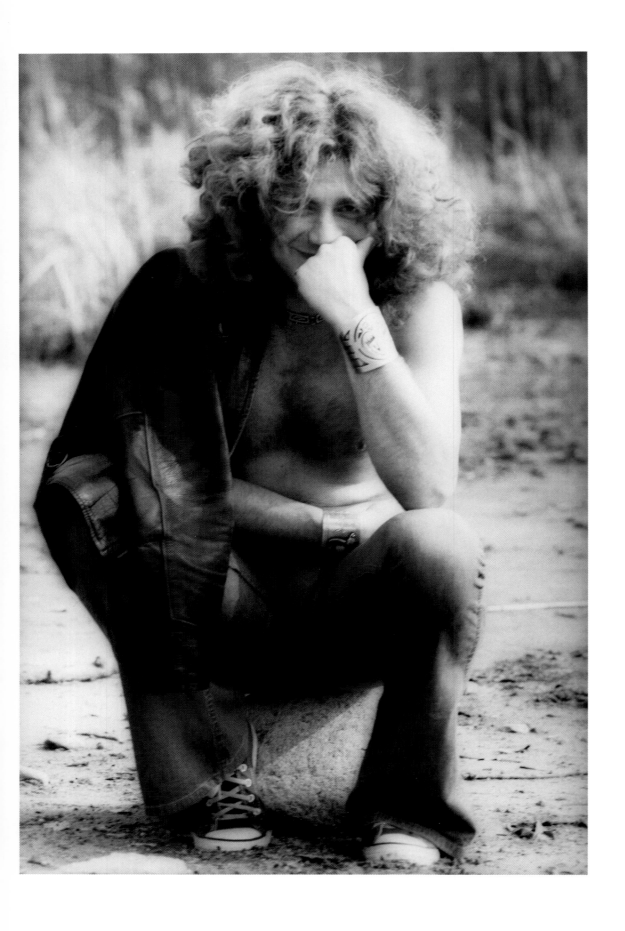

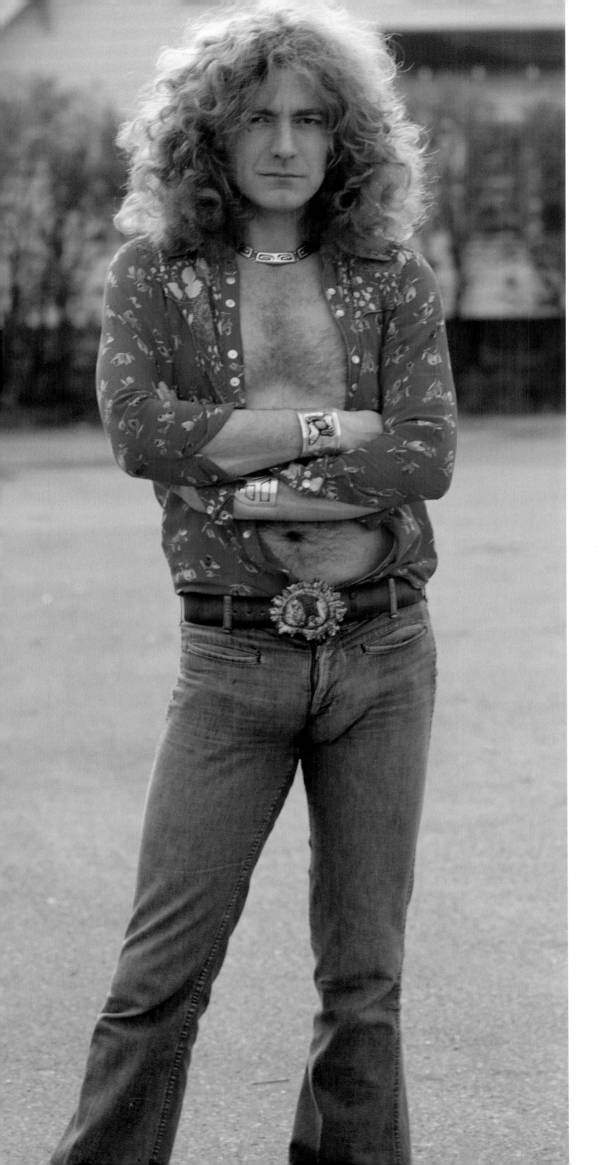

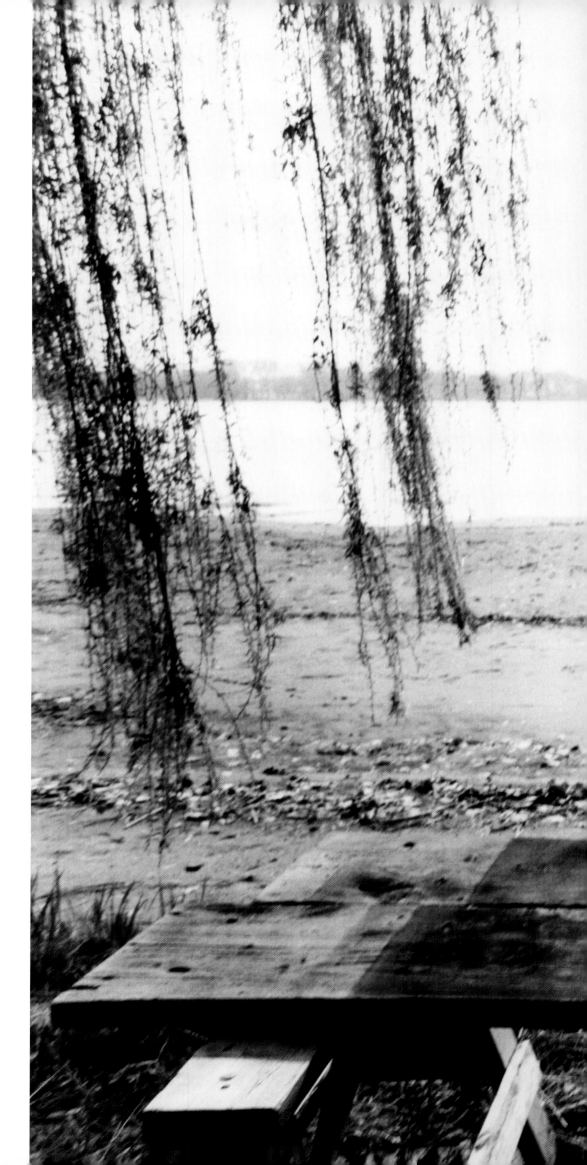

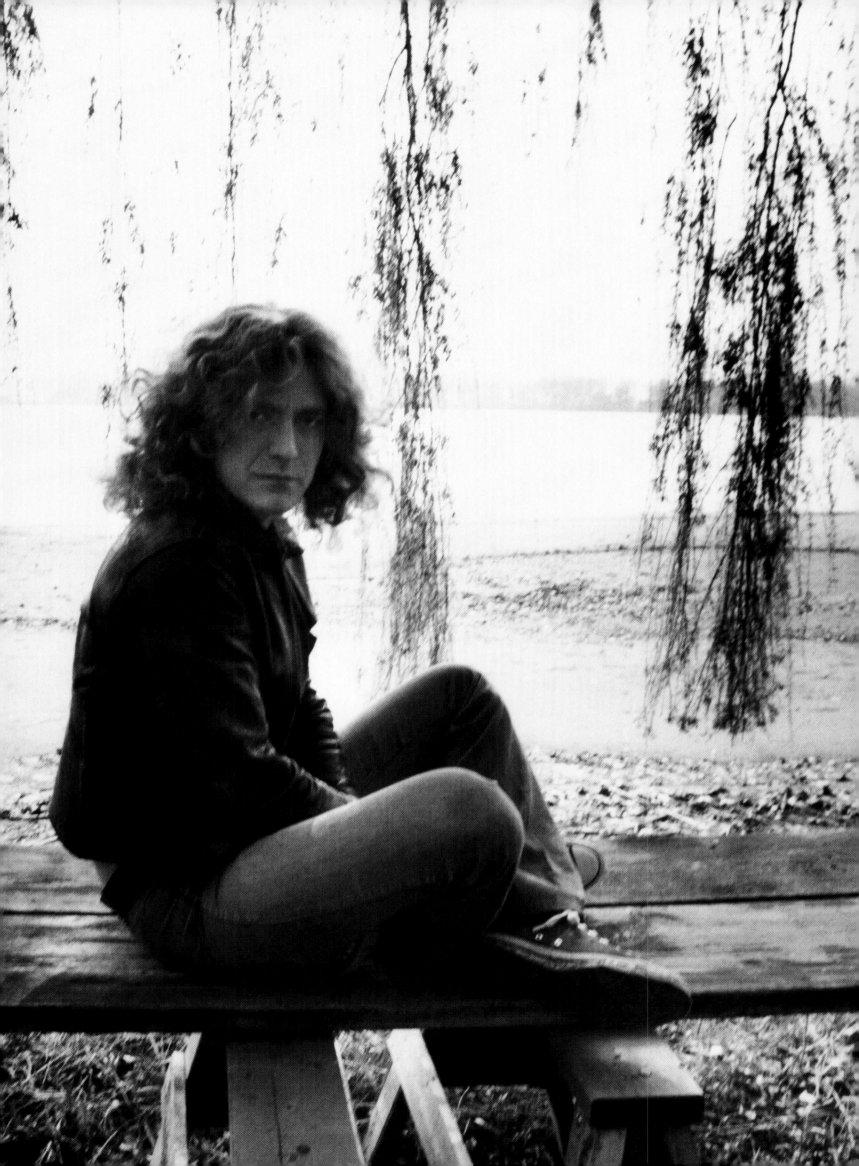

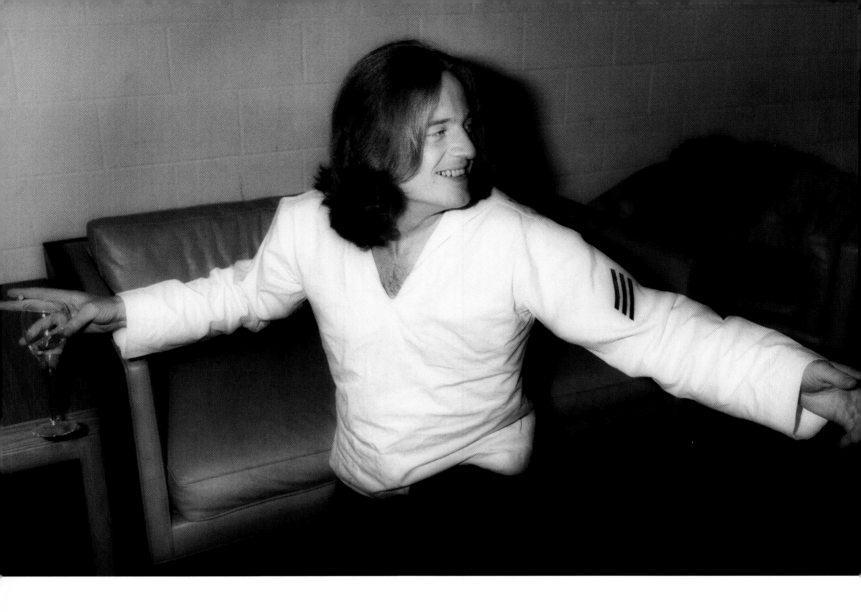

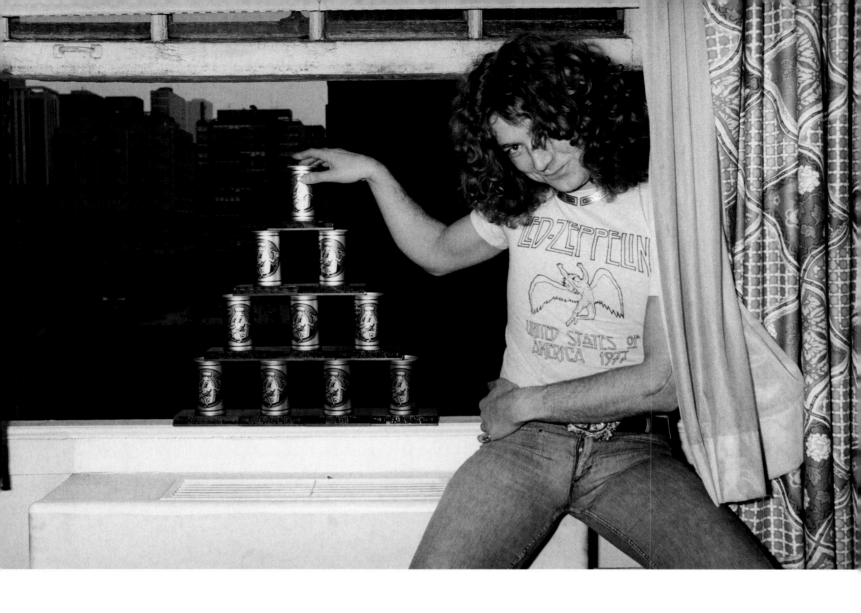

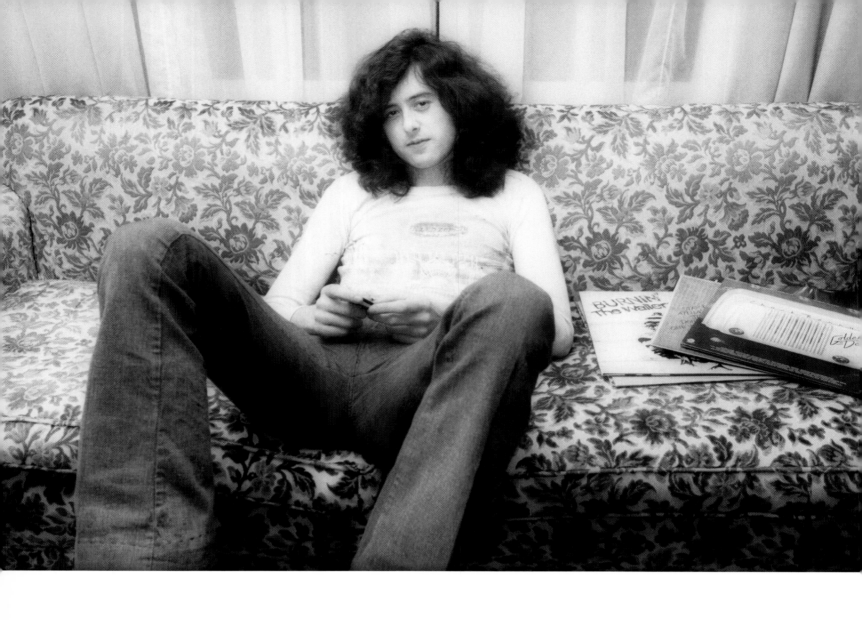

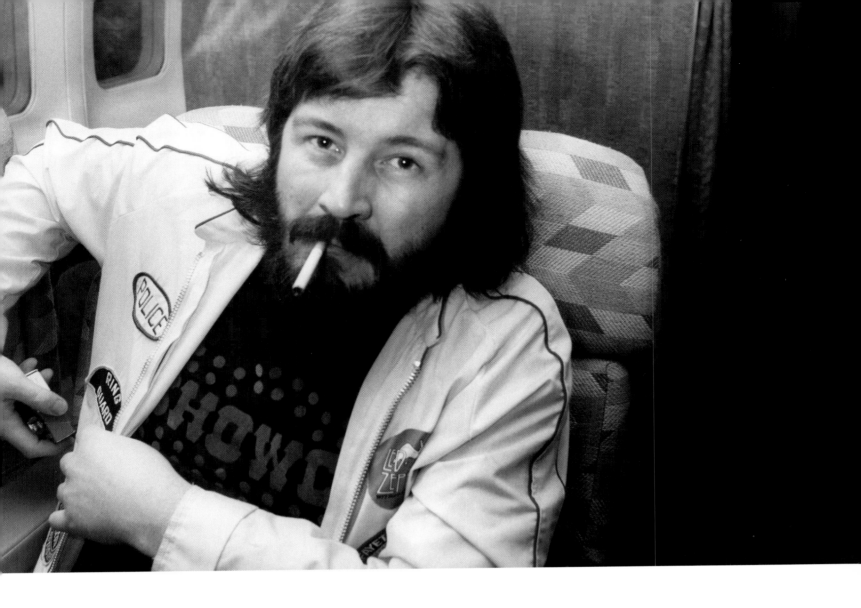

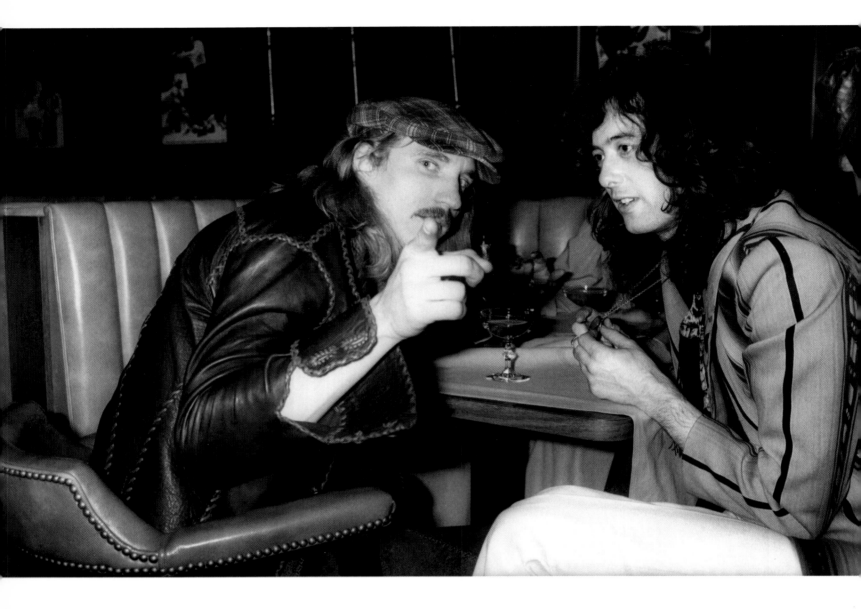

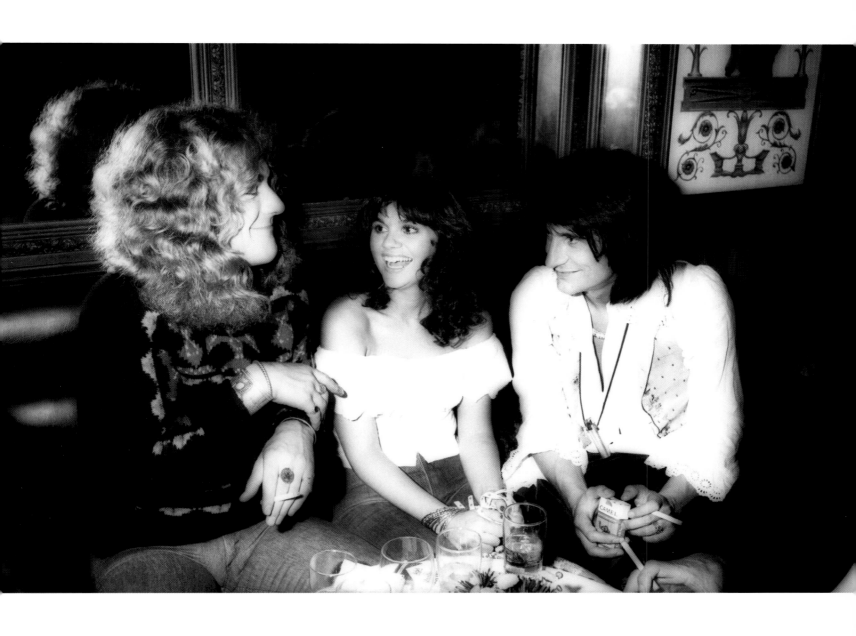

Robert Plant, Linda Ronstadt and Ron Wood
at the Bistro Restaurant · Los Angeles · 21.10.76

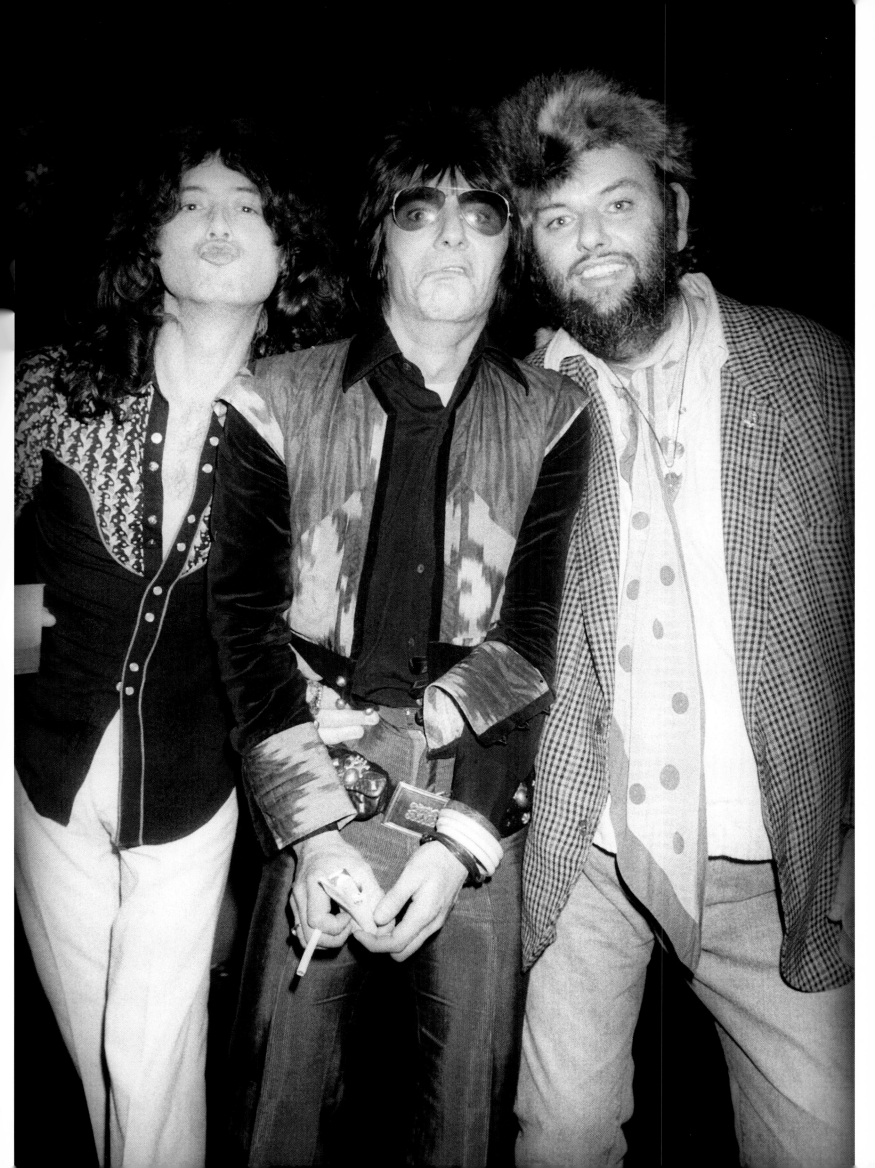

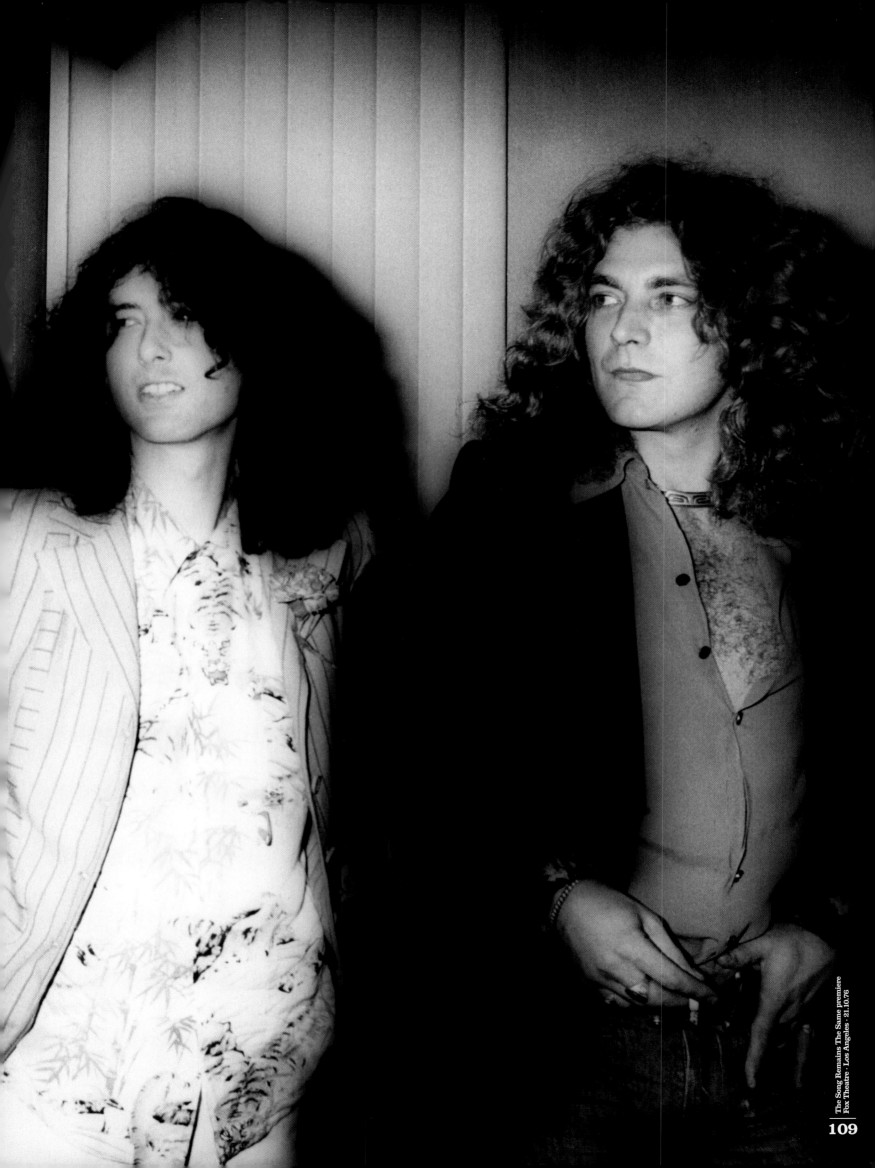

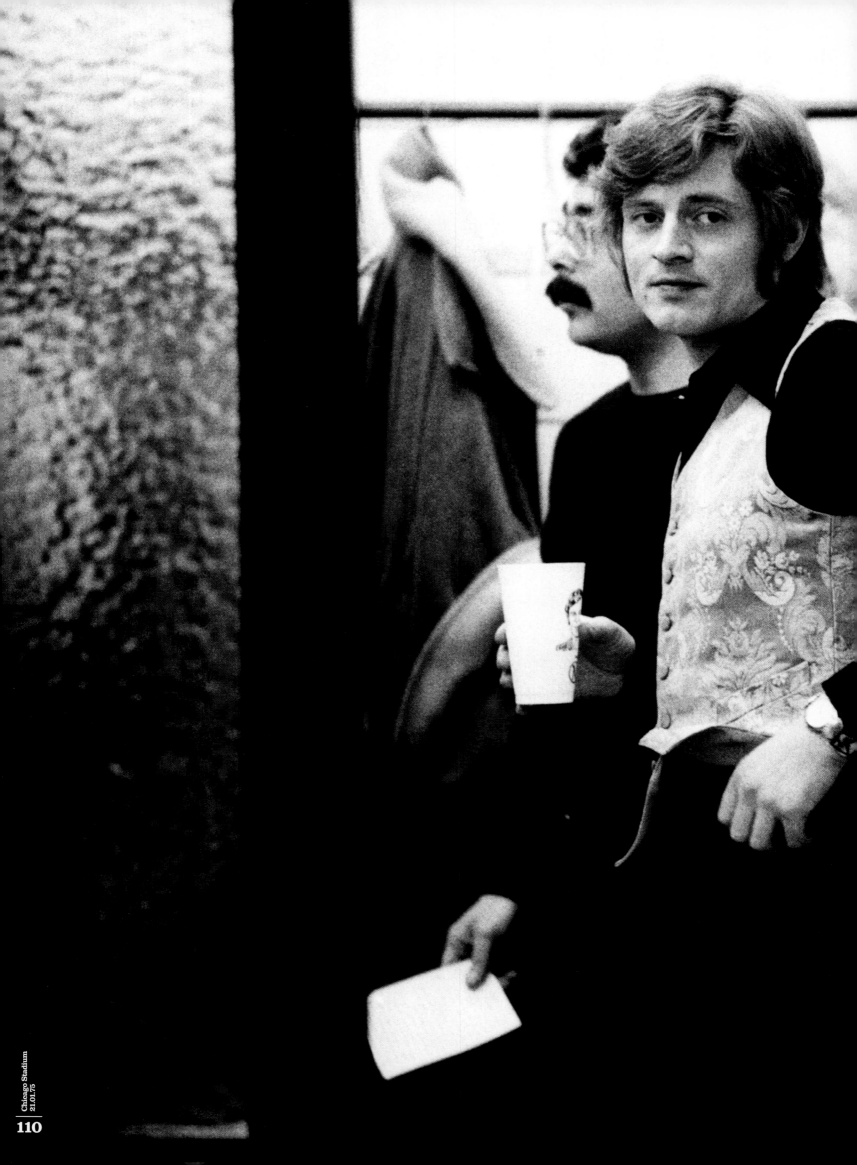

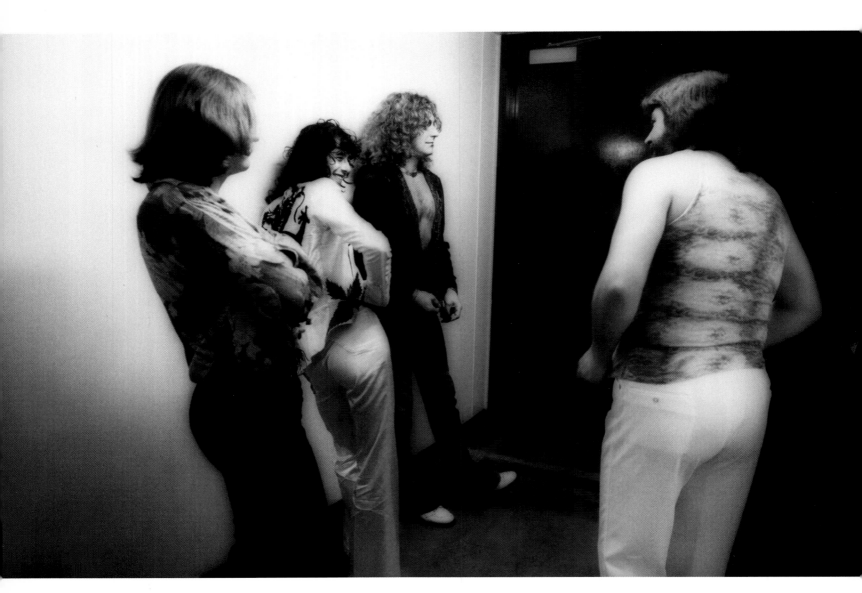

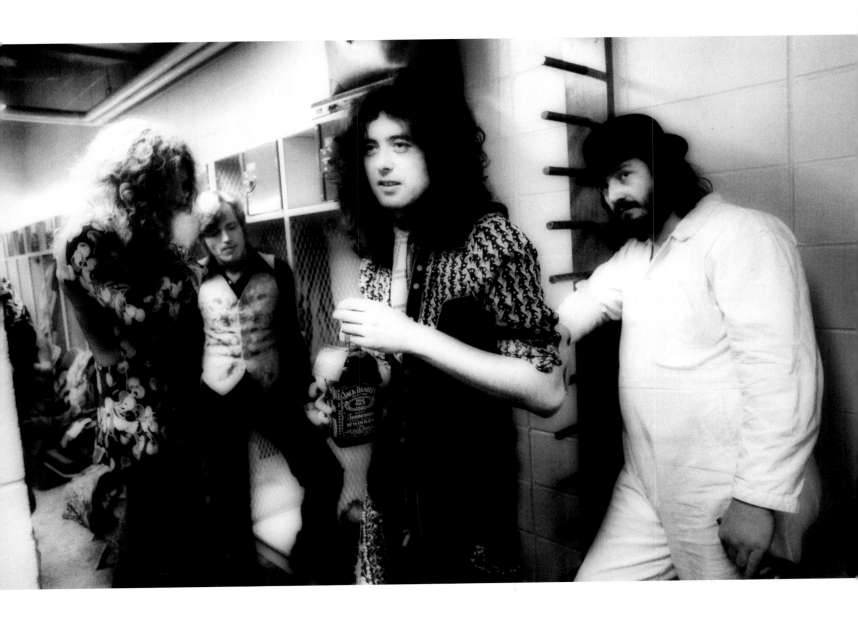

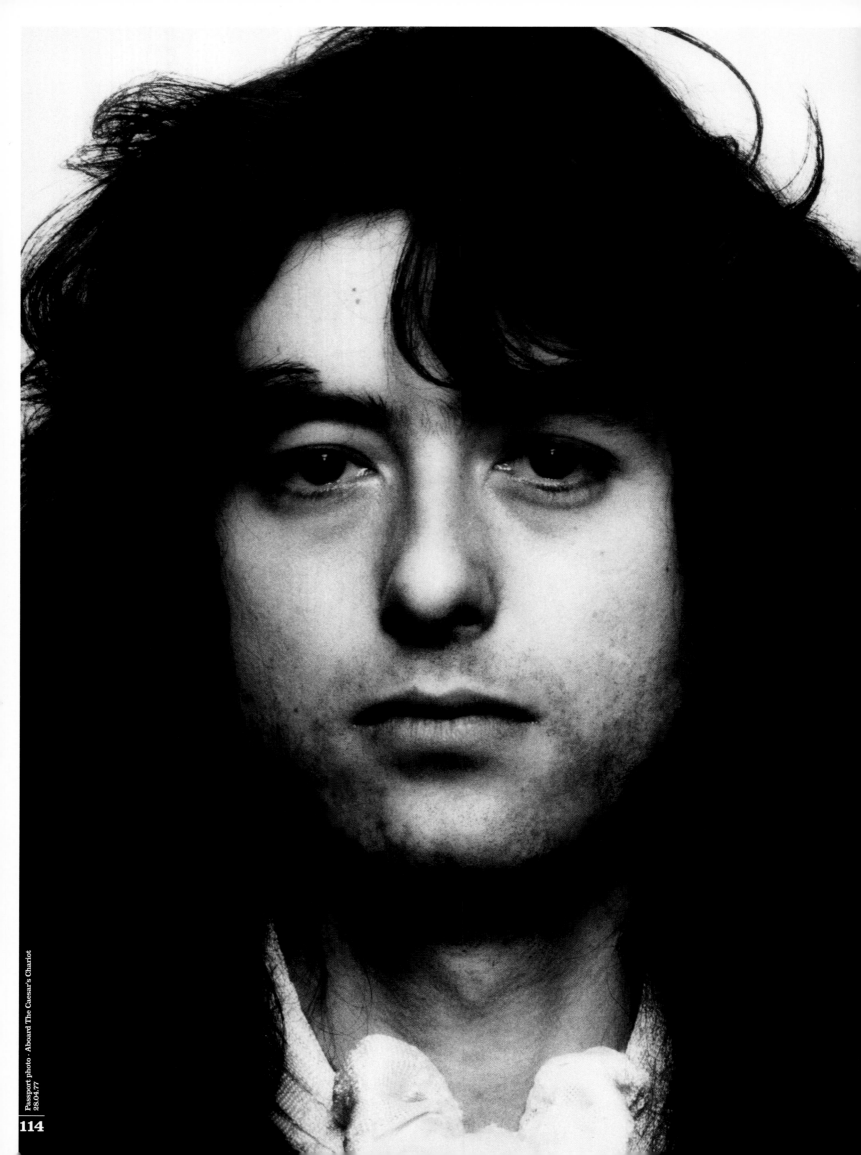

Passport photo · Aboard The Caesar's Chariot
28.04.77

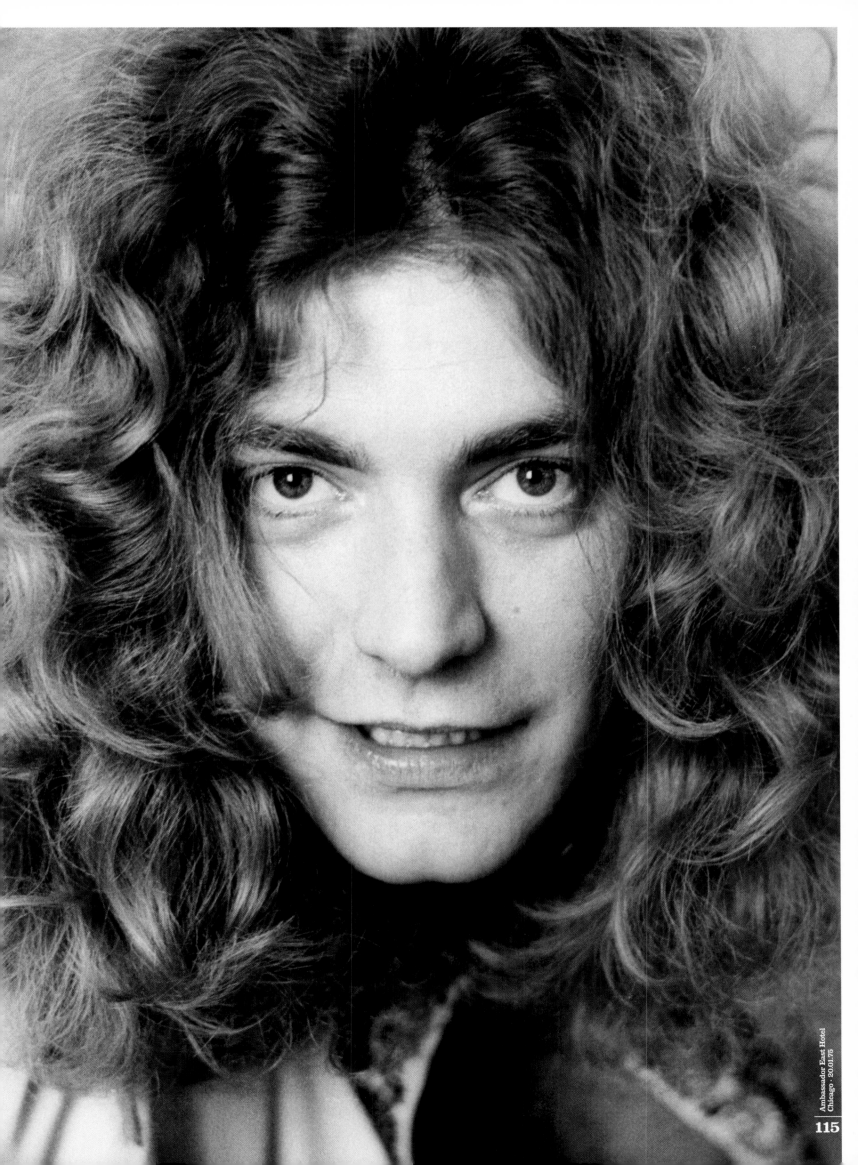

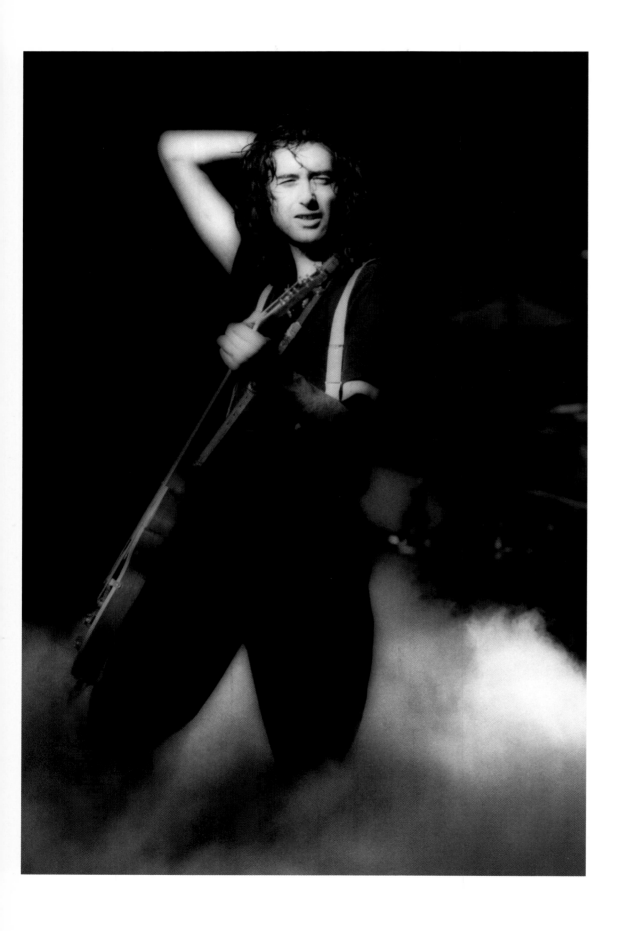

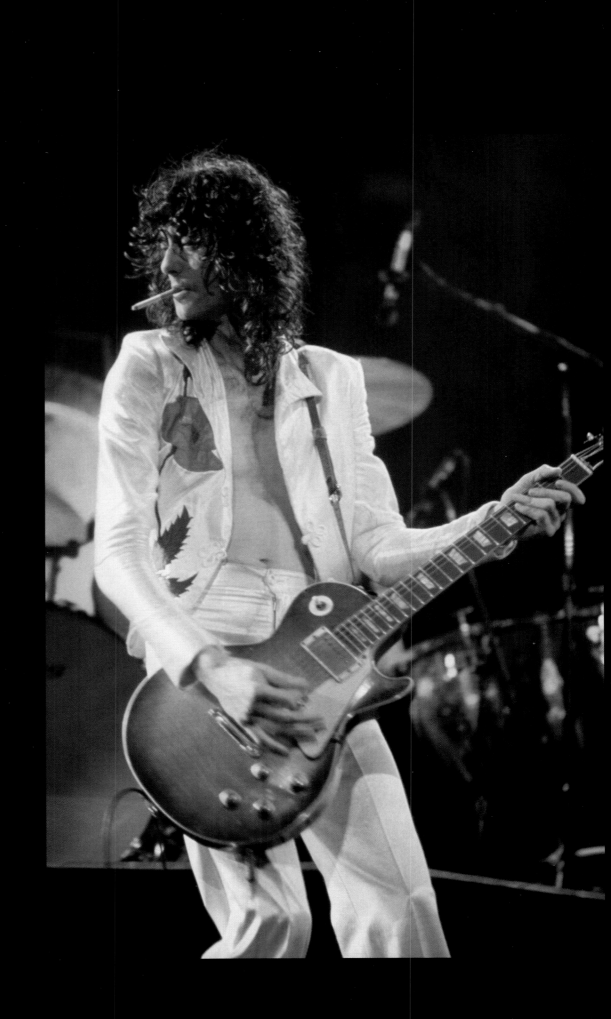

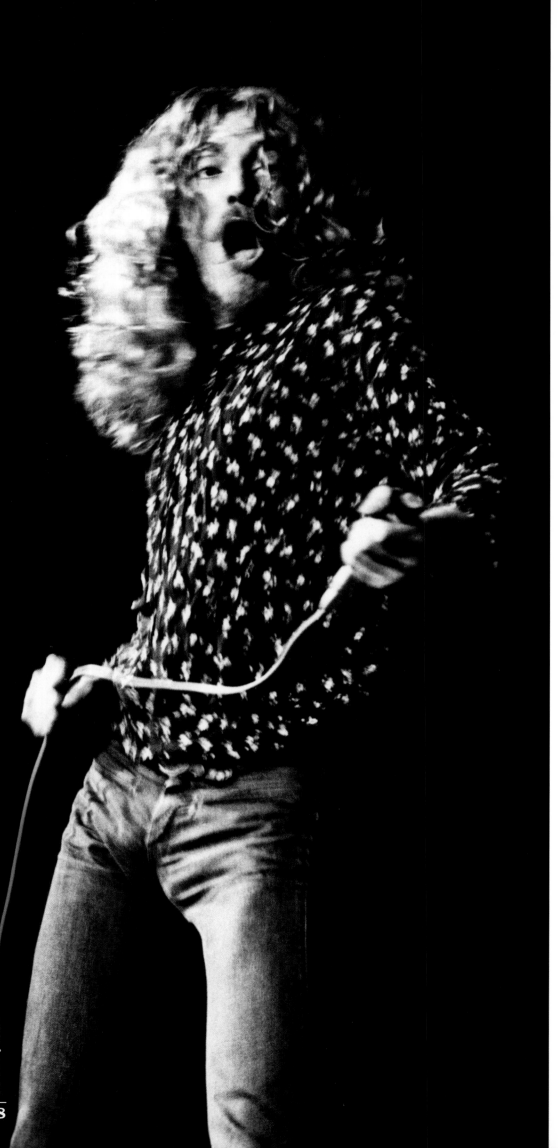

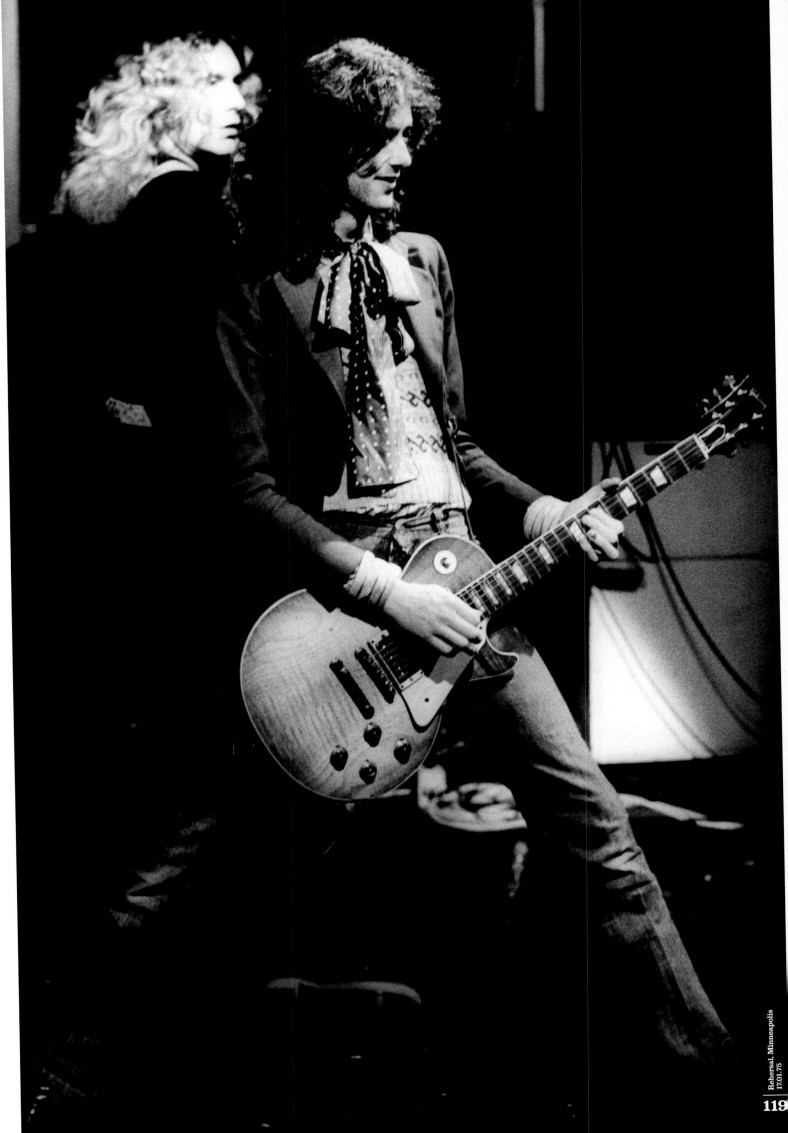

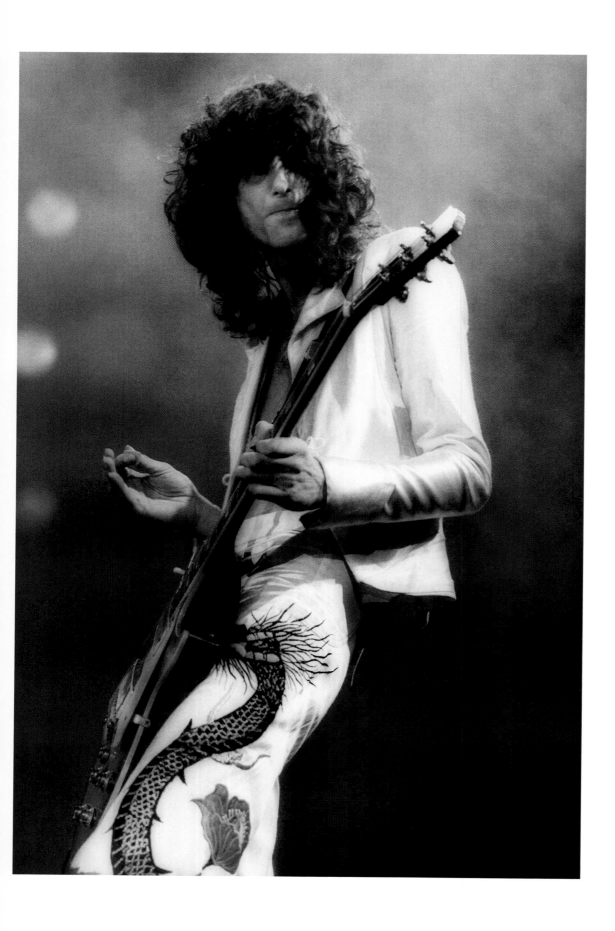

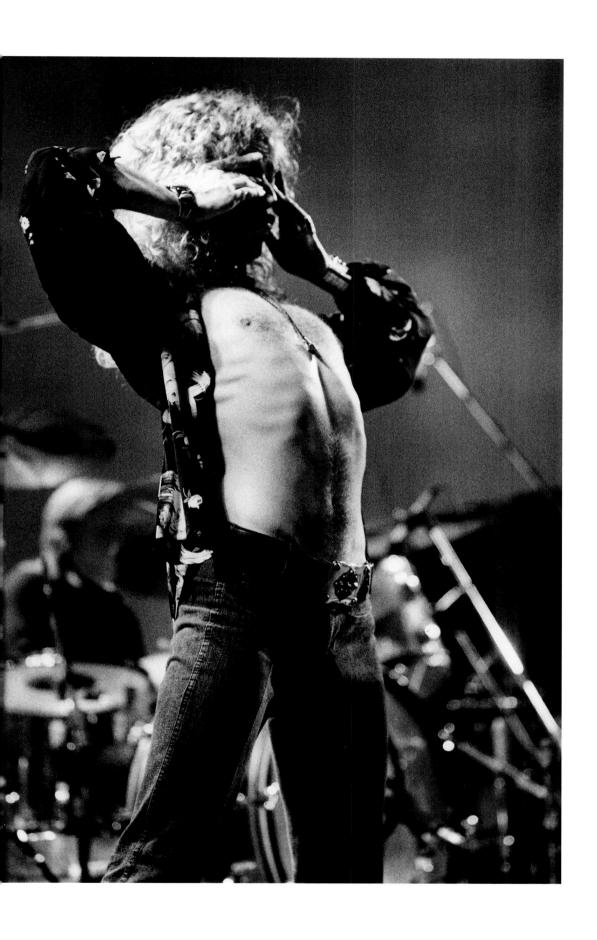

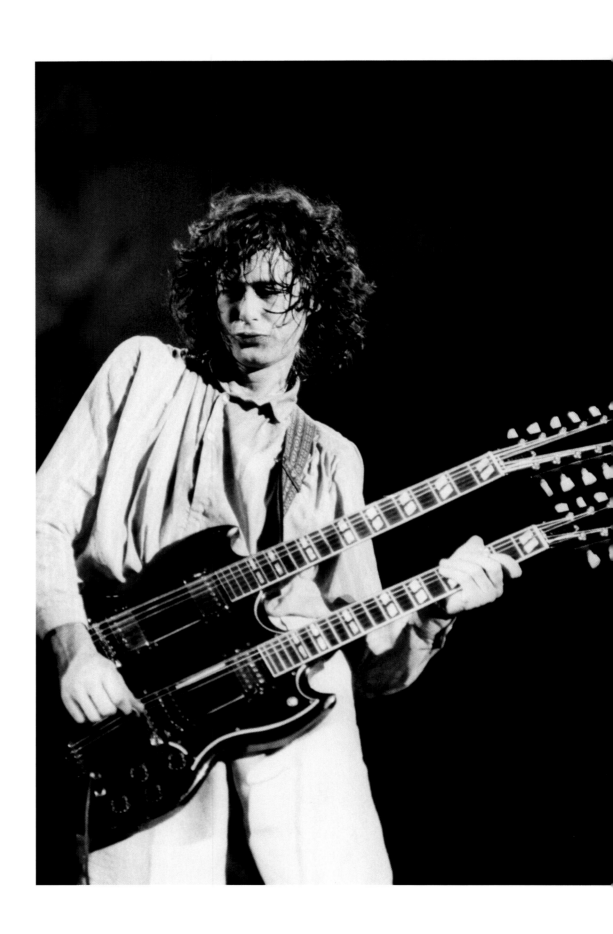

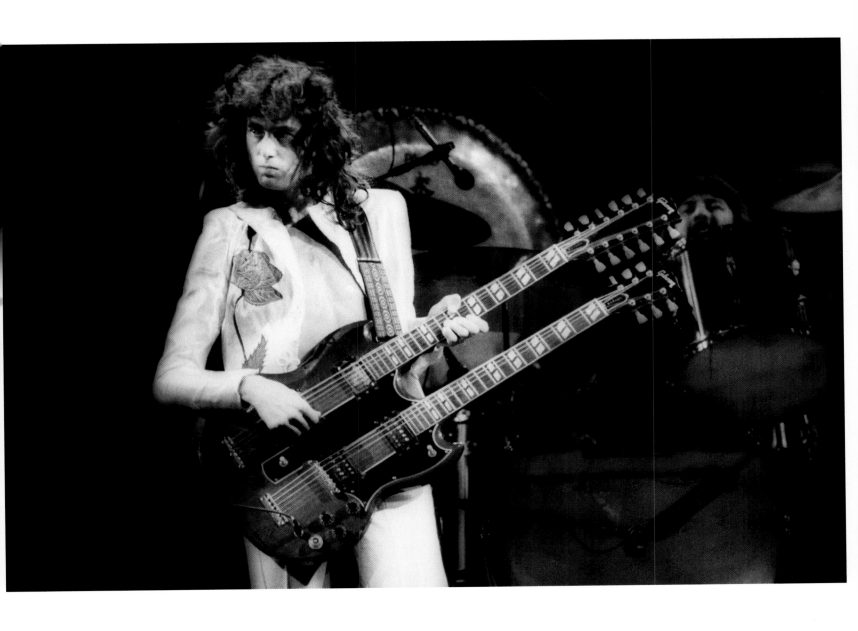

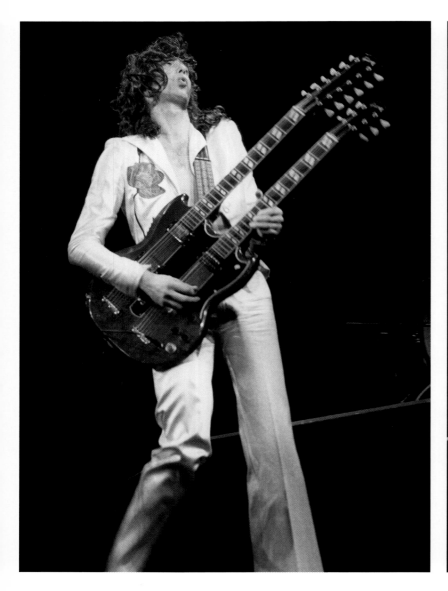
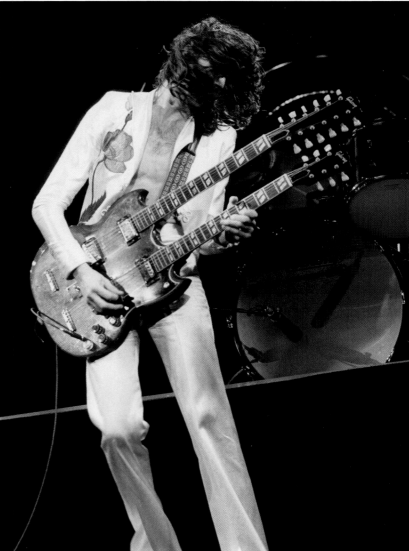

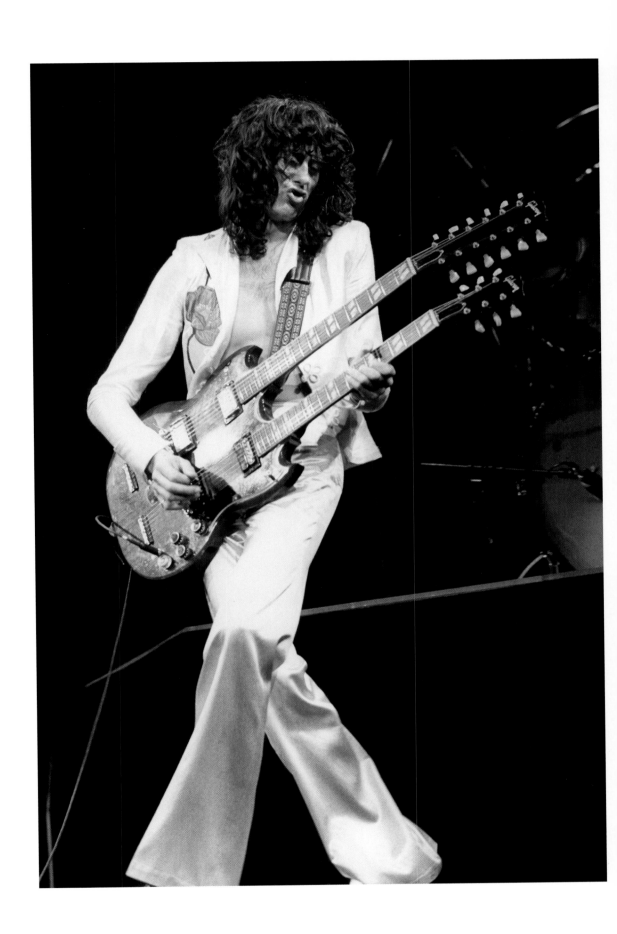

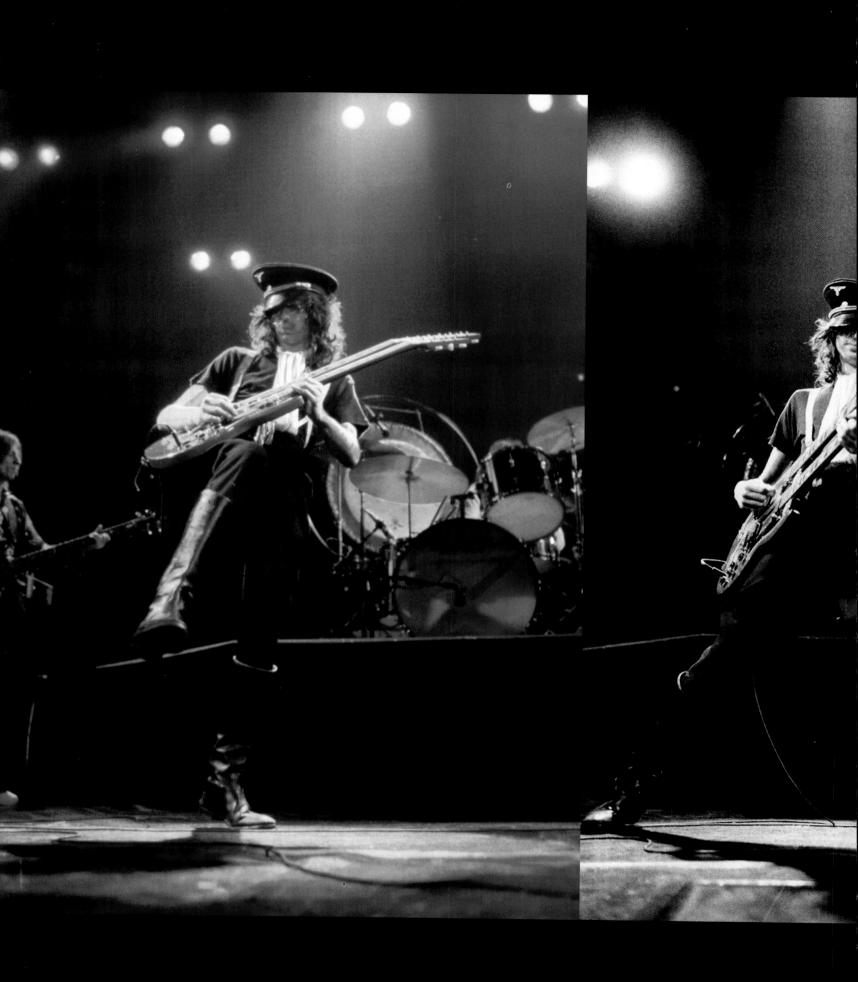

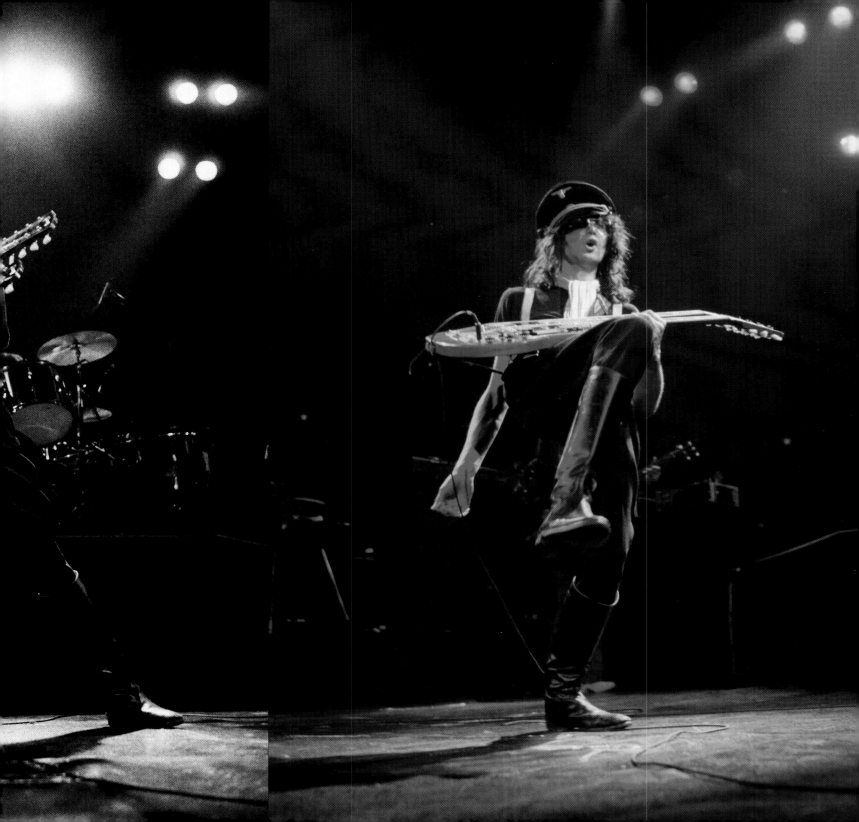

Polar studios in Stockholm, they announced their first UK shows in four years. Fittingly, Preston was the only photographer granted full access to shoot what would be Led Zeppelin's final UK shows at the giant Knebworth Festival in August 1979. 200,000 fans came to pay homage - a remarkable show of devotion despite the punk backlash prevalent in England at the time. Neal Preston once again provided visual evidence of a landmark concert. He captured the whole atmosphere of the memorable events of Saturday 4 August: Page arriving on site by helicopter, relaxed backstage shots of the band with their families and friends, and a last iconic glimpse of Robert Plant, hands held high in all his rock god glory, at the end of *Stairway To Heaven*.

After a low key European tour the following summer, Led Zeppelin once again had America in its sights, and Preston was ready to move into action again for a touring campaign that would be dubbed "Led Zeppelin: The 1980s Part One". But it wasn't to be.

On 25 September, John Bonham was found dead at Page's Windsor home, the victim of a huge drinking bout. In a bitter irony, just as these tragic events were unfolding, thousands of Zeppelin fans were queuing to obtain copies of the *Chicago Tribune*, which carried mail order applications for their forthcoming Chicago Stadium concerts in November. Their quest would be entirely in vain. The tour was immediately cancelled and the Led Zep live experience was to become a vivid memory in the minds of all those lucky enough to have witnessed them over the past twelve years. Without Bonham they could not continue as they were - a statement to that effect was issued on 4 December 1980.

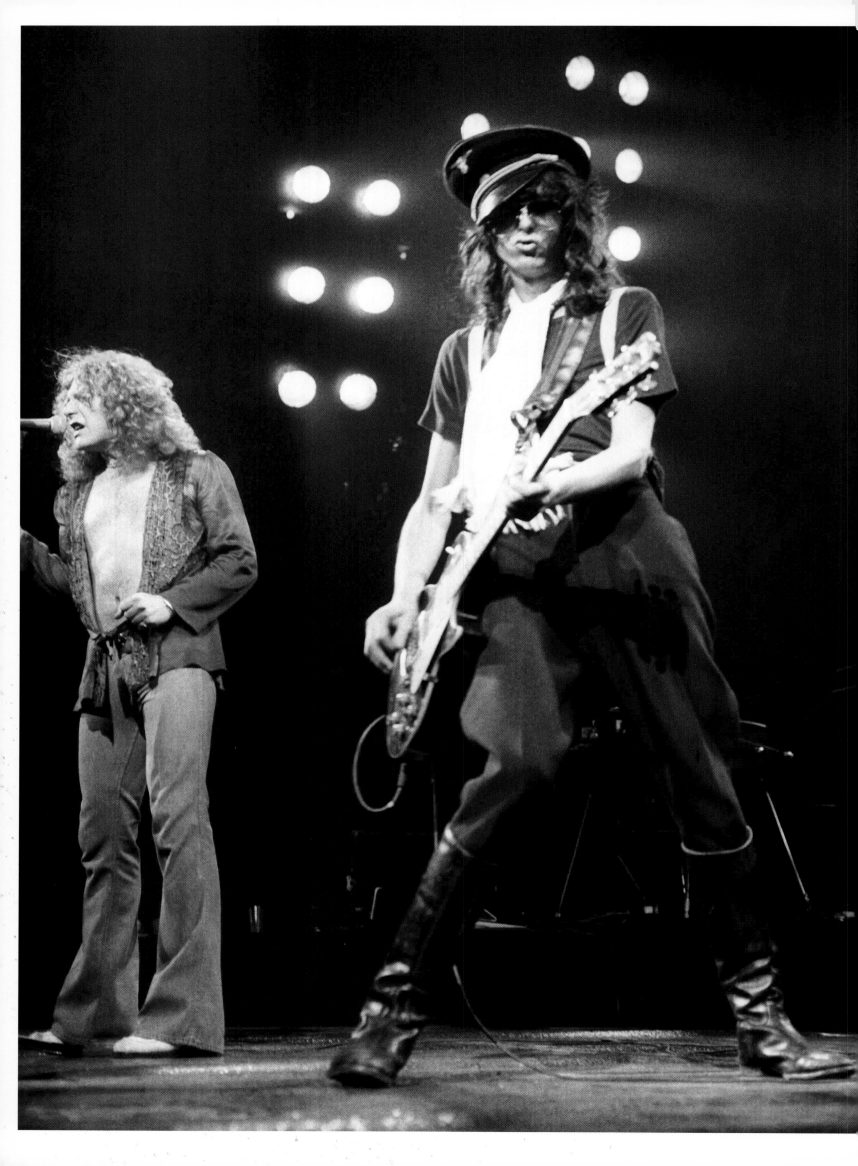

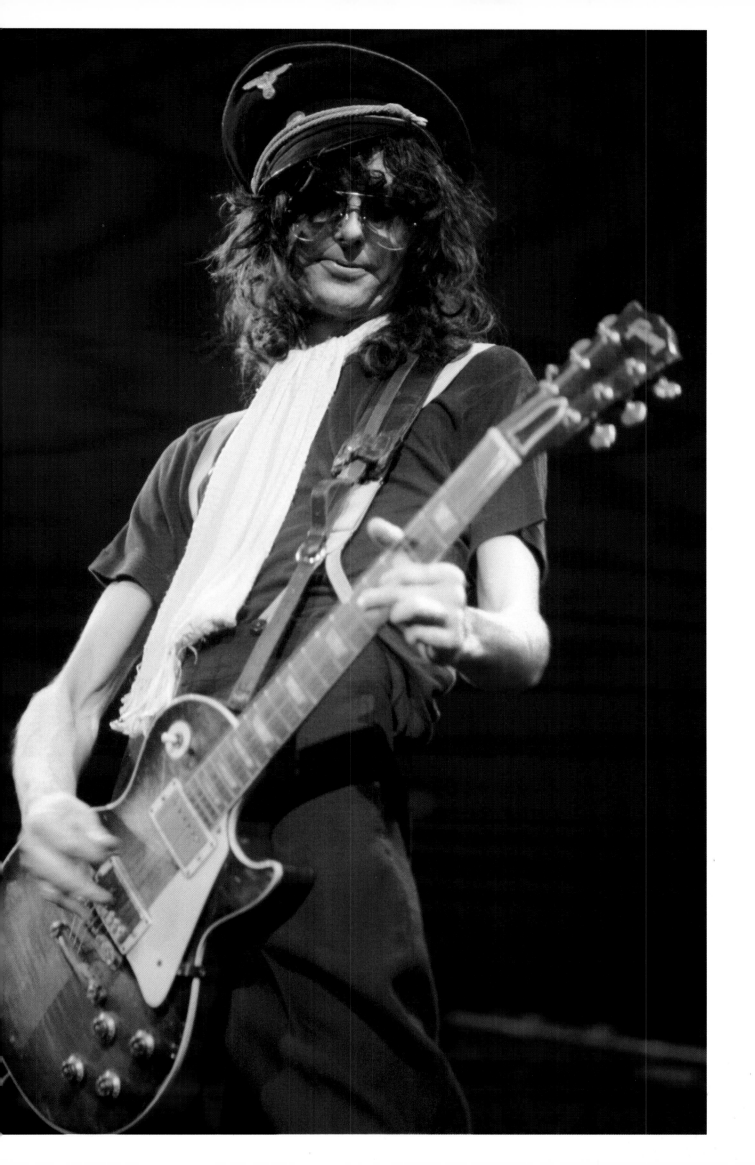

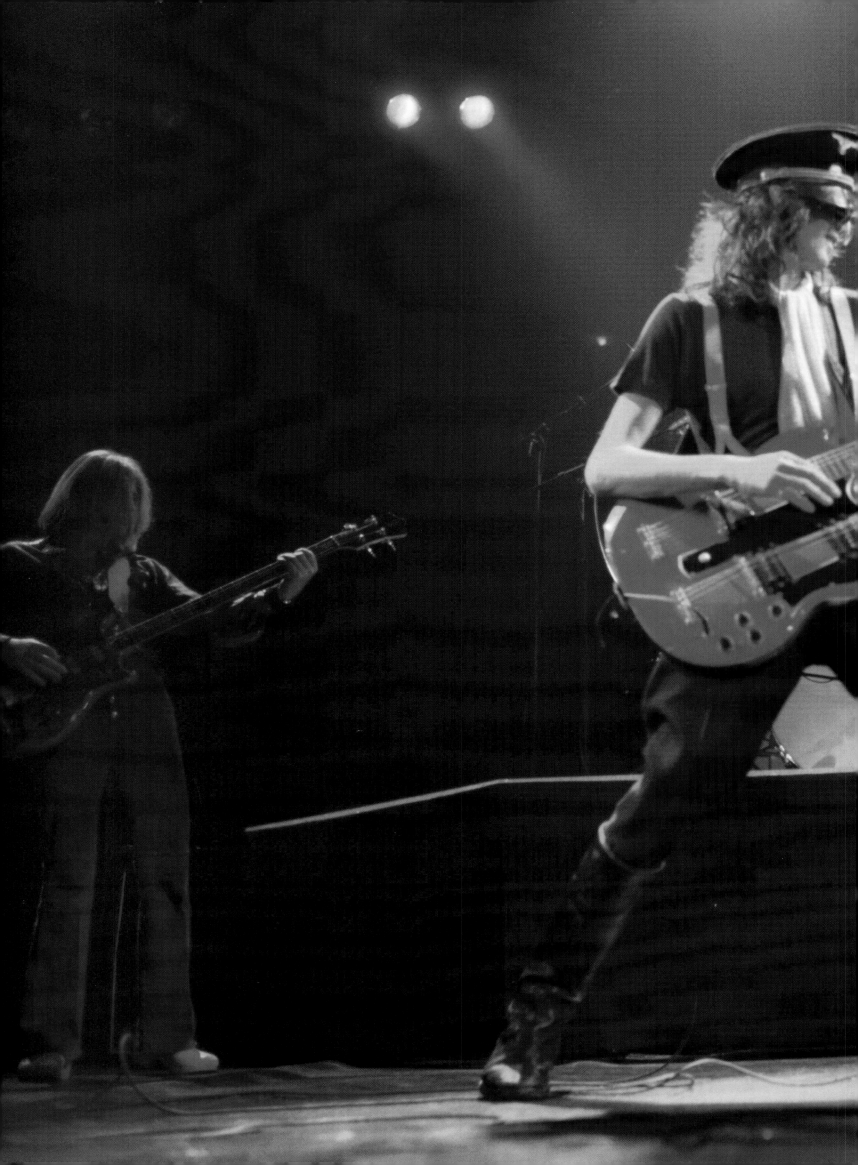

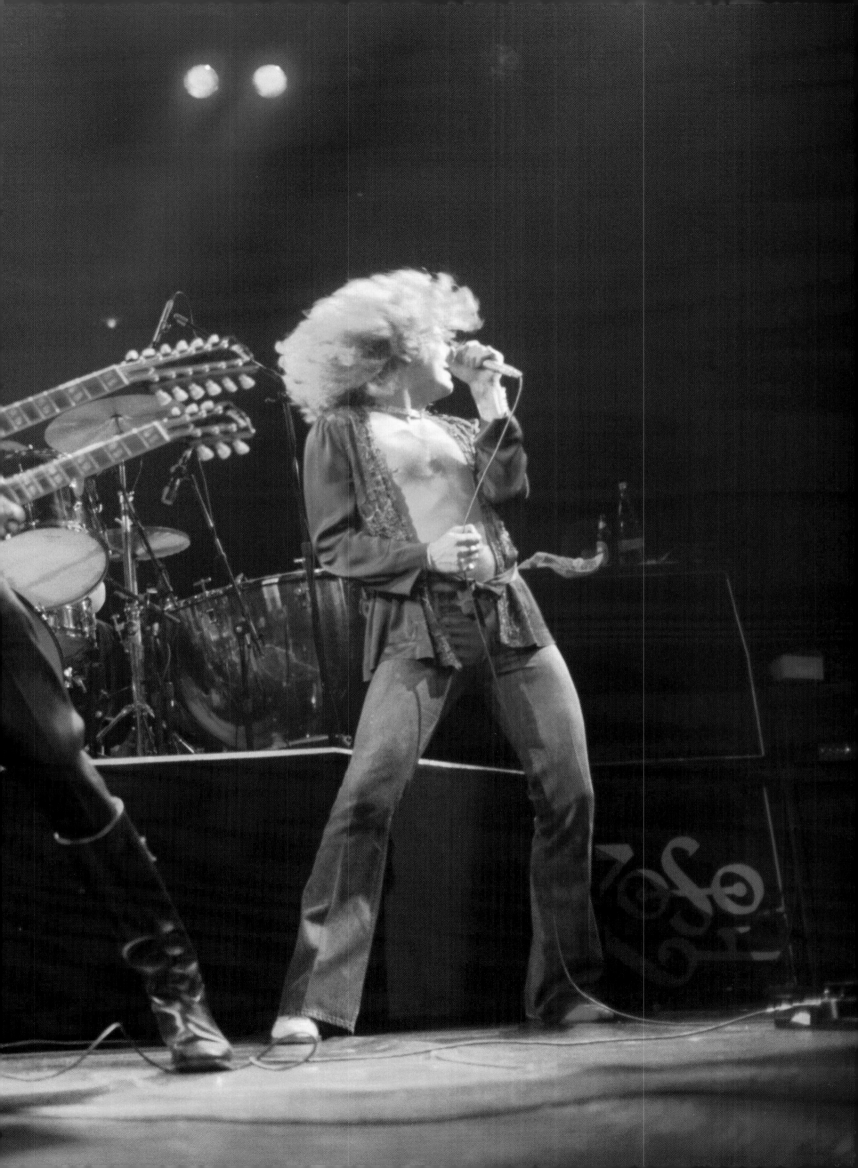

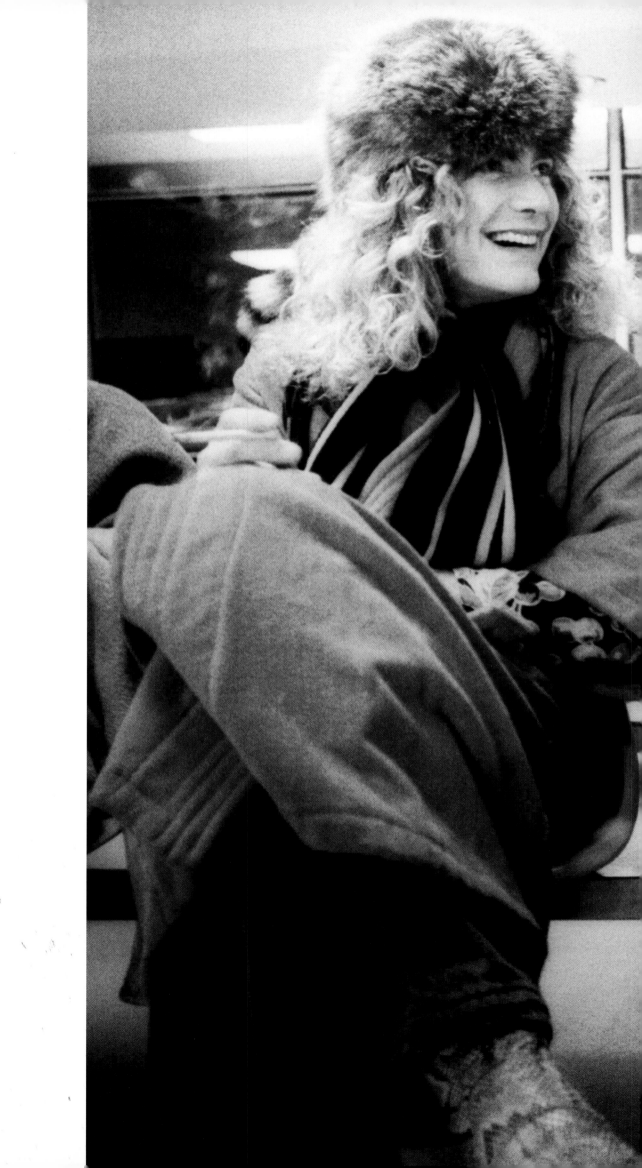

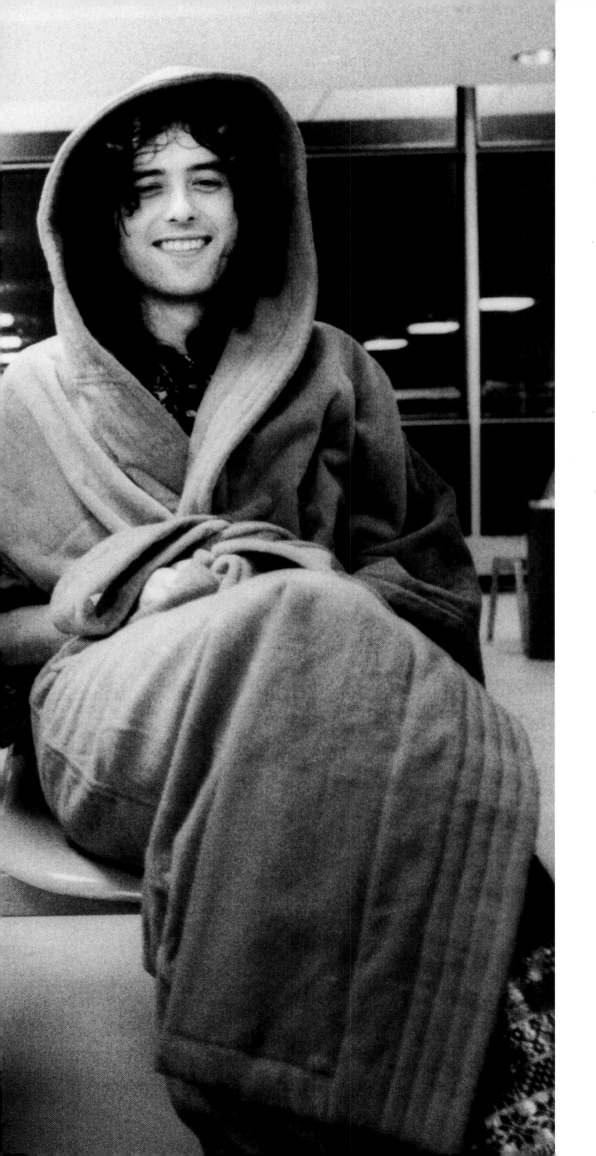

Waiting for the Starship
Minneapolis · 18.01.75

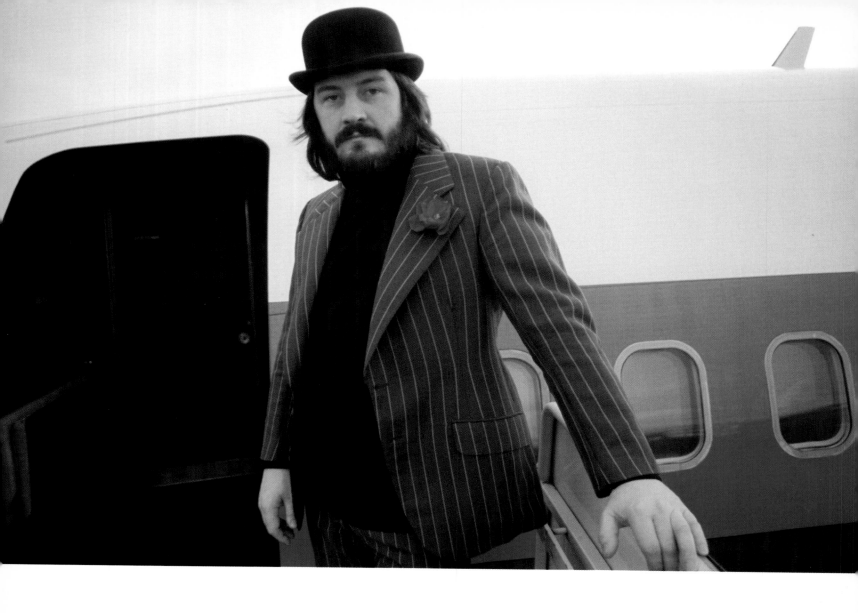

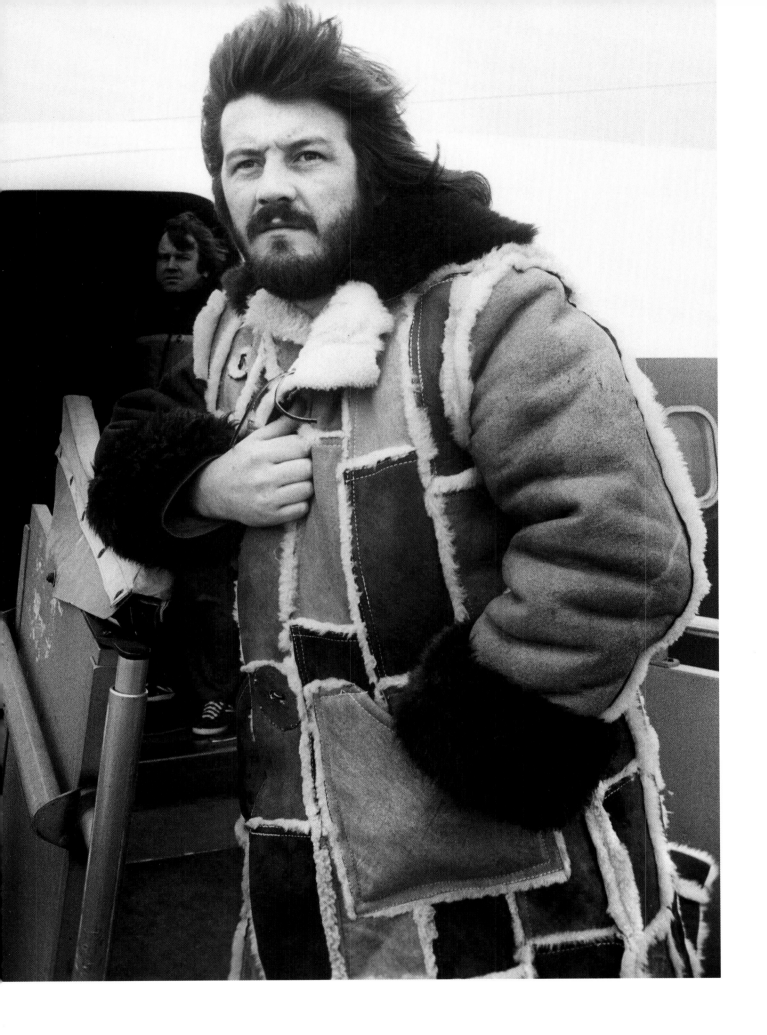

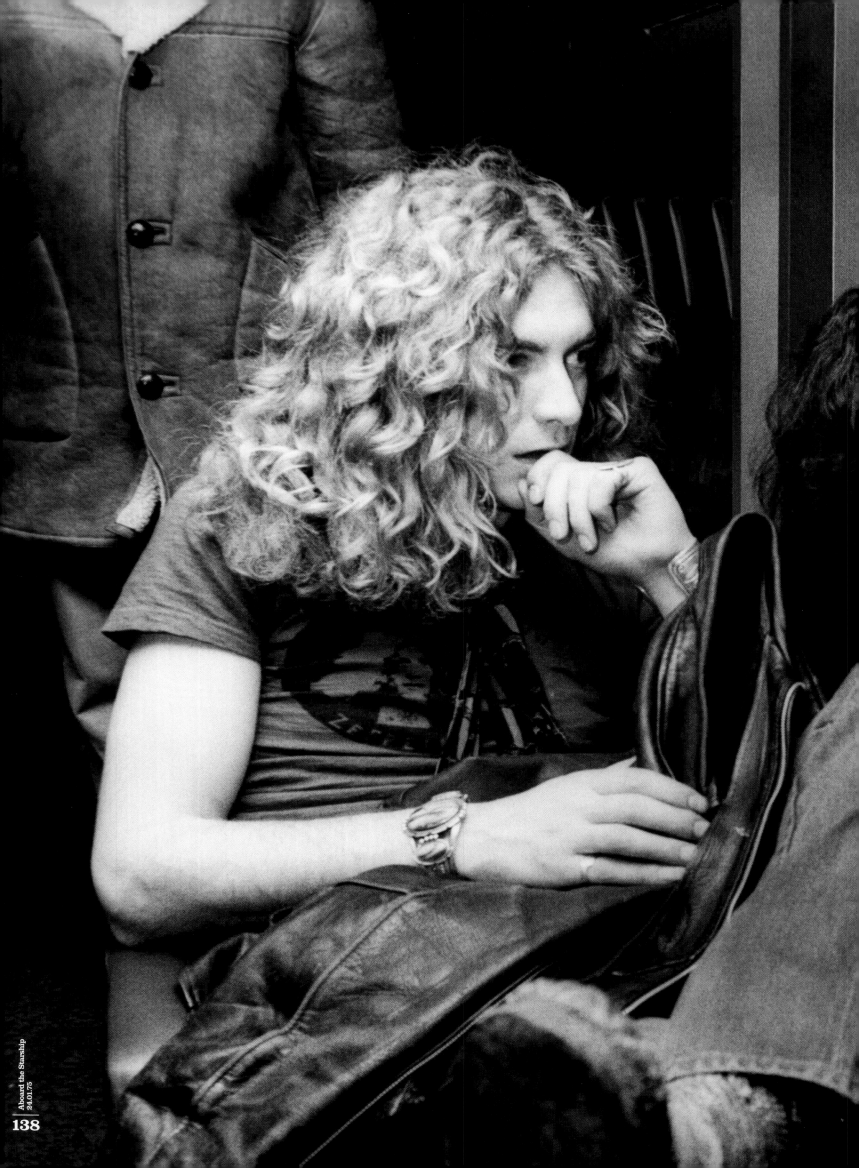

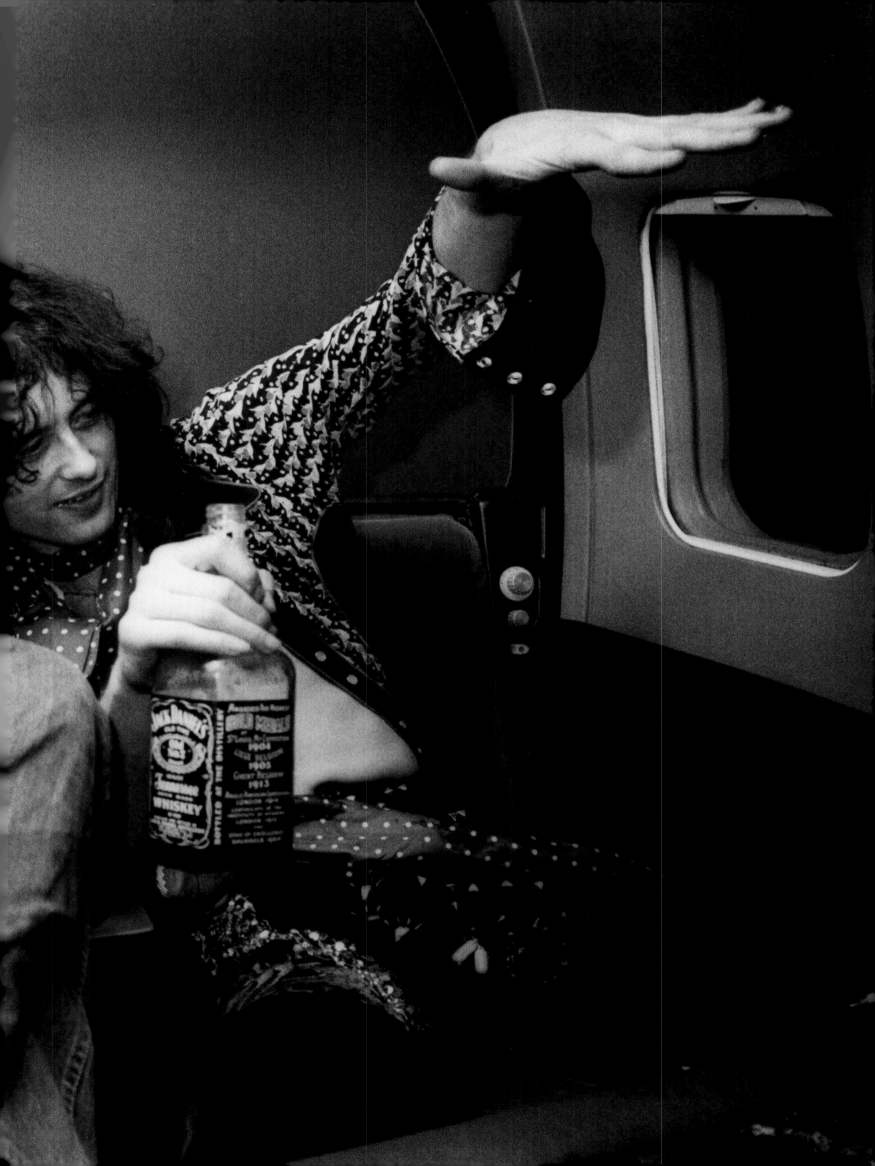

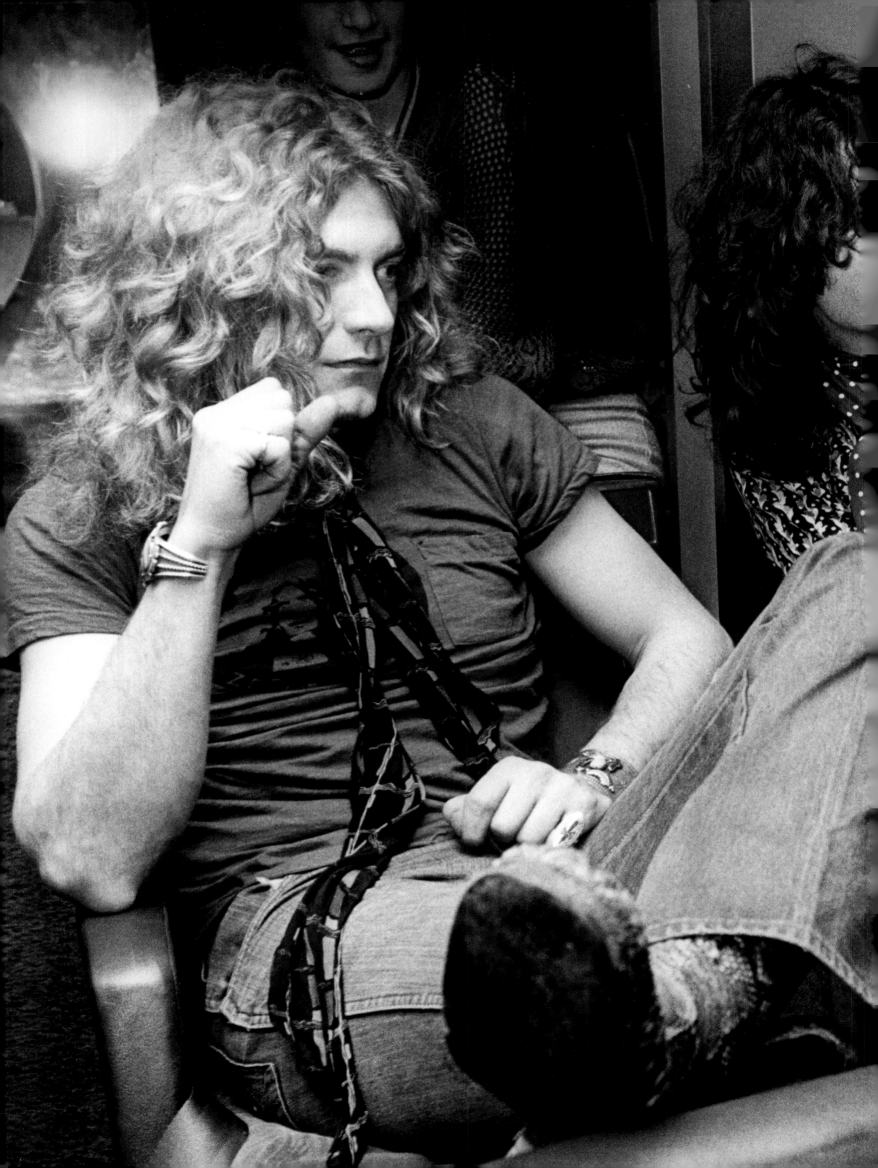

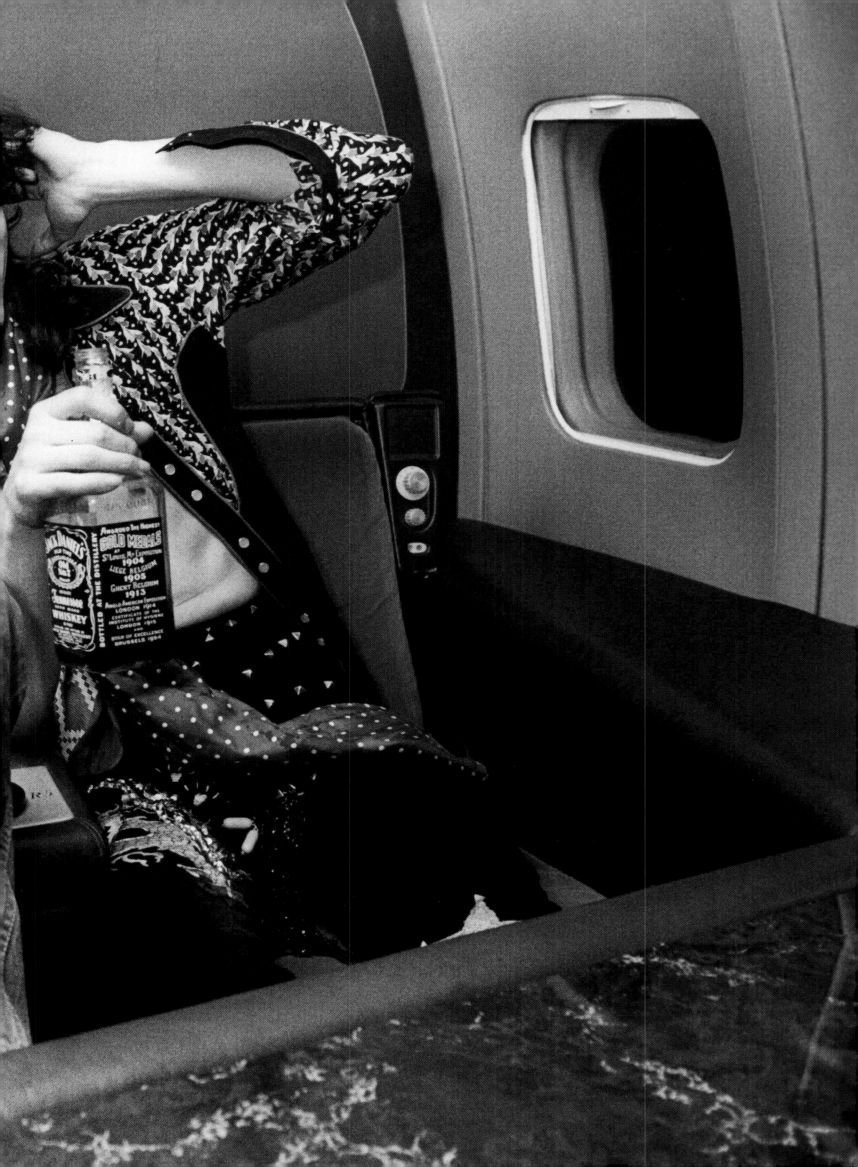

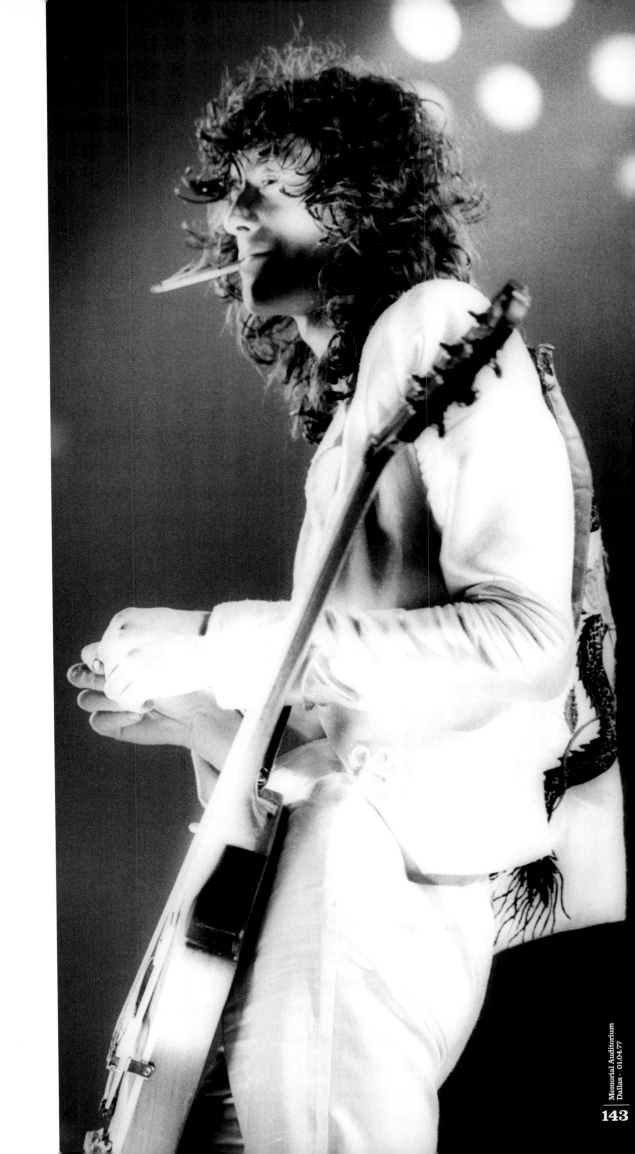

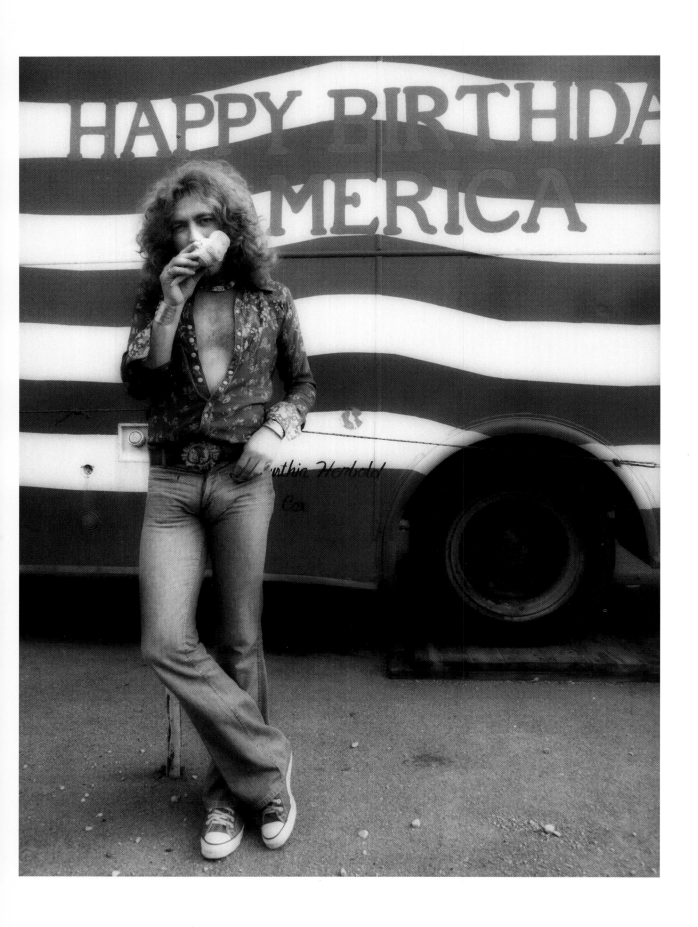

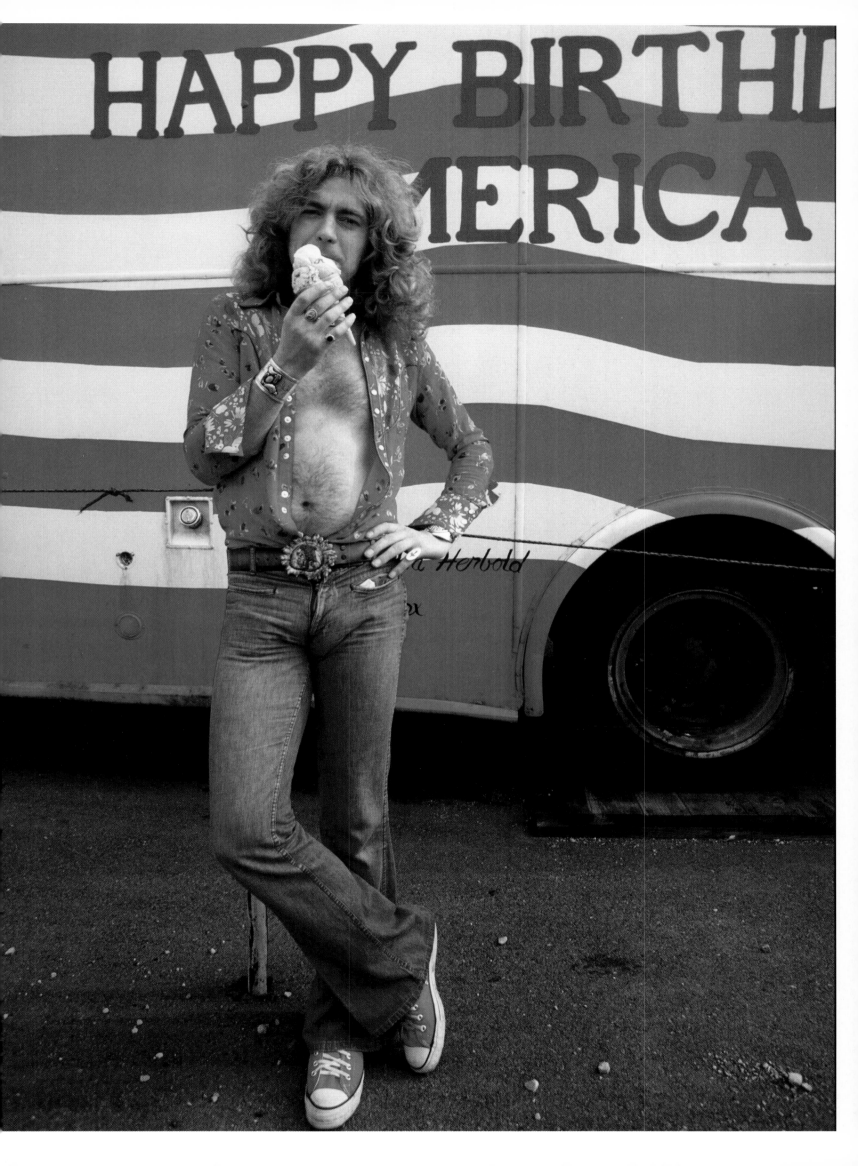

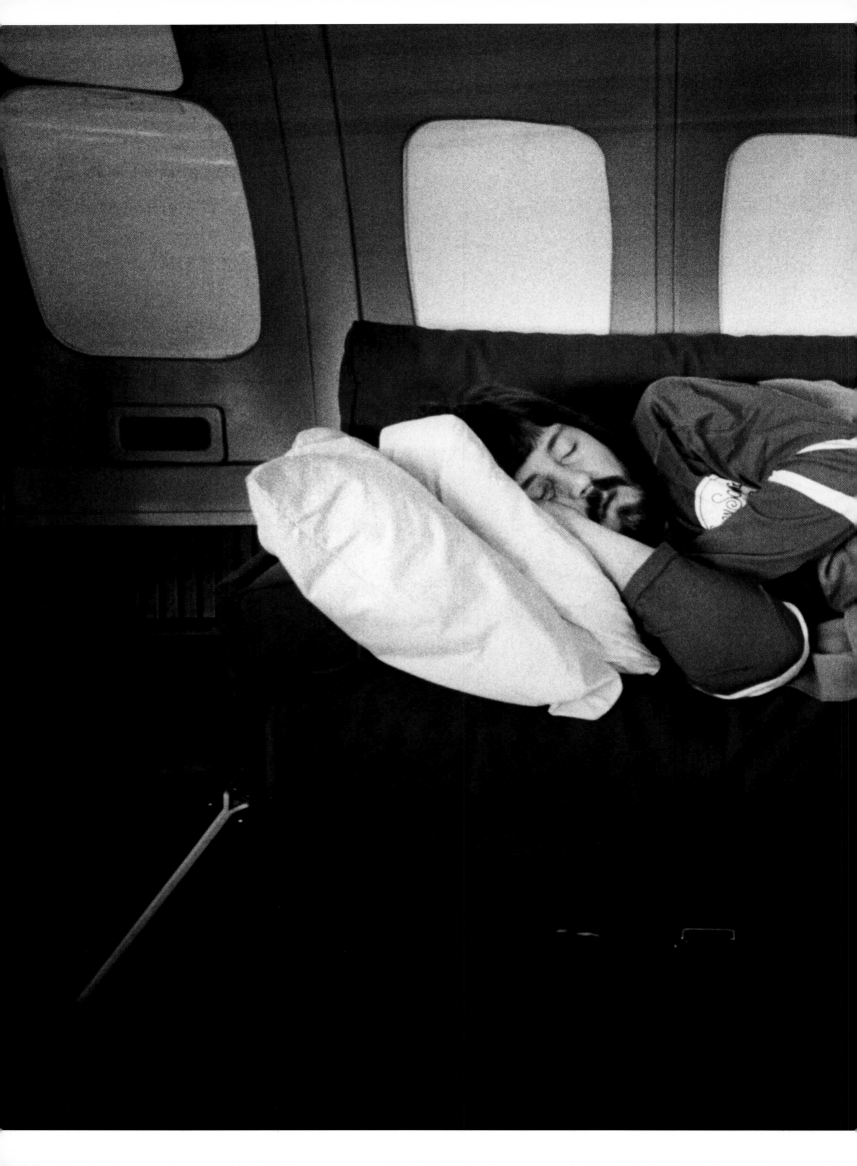

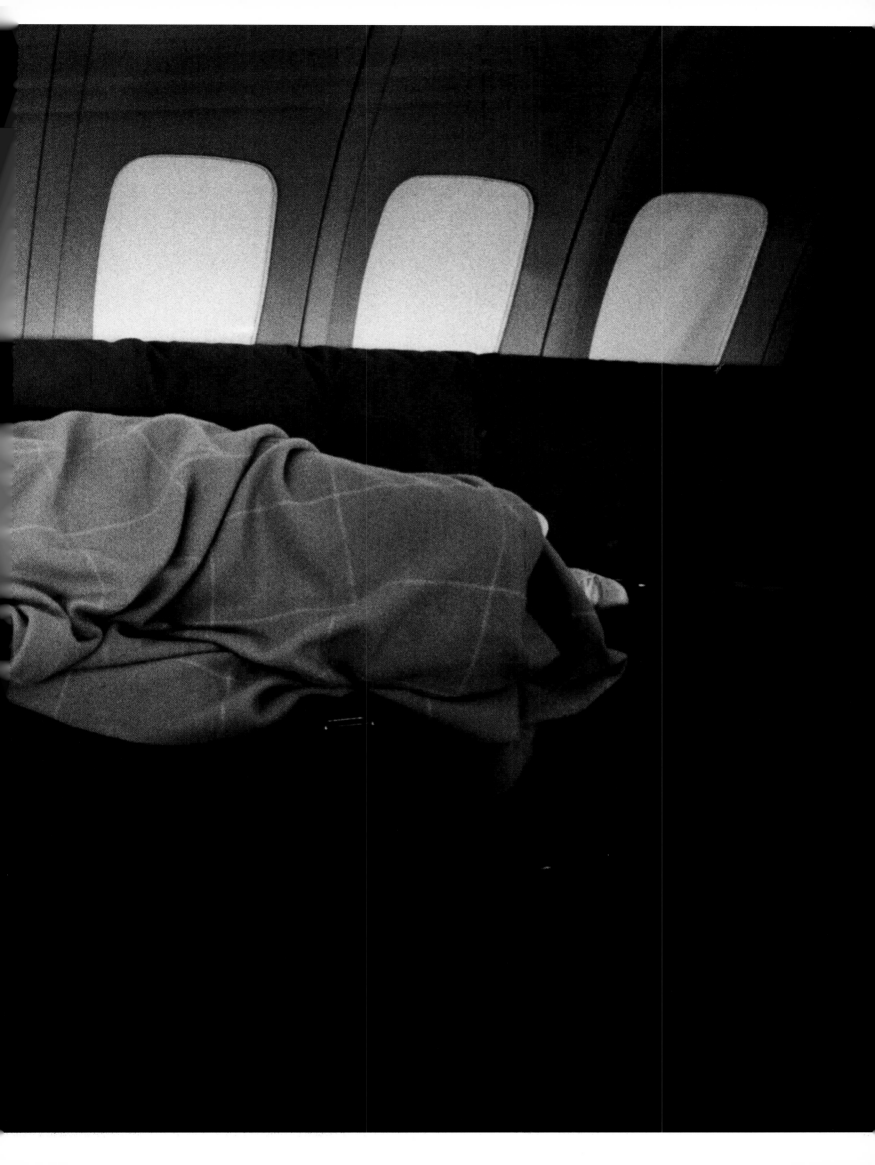

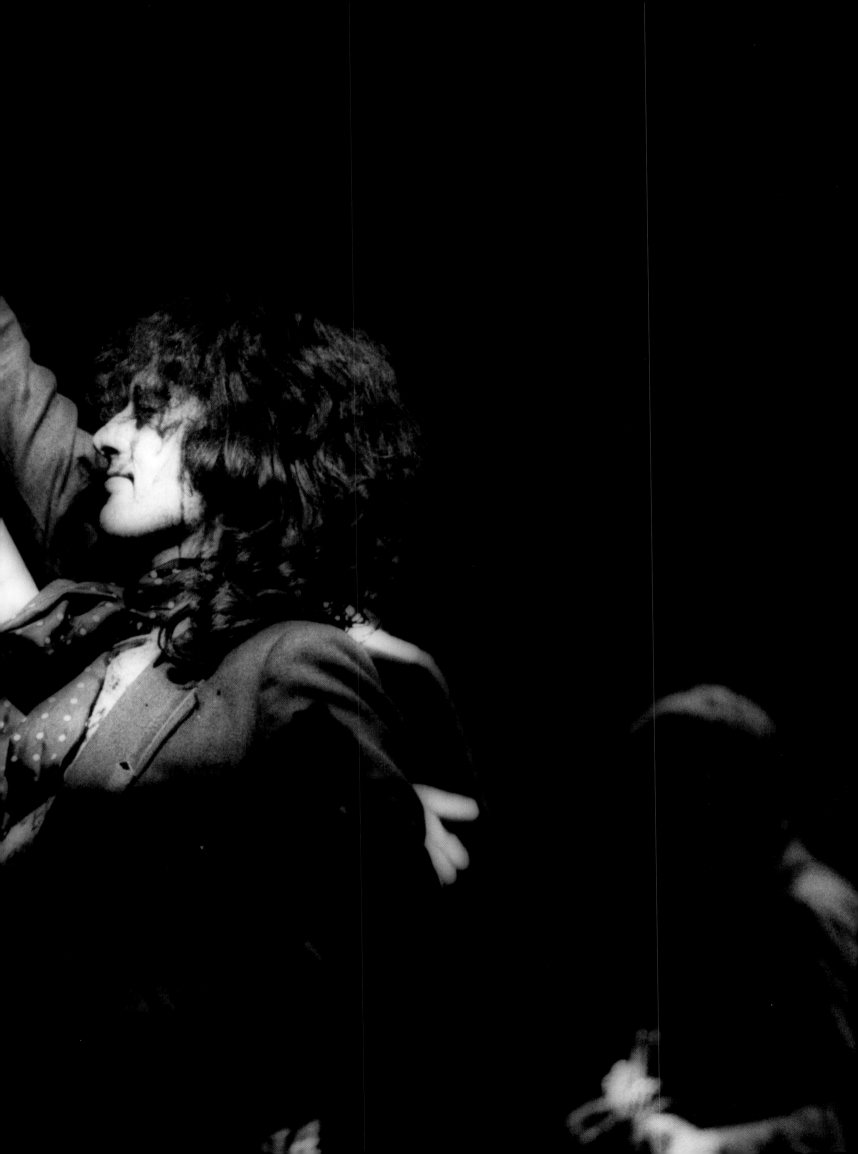

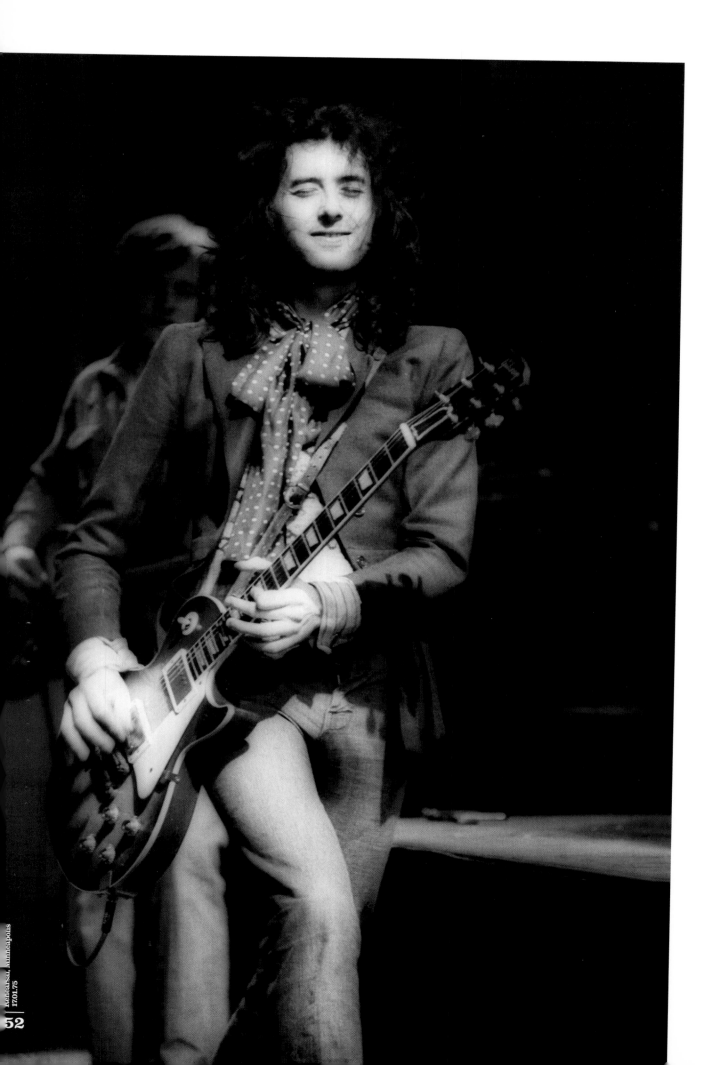

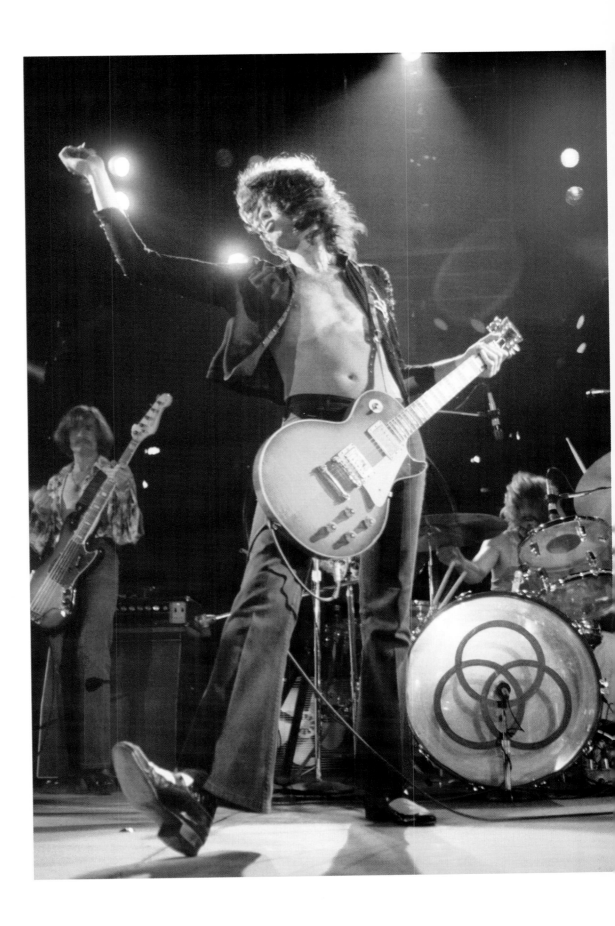

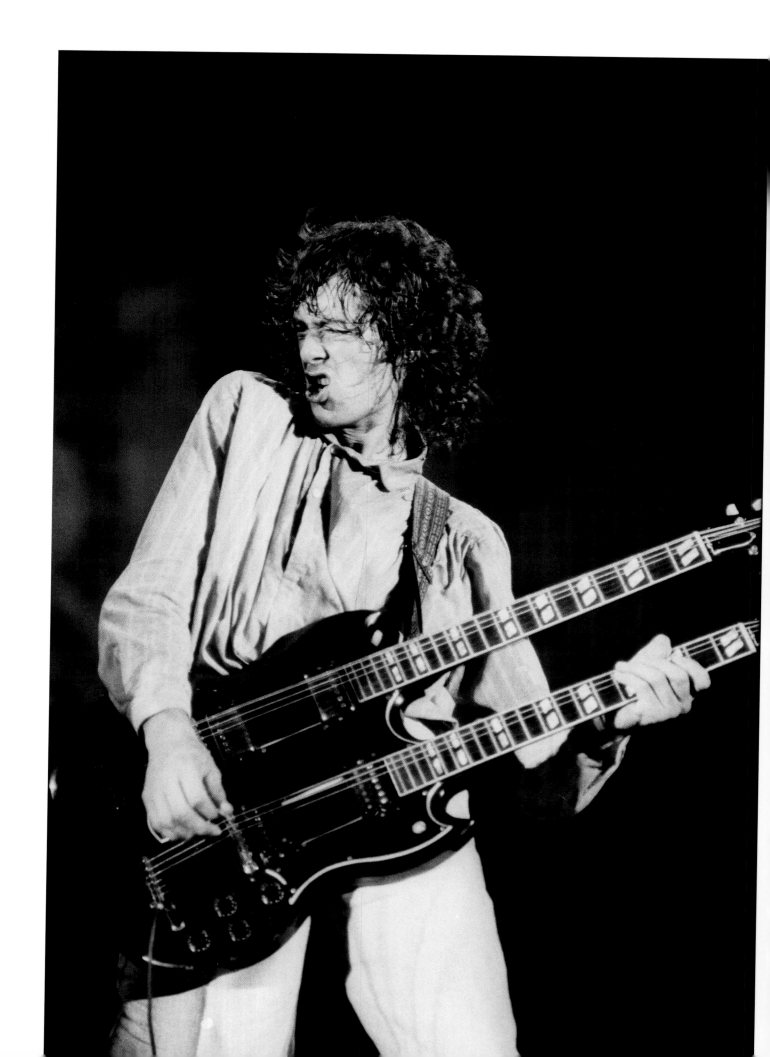

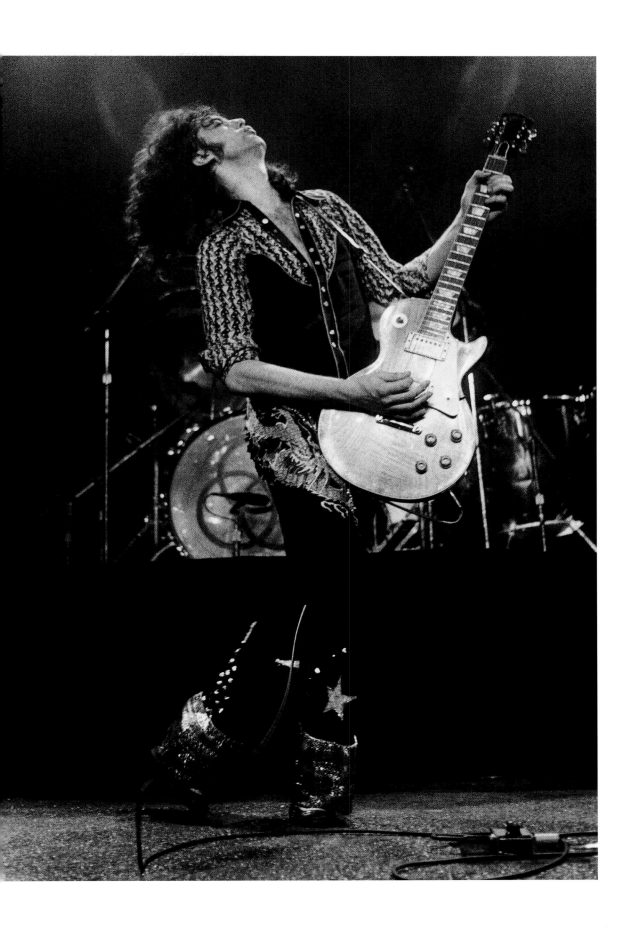

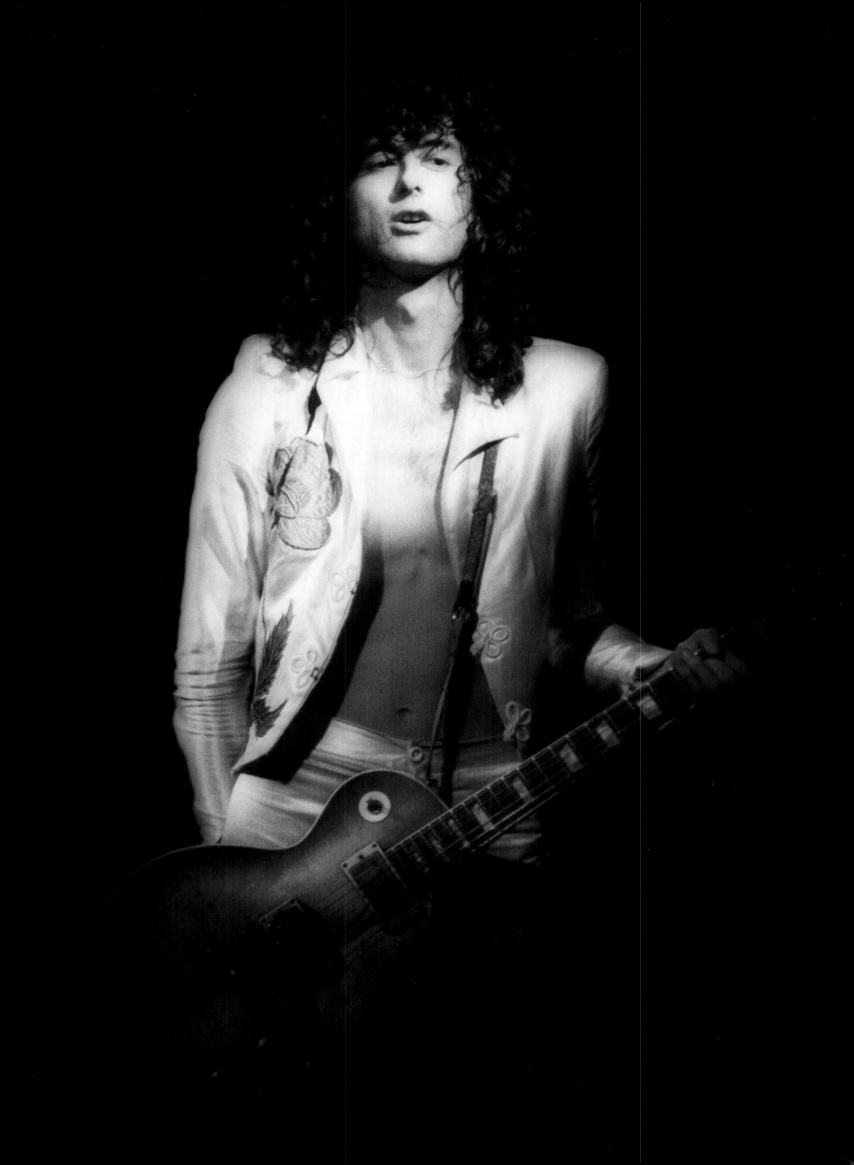

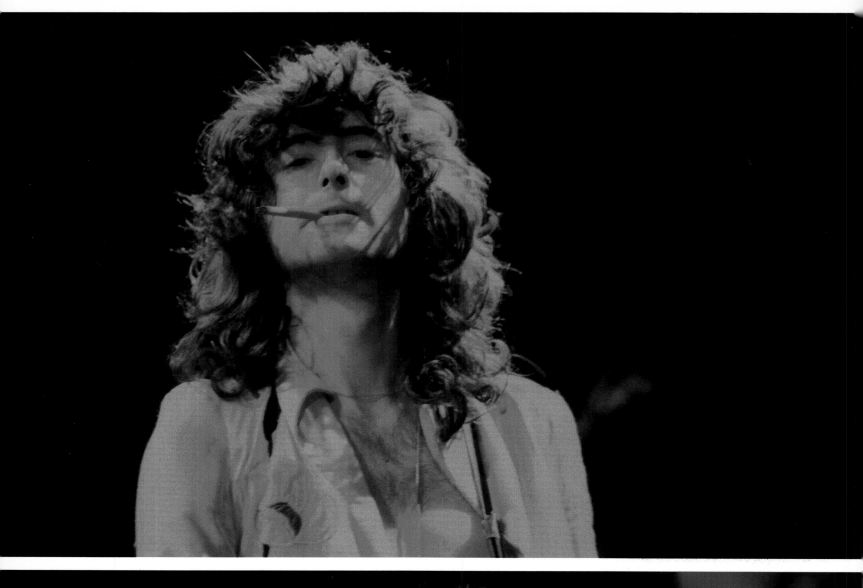
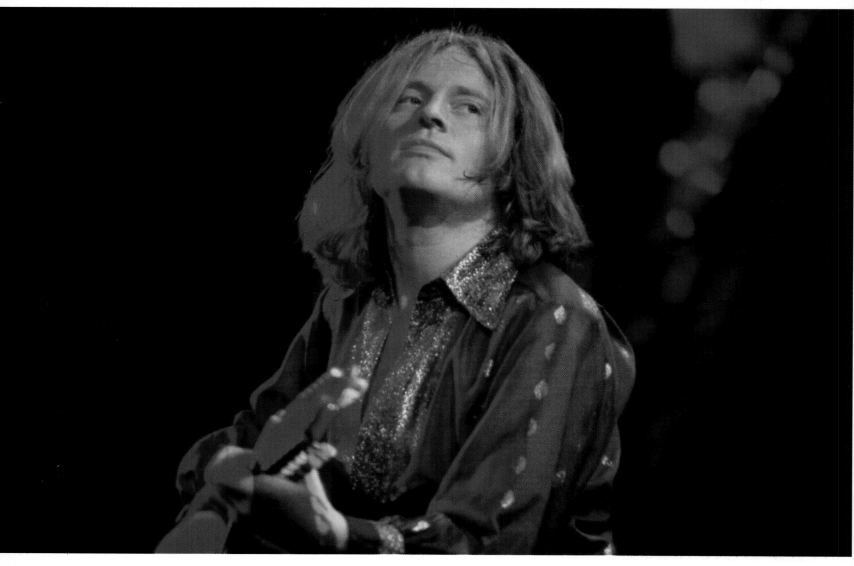

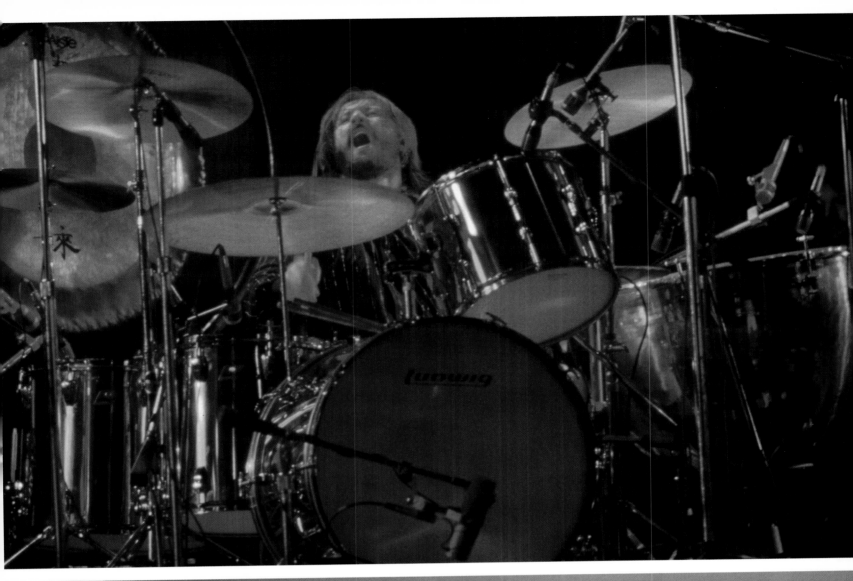
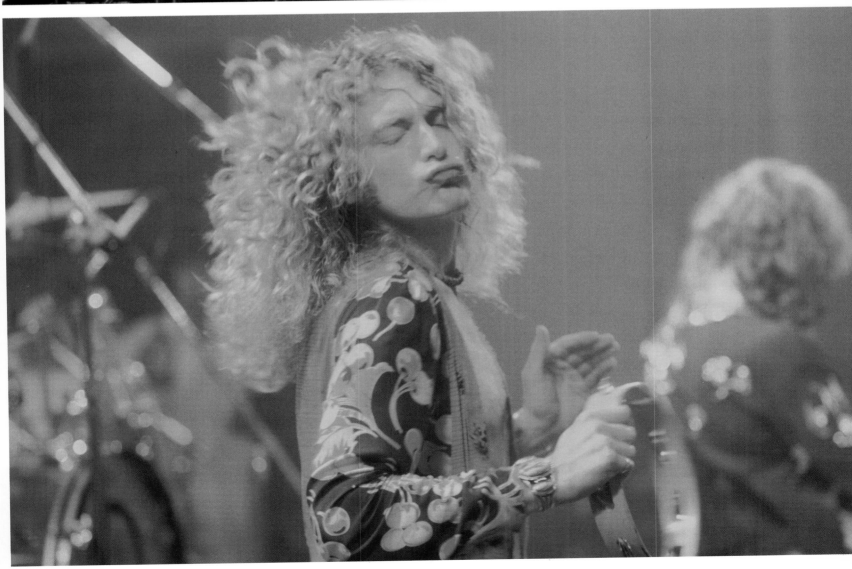

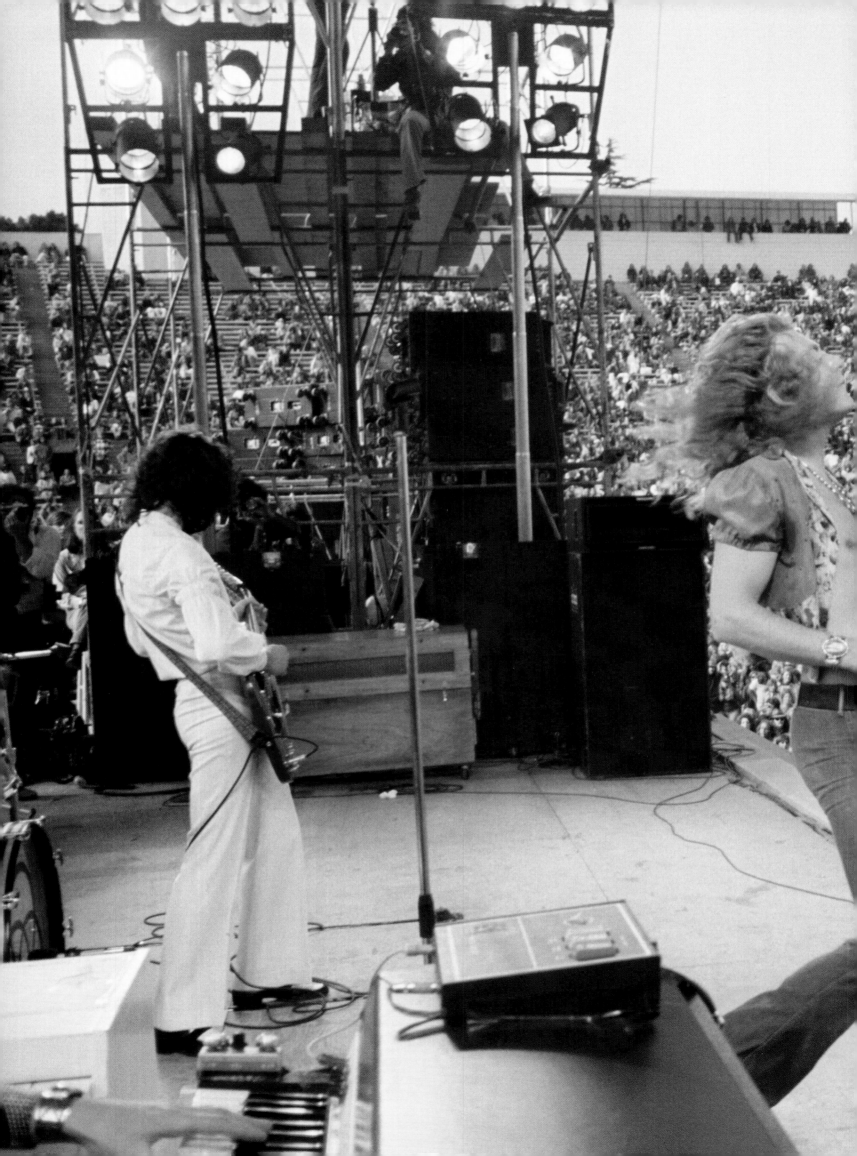

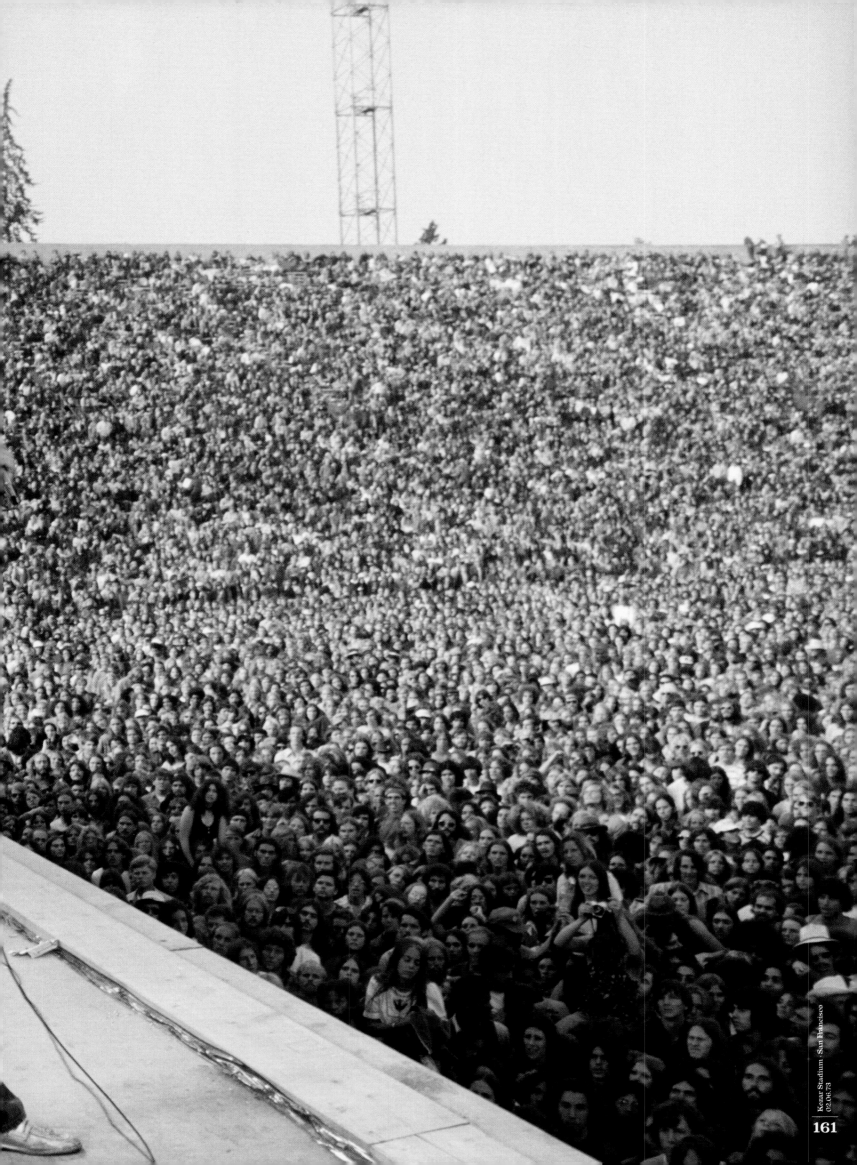

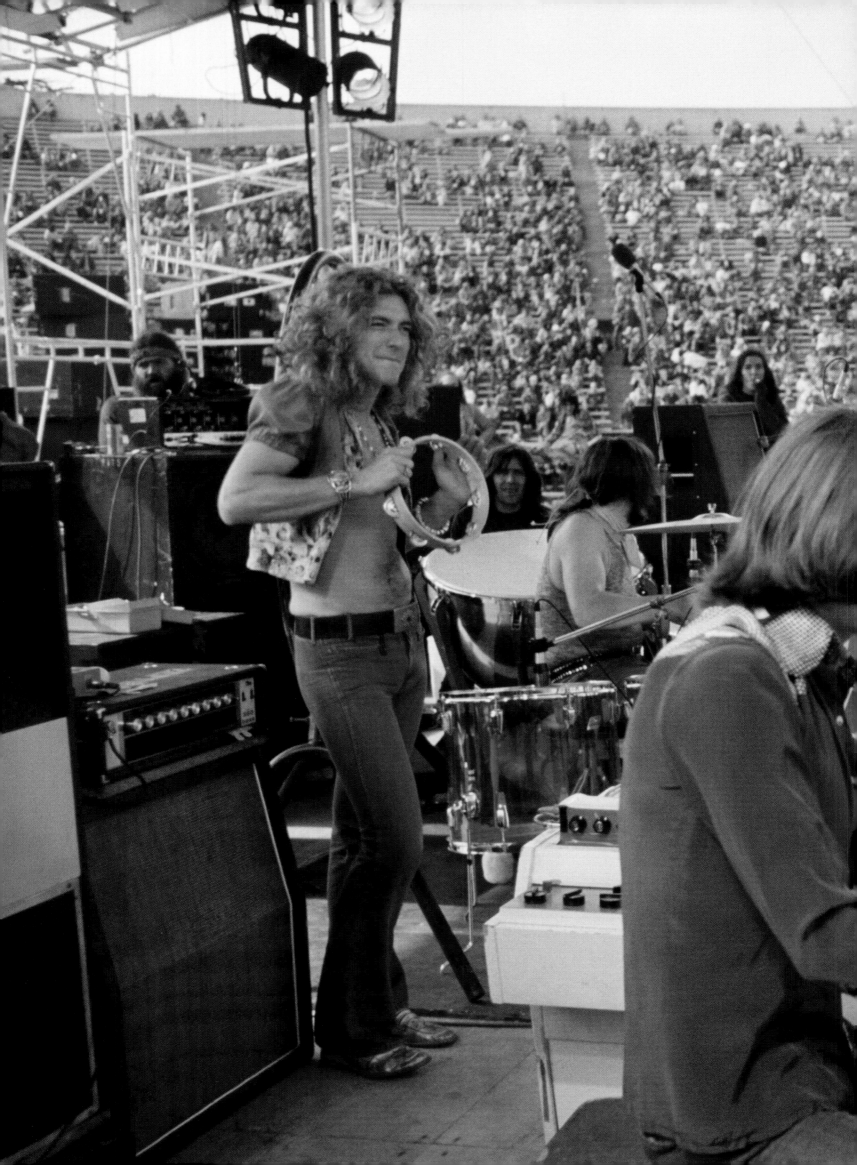

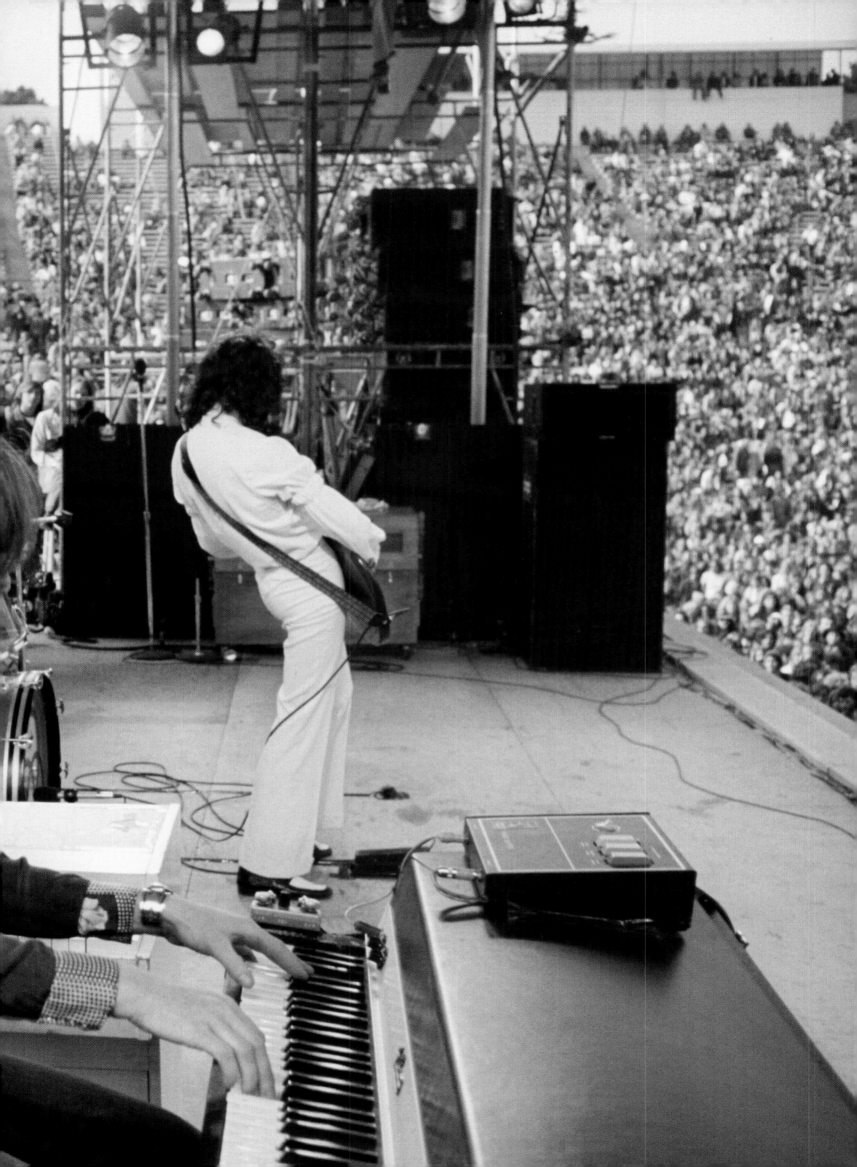

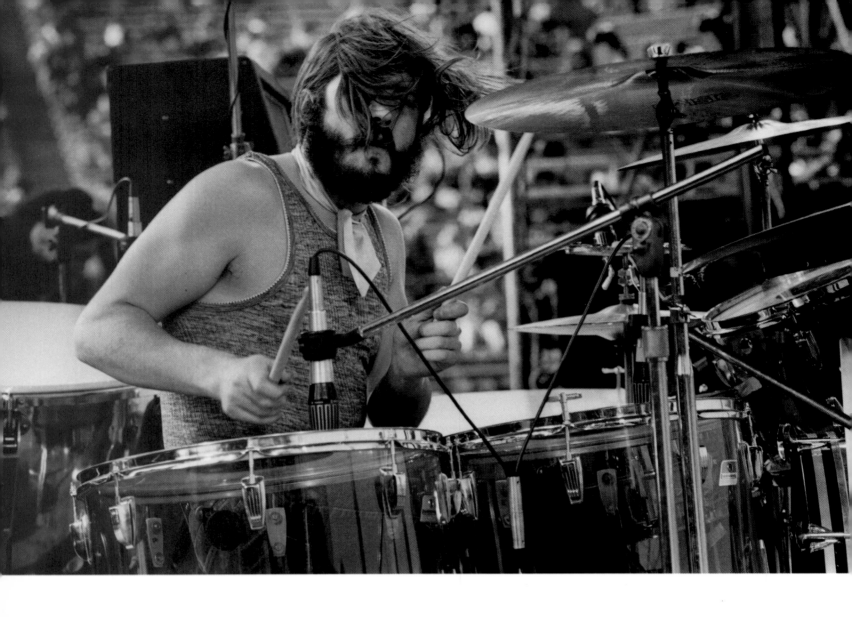

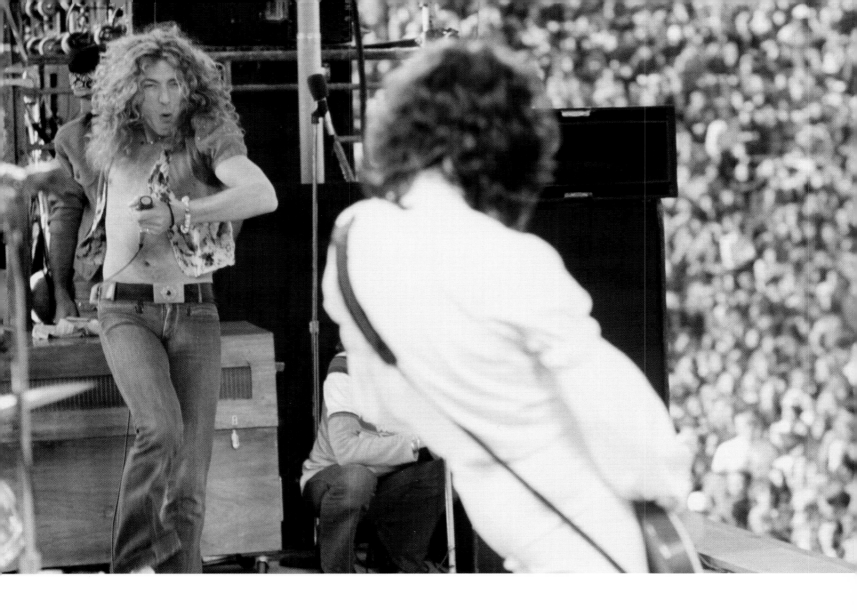

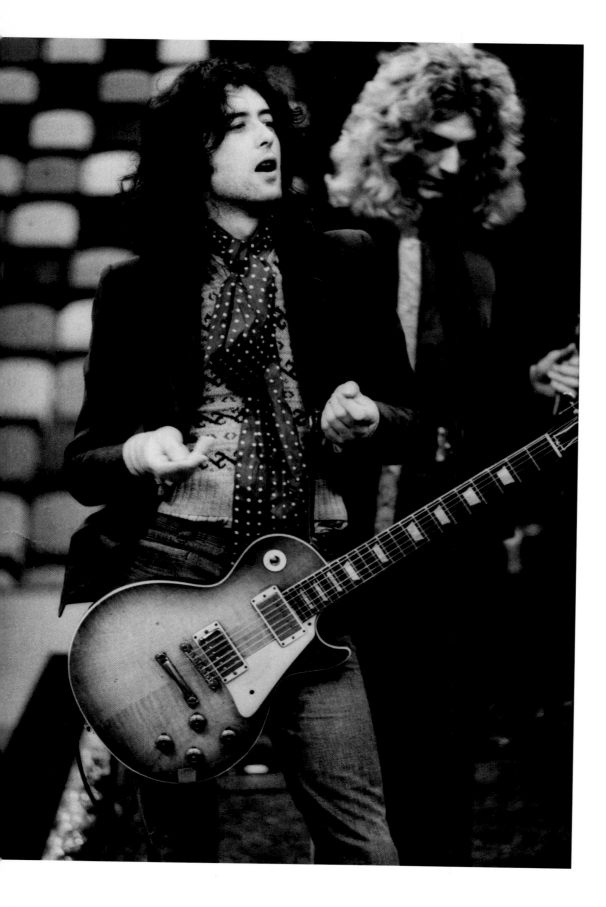

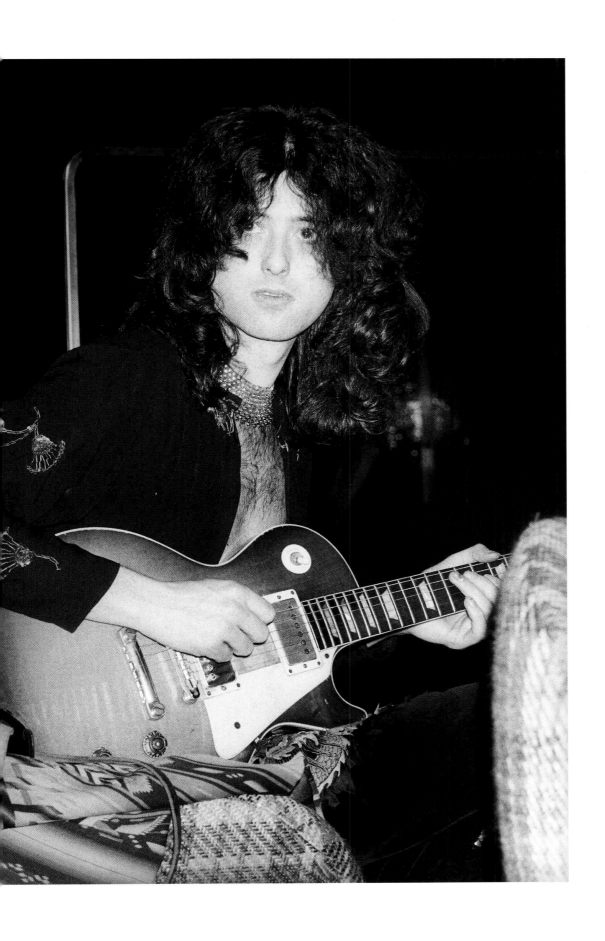

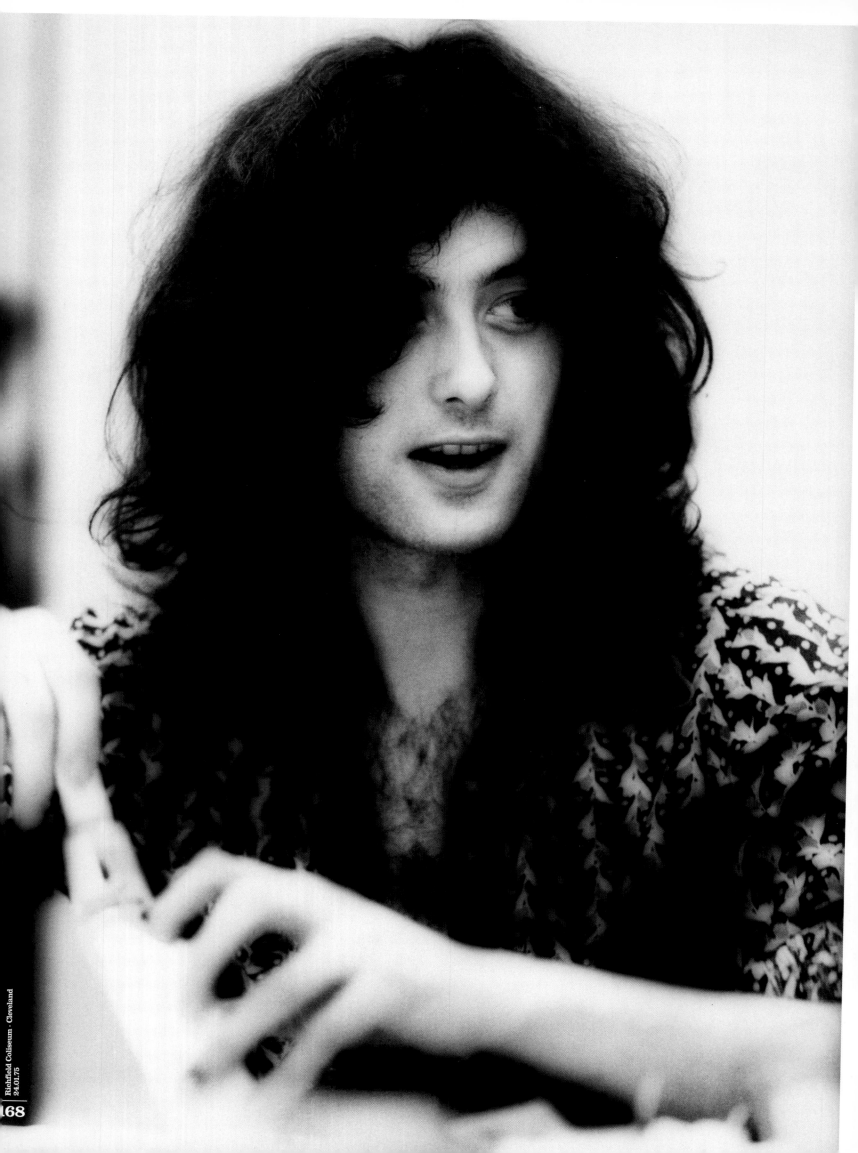

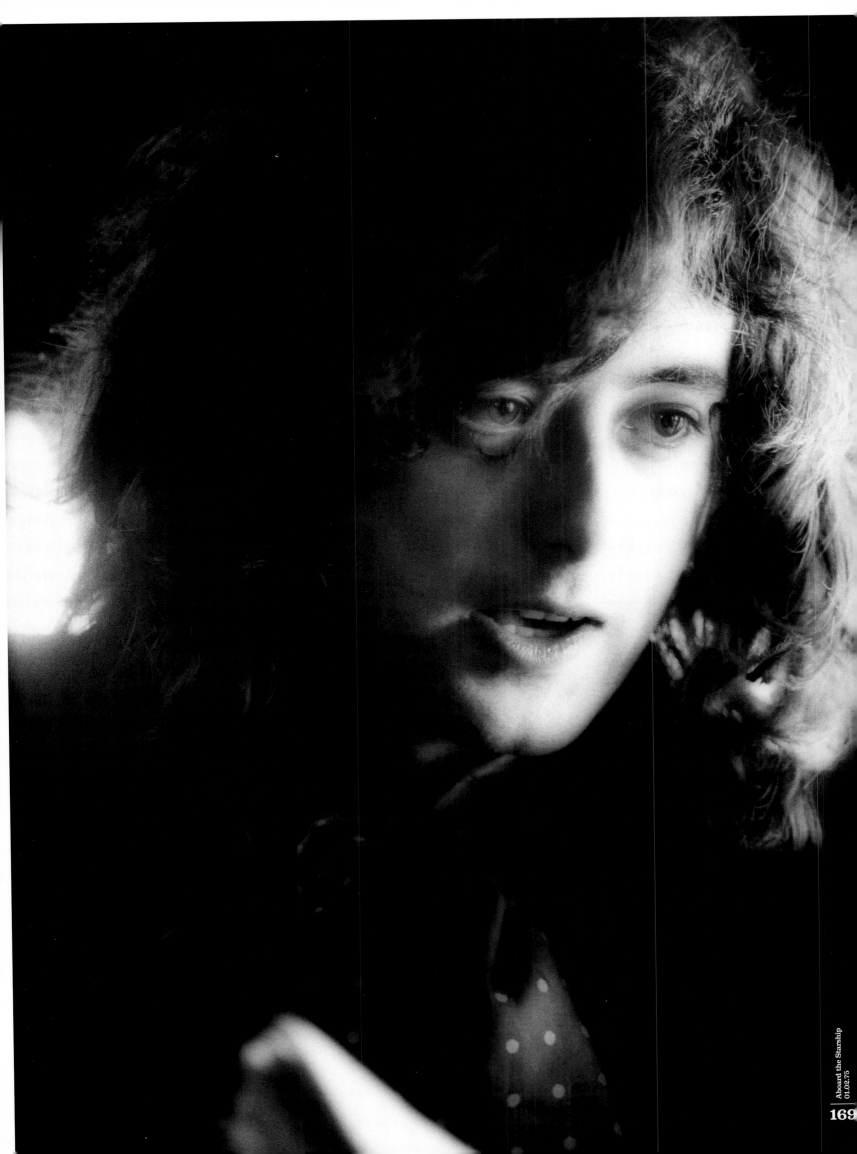

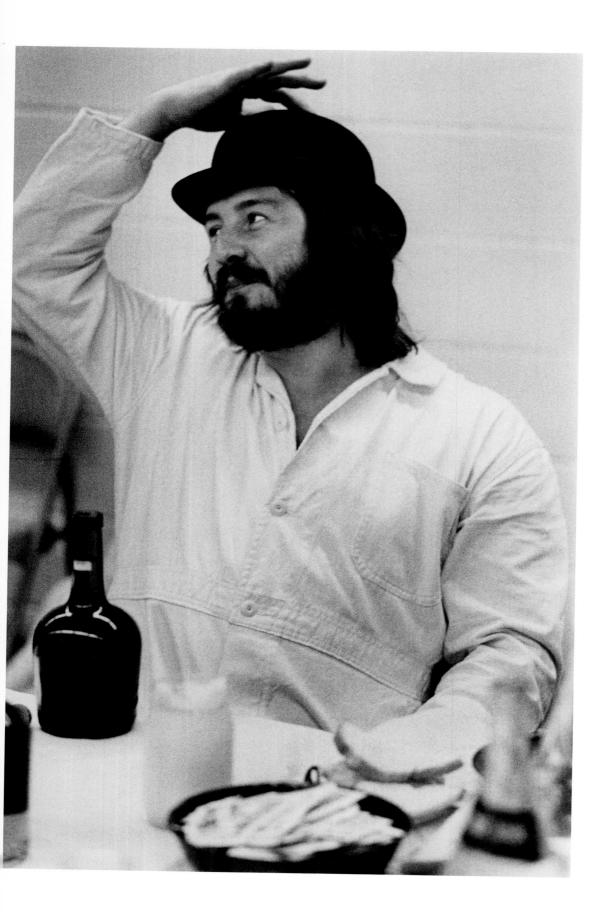

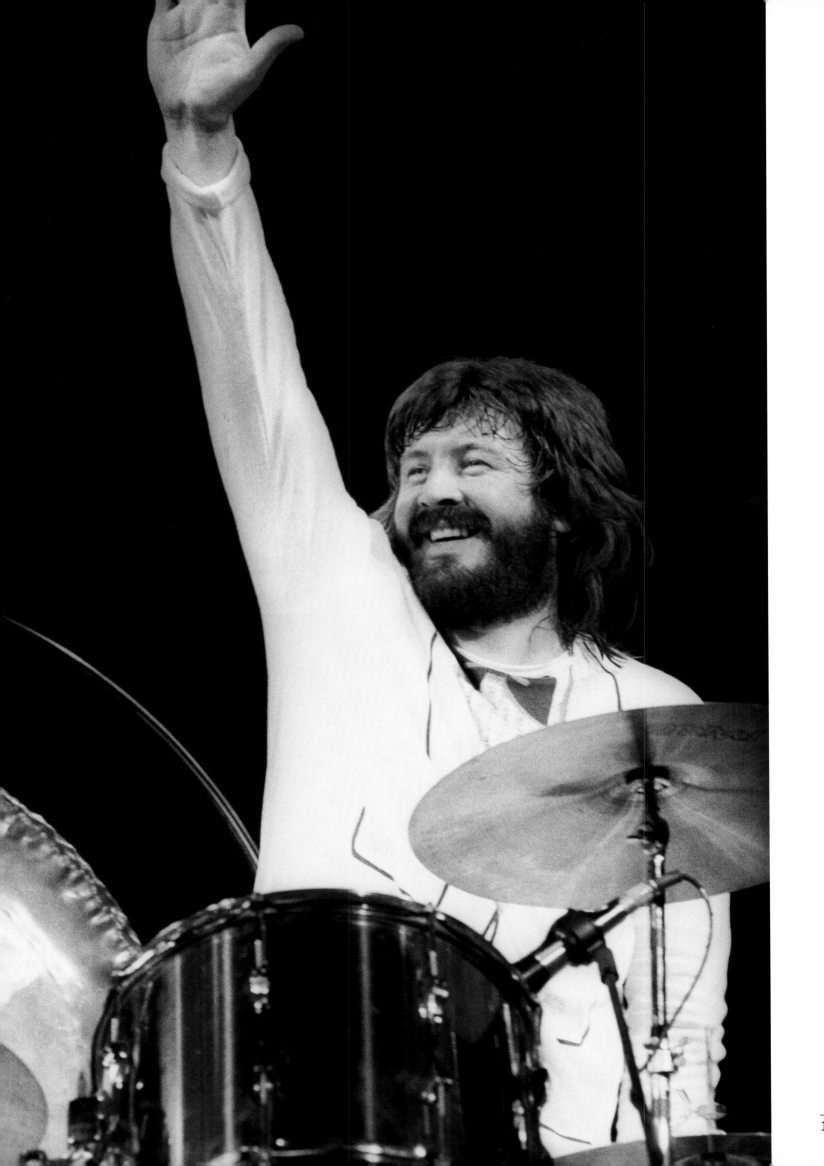

They may have ceased to exist as a working unit, but their legacy was assured. In the two decades since their retirement, the very name Led Zeppelin has come to act as a yardstick for all that is classic in rock. Their albums continue to sell in the millions, their music is a staple diet for countless rock stations and their influence on a whole host of bands that have surfaced in their wake is infinite. Their music still resounds around the world - be it from the countless tribute bands that tread the boards every night to the likes of Puff Daddy reworking *Kashmir*. The ex-band members have also enjoyed fruitful solo careers, happy to acknowledge their previous legacy with reunions at Live Aid and the Atlantic Records birthday show, and of course the renewed partnership of Page and Plant for their *Unledded* album and tours.

So the evolution of Led Zeppelin continues... and if you want to hear what it was all about, their original catalogue is a permanent fixture in record stores all the way from Marrakech to the misty mountains and back again.

If, however, you want to relive the memories or discover what it all looked like, then the photographs Neal Preston took of Led Zeppelin in their absolute prime are simply essential viewing.

Dave Lewis
July 2002

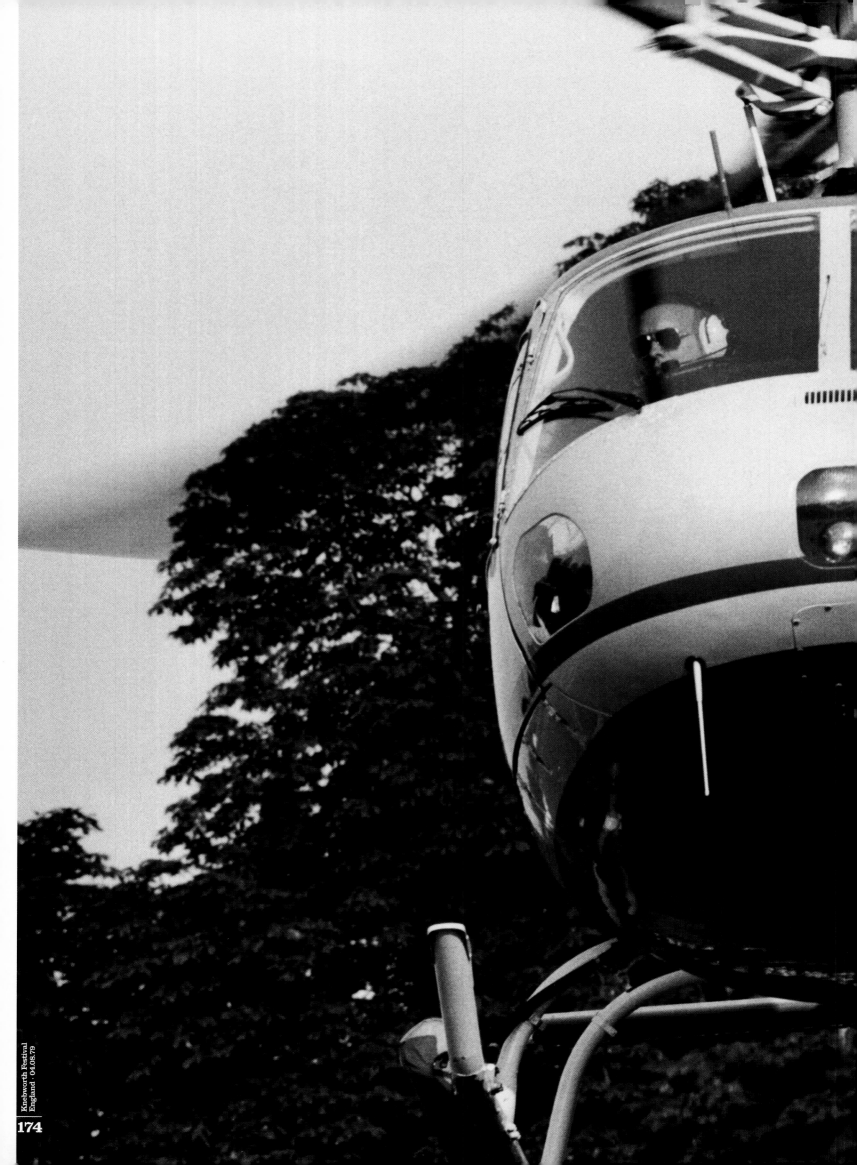

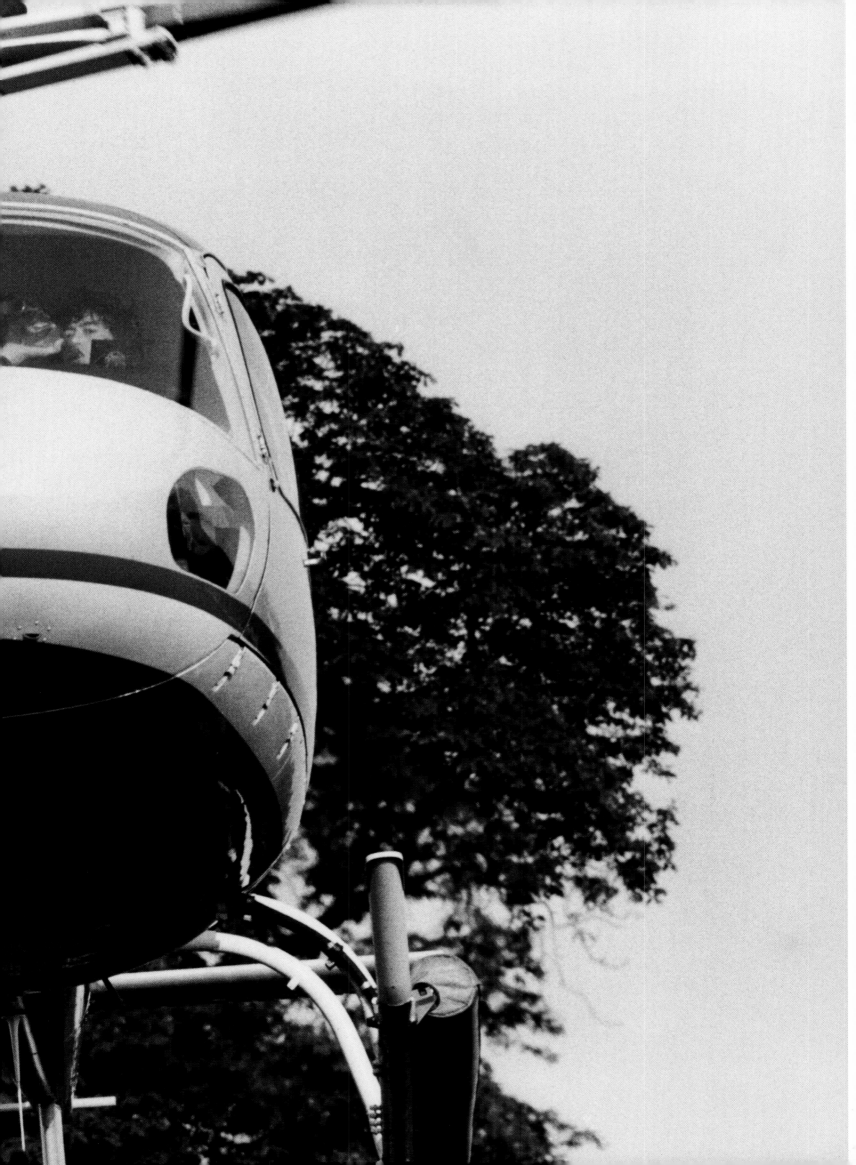

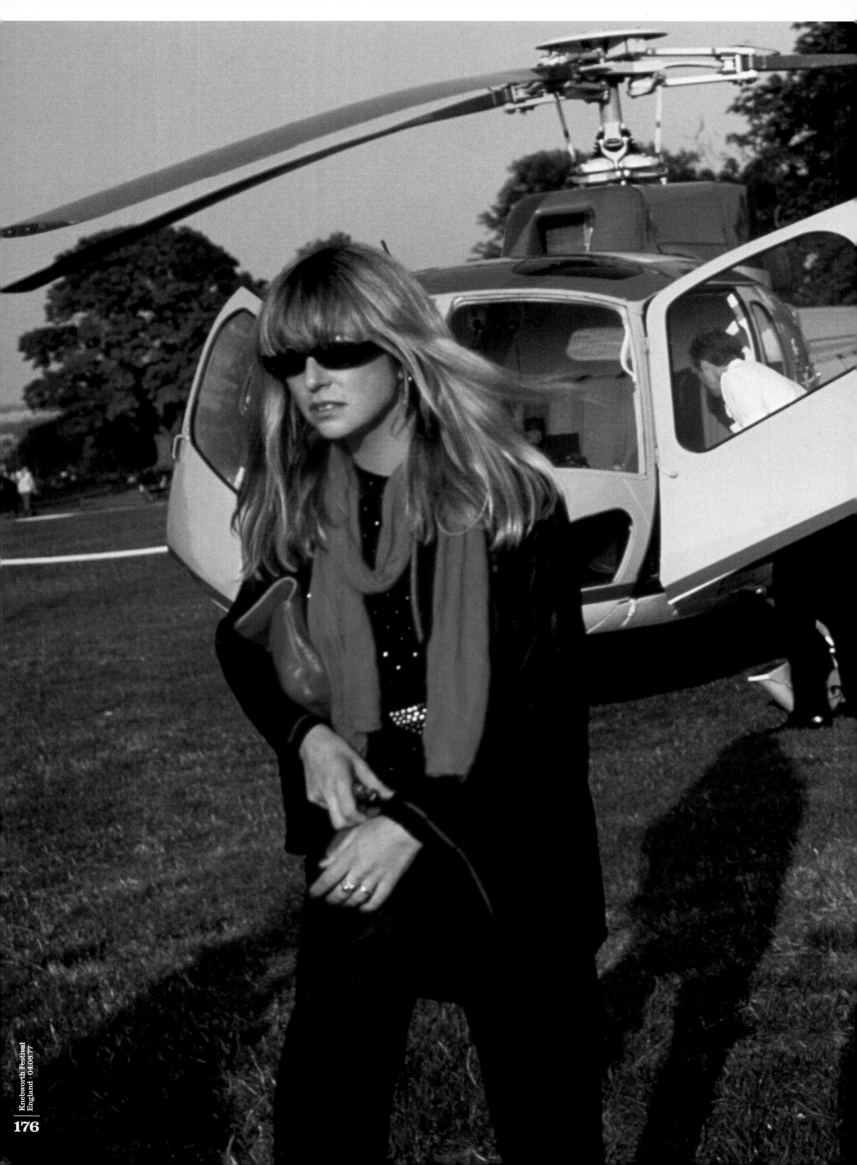

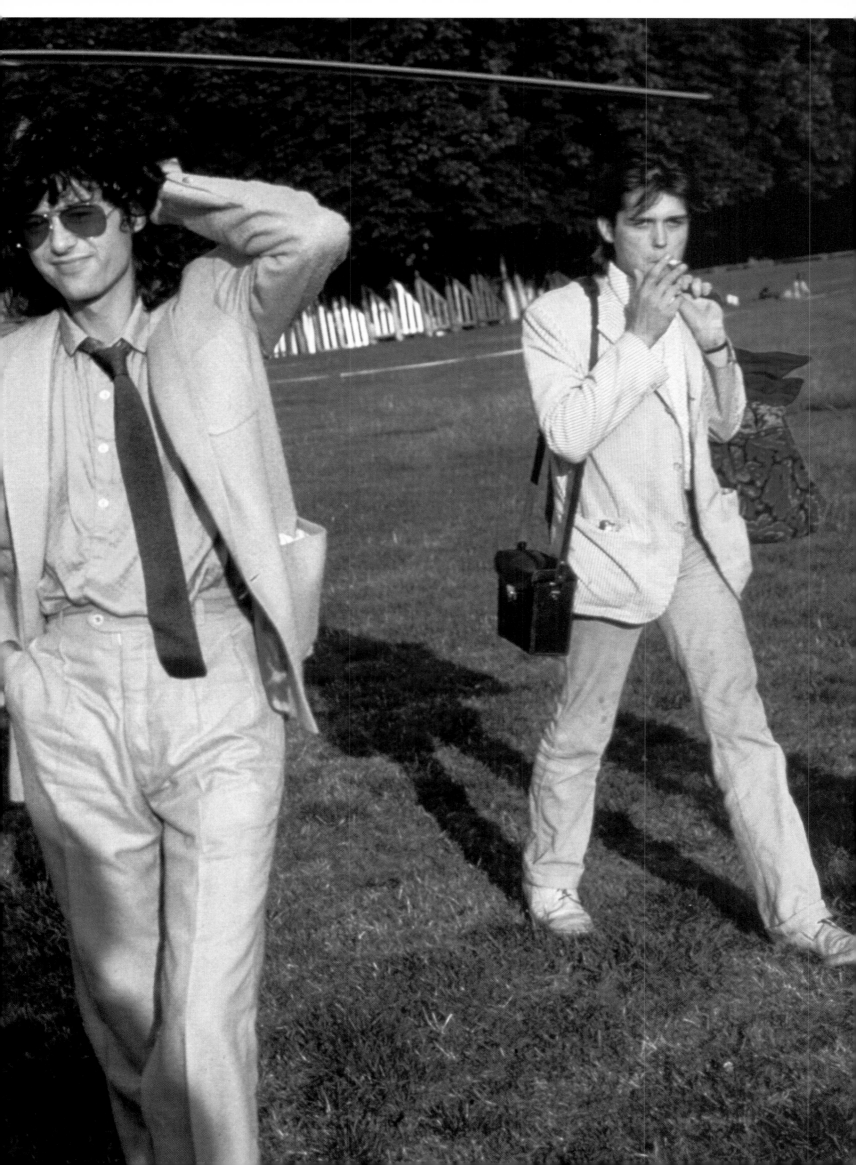

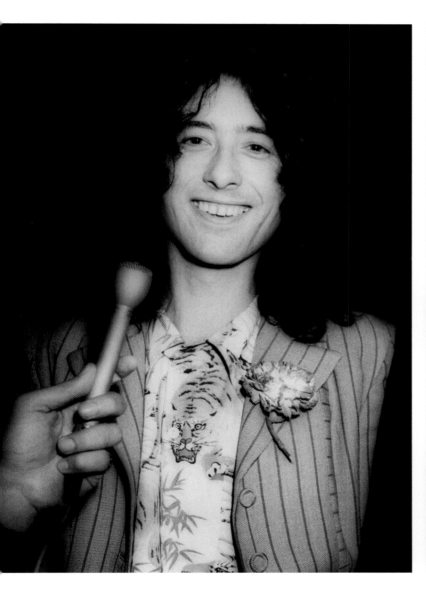

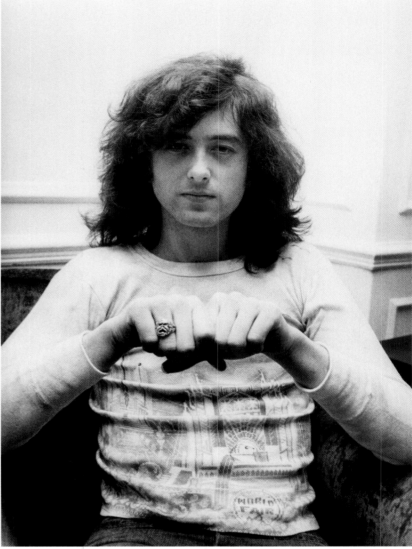

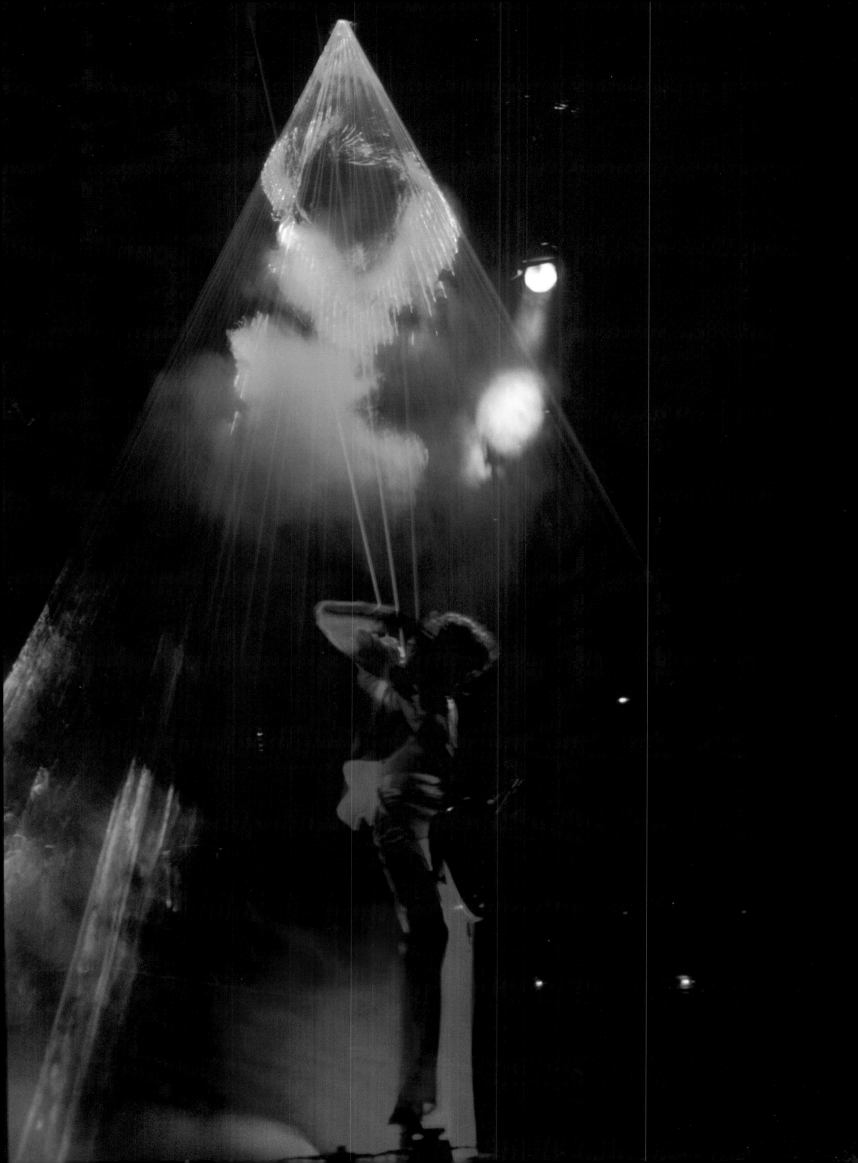

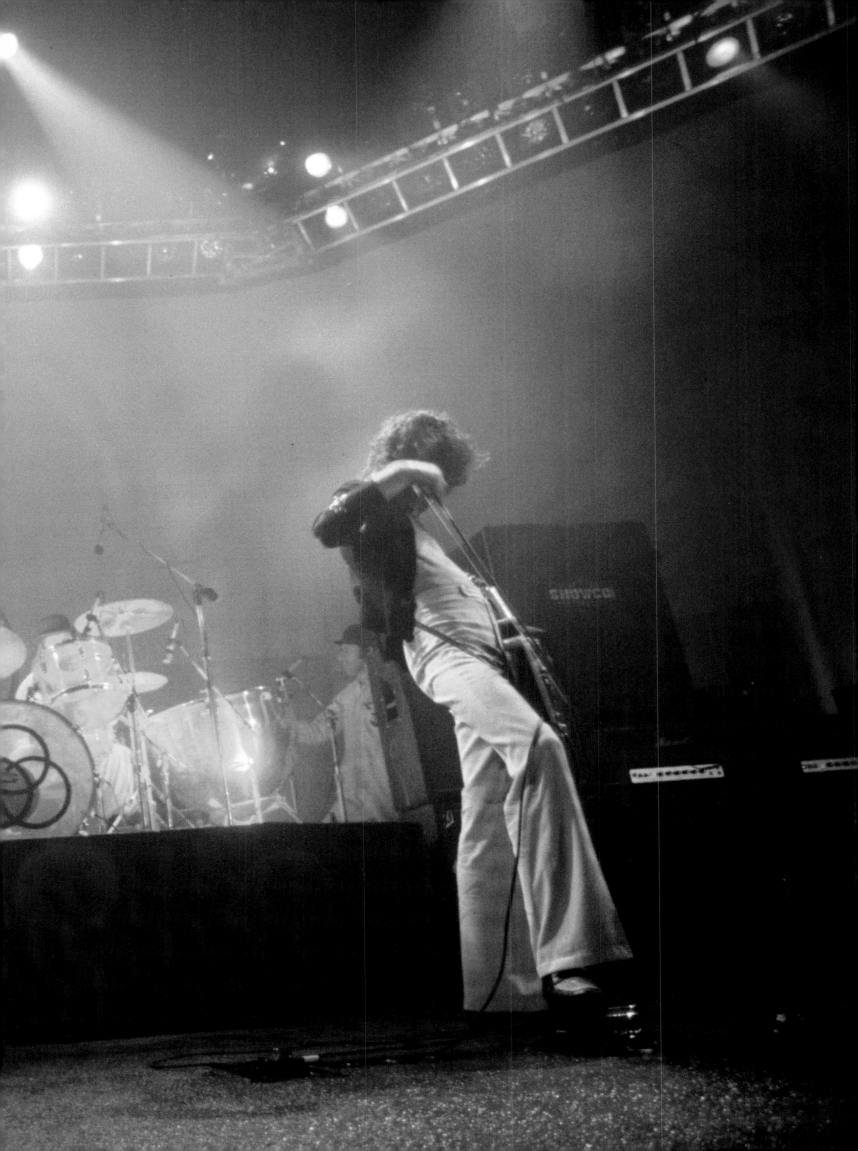

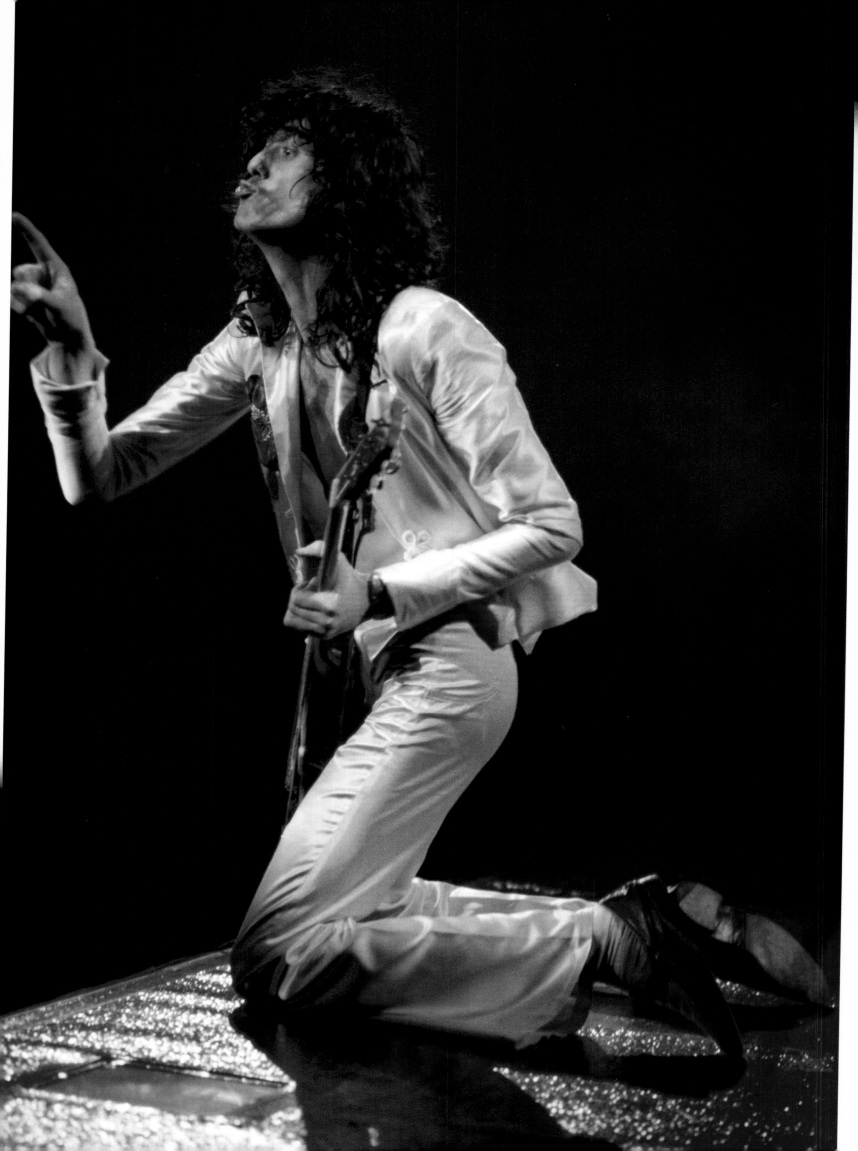

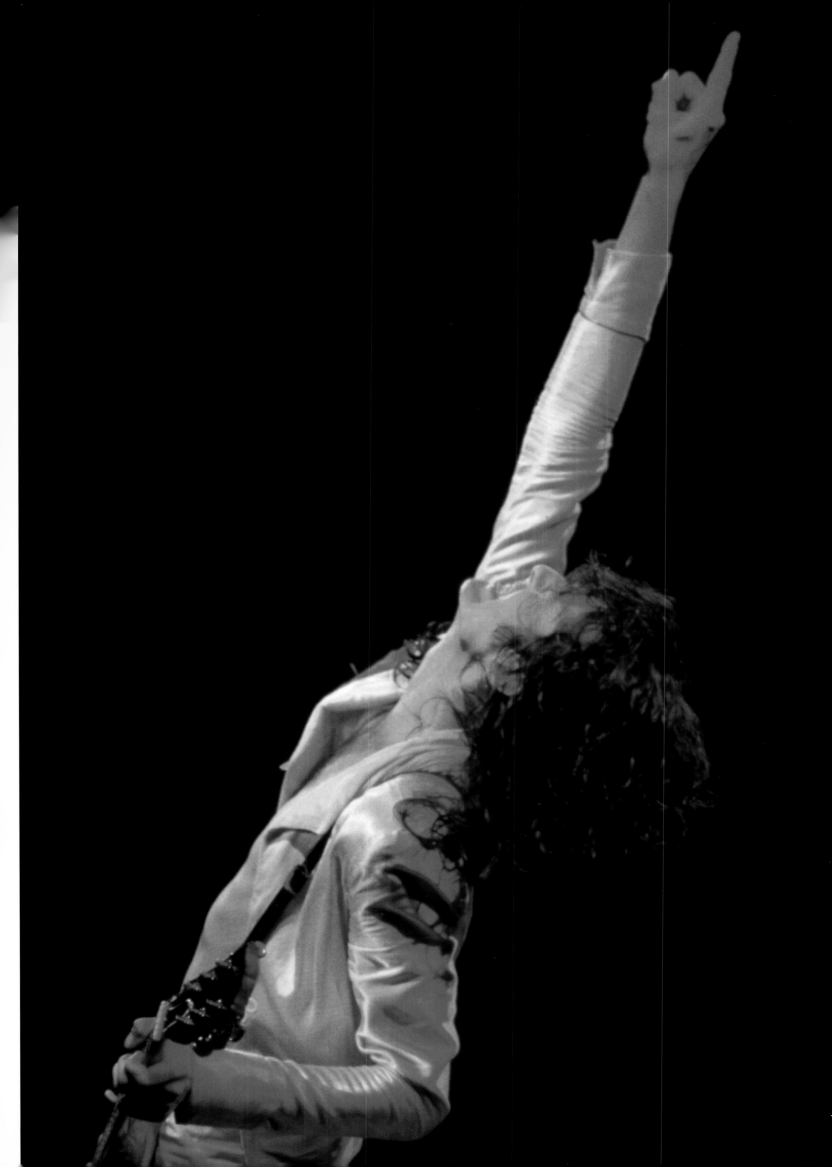

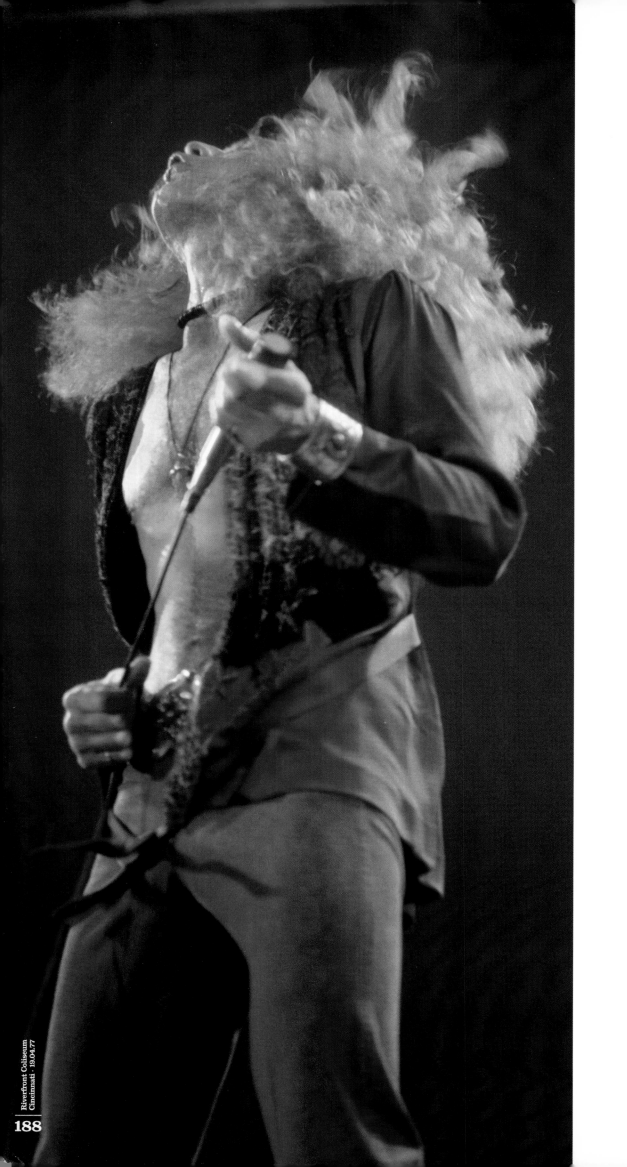

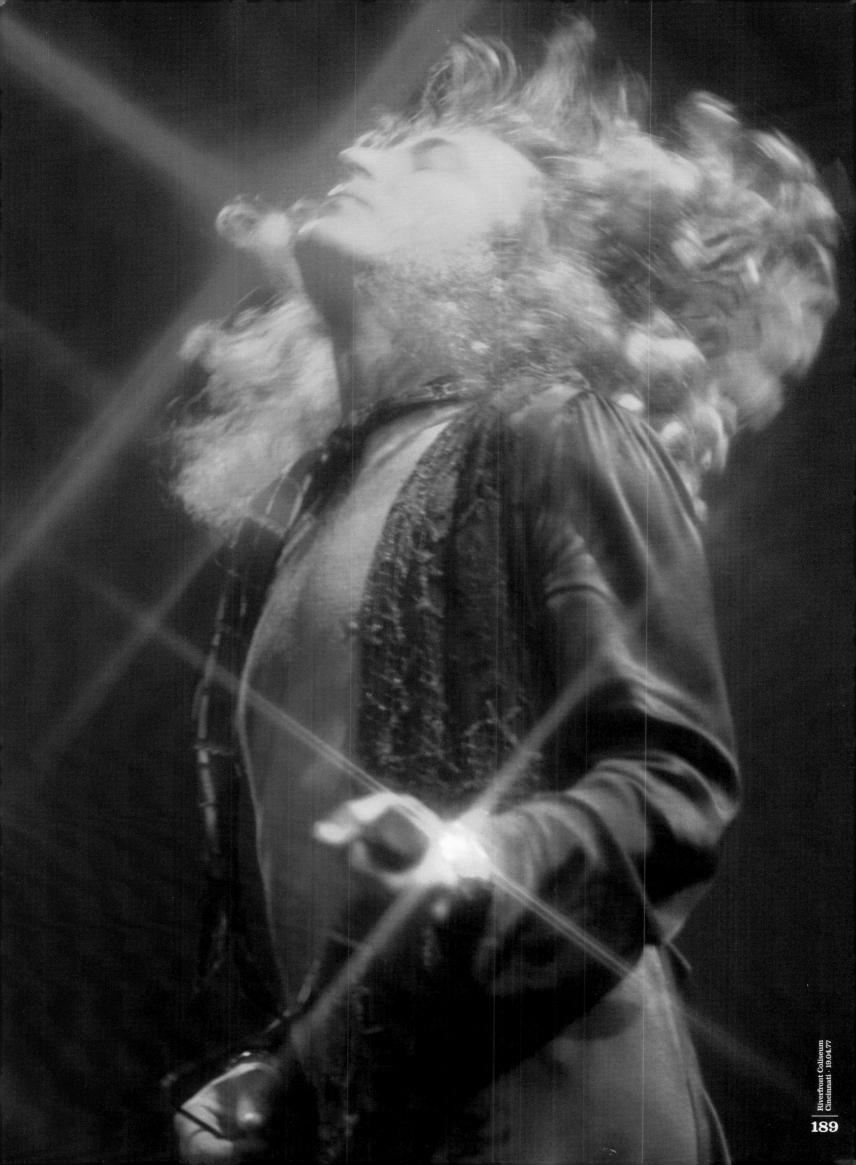

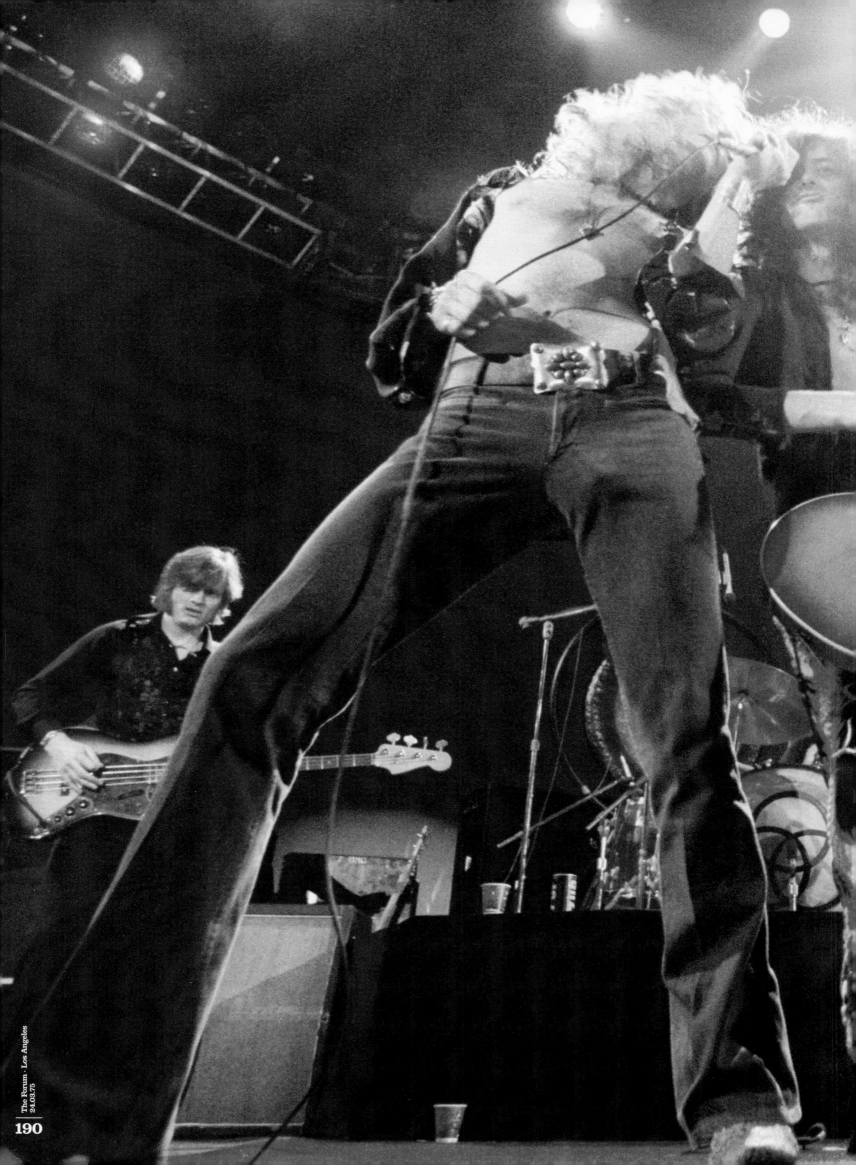

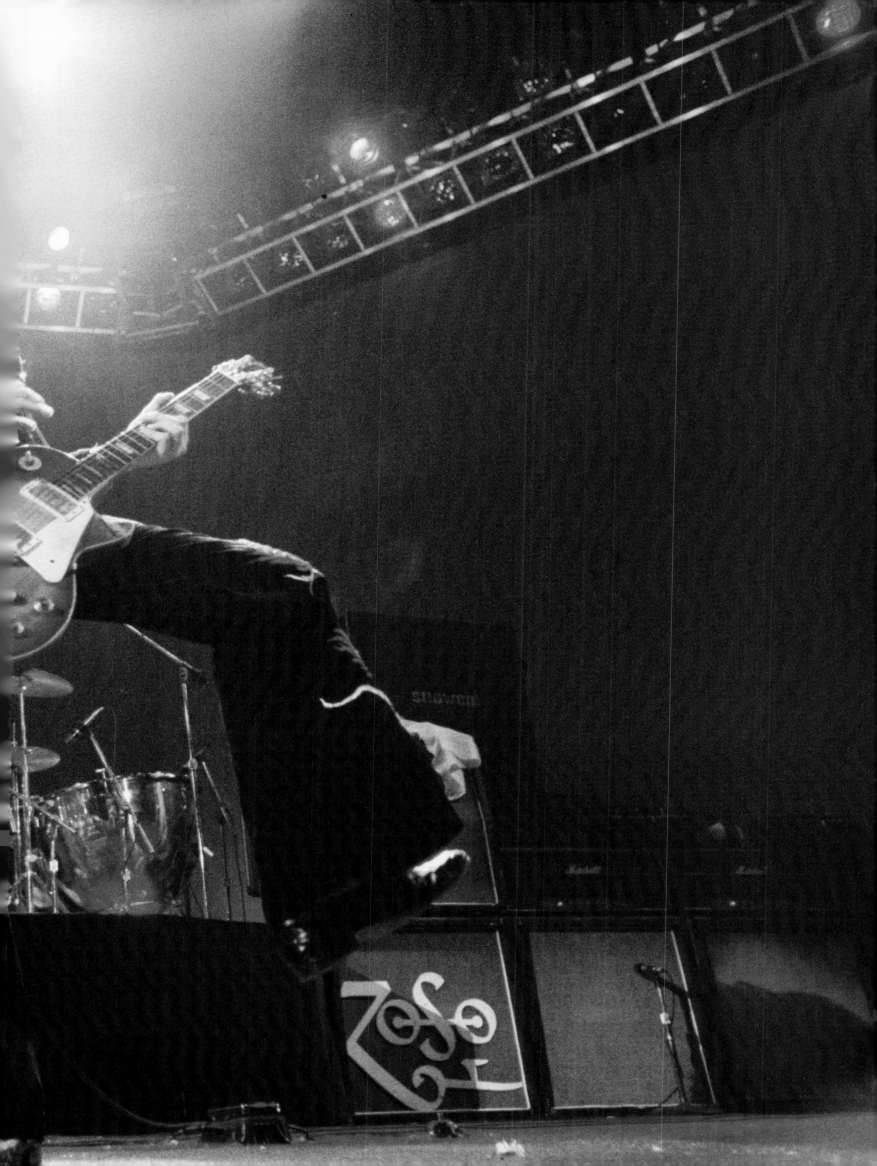

Many thanks to all my friends... and especially:

Cameron Crowe
Jaan Uhelzski
Daniel Markus
M.C. Marden
Sarah Laizen
Danny Goldberg
Richard Cole
Janine Safer
Kimberly Sharp

Brian Greenberg
Jennifer Conradt
Isgo Lepijian
Lesley Zimmerman
Stevie Nicks
Ricardo Cestero

...and the boys in the band

Photography: Neal Preston
Art Direction and Book Design:
Paul West at Form® (www.form.uk.com)
Black and white prints:
Isgo Lepijian, Los Angeles
Colour scanning:
A & I Color, Los Angeles
Reprographics: AJD Colour Ltd
Print: Compass Press Ltd

Led Zeppelin first published in Great
Britain in 2002 by Vision On Publishing
112-116 Old Street, London EC1V 9BG
T +44 (0)20 7336 0766
F +44 (0)20 7336 0966
www.vobooks.com
info@vobooks.com

All photography © Neal Preston
Book design © Form®

The right of Neal Preston to be
identified as the author of his work
has been asserted by him in accordance
with the Copyright, Designs and
Patents Act of 1988

For exhibition print sales, please
contact www.prestonpictures.com

Dave Lewis first heard Led Zeppelin in
1969 at the age of 13. The effect has been
a lasting one. He is recognised as a
foremost authority on their work. Dave
has written a variety of books on the band
notably the definitive reference work "Led
Zeppelin A Celebration". He is also the
editor of Tight But Loose, the long
running Led Zeppelin magazine he
founded in 1978.

Dave continues to edit the magazine and
chronicle the work of Led Zeppelin and
the solo projects of their ex members for a
variety of publications including Record
Collector, Classic Rock and Mojo. A music
retailer by profession, he lives in Bedford,
England with his wife Janet and children
Samantha and Adam.

*For details of the Led Zeppelin magazine
Tight But Loose visit www.tblweb.com
or email davelewis.tbl@virgin.net